ATHENE Series

General Editors

Gloria Bowles
Renate Klein
Janice Raymond

Consulting Editor

Dale Spender

The Athene Series assumes that all those who are concerned with formulating explanations of the way the world works need to know and appreciate the significance of basic feminist principles.

The growth of feminist research internationally has called into question almost all aspects of social organization in our culture. The Athene Series focuses on the construction of knowledge and the exclusion of women from the process—both as theorists and subjects of study—and offers innovative studies that challenge established theories and research.

ATHENE, the Olympian goddess of wisdom, was honored by the ancient Greeks as the patron of arts and sciences and guardian of cities. She represented both peace and the intellectual aspect of war. Her mother, Metis, was a Titan and presided over all knowledge. While pregnant with Athene, Metis was swallowed whole by Zeus. Some say this was his attempt to embody her supreme wisdom. The original Athene is thus twice born: once of her strong mother, Metis, and once more out of the head of Zeus. According to feminist myth, there is a "third birth" of Athene when she stops being an agent and mouthpiece of Zeus and male dominance, and returns to her original source: the wisdom of womankind.

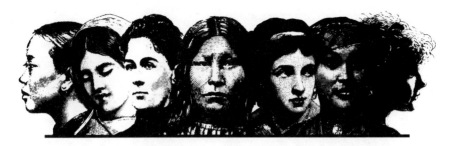

women's studies graduates

THE FIRST GENERATION

Barbara F. Luebke
Mary Ellen Reilly

 ATHENE SERIES

Teachers College Press
Teachers College, Columbia University
New York and London

Published by Teachers College Press, 1234 Amsterdam Avenue,
New York, New York

Research was conducted with the aid of grants from the University of Rhode Island
Faculty Development Fund, administered by Provost M. Beverly Swan, and from
Dean Steffen Rogers of the College of Arts & Sciences.

The collage of faces, created as the logo of the University of Rhode Island Women's
Studies Program, is used with permission of the university.

Library of Congress Cataloging-in-Publication Data

Luebke, Barbara F.
 Women's studies graduates: the first generation / Barbara F.
 Luebke, Mary Ellen Reilly.
 p. cm. — (Athene series)
 Includes biliographical references (p.).
 ISBN 0-8077-6275-X. — ISBN 0-8077-6274-1 (pbk.)
 1. Women's studies — United States. 2. Women college graduates —
 Employment — United States. 3. Occupational surveys — United States.
 I. Reilly, Mary Ellen. II. Title. III. Series.
 HQ1181.U5L84 1994
 305.42'071'173 — dc20 94-23288

ISBN 0-8077-6275-X
ISBN 0-8077-6274-1 (pbk.)

Printed on acid-free paper

Manufactured in the United States of America

99 98 97 96 95 8 7 6 5 4 3 2 1

DEDICATION

For Eleanor M. Carlson, whose endowed chair ensures that Women's Studies at our university will continue for generations to come.

MER: For the women who have inspired me, believed in me, and shared their love: my mother, Dorothy Dowd Reilly; my friends Bernice Lott, Joan Talbot, and Cynthia Wilcox; and especially Barbara Luebke, my dearest friend and a superb journalist, whose perseverance and editorial excellence moved this book from idea to reality. It has been a remarkable journey.

BFL: For my parents, whose unconditional love is a blessing. For Beverly Serabian, whose immeasurable wisdom helped me find my way and my voice. And most of all for my partner, Mary Ellen Reilly, who daily renews my faith in goodness and who constantly dazzles me with her brilliance. The journey has just begun.

BFL and MER: For our friends Roberta Richman, Sandra Enos, Kate Marion, and Susan Hartblay. You entertained us, fed us, helped nurse one of us back to health, and kept us smiling through many difficult days. We're ready to play again!

CONTENTS

Claimants' Trust; Planned Parenthood Clinic Coordinator; Recreational
Therapist; Nurse; Health Clinic Medical Assistant; Sexual Assault/
Abuse Educator; Graduate Student in Clinical Social Work

PREFACE

During the 1980s—with the emphasis on jobs, careers, and making money—students (and their parents) asked pointedly about the utility of any liberal arts degree. When we were asked, "What can I possibly do with a Women's Studies major?" we were able to respond based on our limited experiences with graduates from the University of Rhode Island and the University of Missouri. But we wanted more examples. A few others, including students, had investigated the question. Florence Howe (1977) had studied 15 Women's Studies programs nationwide, and a subsequent series of monographs explored some of the issues she raised, among them the relationship between Women's Studies and career development (Bose & Priest-Jones, 1980) and Women's Studies graduates (Reuben & Strauss, 1980). Reuben and Strauss gathered information from programs about their graduates, reviewed the literature about the topic, summarized findings from previous studies, and recommended that information about career and employment issues be collected and distributed. Jennifer Holt and Danit Ben-Ari had written a paper titled "What Do You Do With a Degree in Women's Studies?" for a Women's Studies course at Berkeley in 1980. To our surprise, however, no comprehensive national study of Women's Studies graduates has been published.

There have been articles about graduates from individual programs, and updates on alums are common in newsletters distributed by Women's Studies programs. A few articles have included students from several institutions. For example, Keller and Warner-Berley (1990) profiled three majors who graduated from Yale University, Brown University, and the University of Utah. And four graduates (Smith College, Towson State University, San Diego State University, and the University of Minnesota) were among five women whose observations about the major were published after a National Women's Studies Association (NWSA) conference ("Observations," 1990).

There also have been books about Women's Studies and its students, most notably *The Courage to Question: Women's Studies and Student Learning* (Musil, 1992). That study, funded by a three-year grant from the Fund for the Improvement of Postsecondary Education of the U.S.

Department of Education and conducted under the auspices of the Association of American Colleges and NWSA, gathered data from seven Women's Studies programs nationwide. In her introduction, Musil explained: "We had no national study that probed the learning process itself, that turned to the students to hear in their own voices a description of what was happening to them as thinkers, as inquirers, as people. 'The Courage to Question' sought to do just that" (p. 4). O'Barr and Wyer (1992) used archival materials from 60 former Women's Studies graduate and undergraduate students at Duke University for "a self-help guide for students to learn about Women's Studies" (p. 1).

To offer a more complete picture of Women's Studies graduates from American colleges and universities, we set out to answer the question, "What do you do with a Women's Studies major?" We wanted to learn more about the backgrounds of undergraduates drawn to Women's Studies and what people have done since graduation. We also wanted to assess the impact of Women's Studies on graduates' lives—both personally and professionally. Finally, we were curious about what advice they might offer today's students (and potential students), faculty, and administrators. From the beginning, we agreed that the graduates were the experts and it was their voices we wanted readers to hear. Our book would provide graduates a forum for speaking.

Their stories are important for several reasons. As funding for higher education continues to be cut, sometimes dramatically, among the most vulnerable programs are those perceived to be marginal, faddish, "politically correct," or peripheral to an institution's mission. It is critical that graduates be heard if Women's Studies faculty and administrators are to persuade officials that their discipline is essential in higher education. If budget worries are not enough, the backlash against feminism and Women's Studies has made us more vigilant. The young journalist Paula Kamen (1991) interviewed women and men in their twenties about feminism and found that the label "feminist" is perceived by many as a stigma identifying adherents as man-hating, humorless, antifamily radicals.

If the stereotypes came only from the media, educators might have an easier time debunking the myths. But the assault has come from multiple sources, including academics. As journalist Susan Faludi (1991) documents, thinkers—some of whom even call themselves feminists—are among the attackers. Humanities professor Camille Paglia (1992) and philosophy professor Christina Hoff Sommers (1992), for example, seem to be engaged in a "holy war," and their attacks have taken on a viciousness seldom witnessed in academic life. Paglia contends that "Women's Studies is institutionalized sexism. . . . [It] is a comfy, chummy morass of unchallenged groupthink. It is, with rare exception, totally unscholarly" (p. 242). And Sommers has concluded that "there are a lot of homely women in women's

studies. . . . Preaching these antimale, antisex sermons is a way for them to compensate for various heartaches—they're just mad at the beautiful girls" (Friend, 1994). We puzzle over how Sommers could generalize about the entire discipline by looking at one course outline from one university (Sommers, 1992, p. 32). Yet those seeking any excuse to trash Women's Studies embrace her claims as respectable. On our campus, the Rhode Island Association of Scholars (an affiliate of the conservative National Association of Scholars) featured Sommers as its first speaker; her topic was "What Went Wrong With Women's Studies?"

Such generalized criticism is common among lay critics, too. Writing in *Mother Jones*, Karen Lehrman (1993) purported to offer an investigative look at the field. Her title, "Off Course," set the tone for a report that was biased, unbalanced, and bad journalism. After touring "the world of Women's Studies" (p. 46)—four colleges and universities—she generalized about the discipline as if she had completed a thorough and comprehensive study. Of course, Lehrman pointed out that she is a feminist!

Feminism, and by extension Women's Studies, also has its student critics. In a 1991 issue of *Campus/America's Student Newspaper*, the lead editorial argued that "in the academy, feminists have rejected the customary aims and norms of higher learning in favor of indoctrination. The first casualty in this feminist power drive is the pursuit of truth. In fact, according to feminist dogma, the entire heritage of the West becomes suspect and secondary" (Lutz, 1991, p. 1). Among the articles in *Campus* were "Liberation from Logic: Feminism in the Academy" (p. 2), "The Feminist Politicization of the University" (pp. 3 +), and "Confessions of a First Year Syxist"—a tongue-in-cheek look at feminist jargon and semantics (p. 8).

Attacks against feminism and feminists clearly have become mainstream, as was all too evident at the 1992 Republican National Convention. Also on the rise here and abroad are racism, anti-Semitism, classism, heterosexism and homophobia, ableism, and ageism. To confront all these destructive trends and to dispel ignorance and intolerance, we need more nonsexist and multicultural education—not less. To allay the fears of parents, administrators, politicians, editors, and others who question the value of Women's Studies, we have consulted the experts—members of the first generation of Women's Studies graduates—to learn what impact their education has had on them.

In Chapter 1, we provide a demographic overview of the 89 graduates whose experiences we report. In Chapter 2, reactions encountered by graduates show the many misconceptions about Women's Studies. While there are several widely held stereotypes, graduates generally confront ignorance when people learn they majored in Women's Studies. Readers take note: Graduates have not been discouraged by this. The chapter also explores how graduates respond to people who question the utility of their major.

Beginning in Chapter 2, we attribute graduates' comments to them by name; you will learn much more about them and other graduates in the individual profiles that follow in Chapters 3–6. The profiles are grouped according to graduates' occupations and include their answers to three important questions: "Why did you major in Women's Studies?" "How has your Women's Studies major affected you professionally since your graduation?" and "How has your Women's Studies major affected you personally since your graduation?" While common themes emerge among graduates, the profiles show how the major also satisfies individual needs. With answers generally rich in poignancy and detail, respondents dispel whatever misapprehensions readers might have about the choice of a Women's Studies major. The graduates collectively demonstrate that the major is *not* one that has limited their lives.

Chapter 7 draws on the experiences of the graduates—with individual programs and with Women's Studies in general—to explore how the discipline might be improved. Graduates speak to potential majors by answering, "What advice would you give to students contemplating a major in Women's Studies?" They also address those who are responsible for the programs by answering, "What advice would you give to faculty and administrators involved with Women's Studies?" In Chapter 8, we offer our observations about the first generation of graduates.

Our decision to write this book was not made suddenly. Over the years, many people have asked us questions about Women's Studies: "What is that?" "Why would anyone want to major in it?" "What does someone do with the major?" "What kind of job can a major get?" And someone invariably quips, "Why isn't there men's studies?" Such questions come not just from students, potential students, and parents. We have heard them time and again from colleagues, administrators, politicians, family, friends, and neighbors. But while we may be discouraged that Women's Studies remains so anonymous after more than 20 years as an academic discipline, that anonymity is what challenged us to tackle this project. After a publisher's representative visited our Women's Studies Advisory Committee, we began seriously to ask ourselves what contribution we might make. This book is our answer.

Over the years, it has become clear to us that there is no single definition of Women's Studies. There is no single response to the "what is" question that encompasses the scope of our discipline—which is why you have not yet read a definition and why you will not read *our* definition. By the time you finish reading this book, however, we hope *you* will be ready to answer not only "What is Women's Studies?" but also "What can you do with a major in Women's Studies?" and the many other questions you are likely to be asked if you choose to study, teach, or write about this exciting field.

ACKNOWLEDGMENTS

Our heartfelt thanks to the 89 graduates who made this project possible and to the Women's Studies program directors who gave us their names. Thanks also to:

The Women's Studies students with whom we have worked over the years and from whom we have learned much; Provost M. Beverly Swan, Dean Stef Rogers, and Associate Dean Winifred Brownell, whose financial support and encouragement got us started; Our friends and colleagues on the Women's Studies Advisory Committee, who helped us with postage but most of all gave us moral support; Our friends and colleagues in the Journalism Department, for their laser printer and their patience; The Women's Studies Program staff: Professor Dana Shugar, for always being there; graduate assistant Jennifer Fernald, for literature reviews, data entry, and other tedious tasks; graduate assistant Heather Bullock, for literature reviews, our mailing list, and more tedious tasks; secretary Joan Bently, for turning questionnaire answers into computer files and deftly fielding countless telephone messages; Karen Small, whose close reading of parts of the manuscript saved us from embarrassing errors; and Athene Series editor Gloria Bowles who, when she read our prospectus, dug into her files and shared a paper written for her by two students in 1980. Our very special thanks to Athene Series editor Janice Raymond, who enthusiastically supported us and wisely guided us from beginning to end. Finally, we are deeply grateful to our Teachers College Press editors, Sarah Biondello and Cynthia Fairbanks. Although we balked when Sarah told us to *cut*, this book is all the better because we did it.

women's studies graduates

THE FIRST GENERATION

1

THE STUDY AND THE GRADUATES: AN OVERVIEW

"What can someone do with a major in Women's Studies?" Before we begin to answer that, we need to tell you how we went in search of answers. As social scientists, we believe it is important that you understand not only *what* answers we found but *how* we posed our questions and *who* answered them. Although ours was not a research study in the strictest traditional sense, we were careful to apply the rigor required of good social science.

DETAILS ABOUT THE STUDY

To find out what graduates have been doing, and to learn more about Women's Studies itself, we decided that a national study was needed. We realized that a truly random survey of all graduates in the last 20 years was too ambitious, so we decided to try to create a national sample by asking current Women's Studies directors to choose graduates who reflected the diversity of their programs. The National Women's Studies Association (NWSA) (1990) directory listed institutions offering undergraduate majors, minors, and graduate studies. Because our focus was on individuals who had majored at the undergraduate level, we used only the list "Institutions Offering Undergraduate Majors in Women's Studies" (pp. 100–101). One hundred and forty-two colleges and universities were listed, along with the names of directors or contact persons and addresses for each program. In the summer of 1991, we sent personal letters to each of those individuals and asked for the names and addresses of 3 to 6 graduates, along with a comment or two about each to help us select a diverse representation of potential respondents.

The programs contacted included some that have been offering the major since the 1970s and others that only recently instituted it. We received responses from 79 directors. (Over time, we also were in contact with directors from several additional programs.) From older programs, we

1

often received 6 or more names, while newer programs may have graduated only 1 or 2 majors. In 7 instances, programs were so new that no students had graduated. We also heard from 11 directors who said their schools did not offer the major, indicating that some of the information provided in the NWSA directory was inaccurate.

Once we had compiled our sample of names, we sent each graduate a letter explaining our study and how we had obtained her or his name. Included with the letter was a questionnaire requesting demographic information and responses to a series of open-ended questions, an "informed-consent" form, a postage-paid postcard allowing graduates to tell us whether they planned to participate, and a postage-paid return envelope for the completed questonnaire. In mid-October 1991, we mailed 313 of these packets; 27 were returned as undeliverable. One woman was located and her materials resent. Responses to the survey came quickly, and 120 graduates returned postcards checking "YES, I want my voice included in your book about Women's Studies graduates. I will return the profile to you by December 1, 1991." Many included positive comments about the study and said they were happy/pleased/thrilled/proud to be included. Ten graduates said "no thanks": 5 were not majors and 5 said they were too busy. Thirteen other graduates ultimately returned questionnaires without having returned the postcard. So from the original 287 packets that we assume were delivered, 133 graduates agreed to participate. Completed questionnaires actually were received from 81 respondents. Six of those were from minors and were not included in the final sample; 1 graduate with a "certificate" was included. (We tried several follow-ups with those who responded "yes" but did not complete the questionnaire; these yielded only a few questionnaires.)

Although disappointed that so many "yes" graduates never completed their questionnaires, we were elated by the thoughtful and comprehensive replies we received. Early on, we realized what a significant contribution these graduates would make to Women's Studies. As we assembled the demographic information, we were struck by the diversity of our graduates on all variables except one—race and ethnicity. While we heard from a few women of color, there were no Hispanics or African-Americans among them. We wanted our sample to be more representative, so we contacted some programs that had not responded to our initial request and that we believed were likely to have a more diverse student body. We also broadcast an electronic-mail message on the "Women's Studies List" asking for names and addresses of graduates, particularly women of color. A few directors responded, but only one provided names of students from an undergraduate degree program.

Several of the programs we contacted during this "diversity" follow-up

effort provided lists of graduates, and we sent materials to graduates directly. Other programs had policies against giving out names but were willing to send materials if we provided the packets. (Programs in the first mailing also operated by this rule.) In every instance, we provided the materials. An additional 60 packets were sent during this period and 15 responses were received: 14 questionnaires and 1 letter. Three of these responses were from African-American women, but only 1 is included with the respondents; 1 woman had not yet graduated and another wrote only a letter. We do use some of their comments, however, because they provide insight about the dearth of women of color in Women's Studies.

To summarize: From October 1991 to October 1992, we distributed approximately 375 questionnaires and received 95 replies from graduates of 43 programs, which is a 25% response rate. Because some respondents were not majors or graduates, 89 individuals comprise our sample. Before you continue reading, you might want to take a few minutes to think about your own images of Women's Studies students. Jot down a few adjectives or characteristics so you can see if your images fit with the demographic summary that follows. And remember, while our graduates may not be representative of all those students who have majored in Women's Studies, they certainly reflect a national, nonrandom sample of individuals who selected the major during its first two decades in American colleges and universities.

This summary that follows provides you with an overview of our participants as a group. These data are useful because they introduce you in a general way to those graduates you will meet in a more personal way throughout the rest of the book. Also, the data help you see that Women's Studies graduates are a diverse group; for example, they are young and old, come from all parts of the country, grew up in all kinds of places, and were raised in many kinds of families. When you finish this chapter, you will be ready to meet the graduates.

GENDER, AGE, AND RACE/ETHNICITY

Eighty-eight women and 1 man ranging in age from 21 to 73 responded to our questionnaire. Of the 88 who gave their ages, 47 were in their twenties, 29 were in their thirties, 7 were in their forties, 3 were in their fifties, and 2 were in their seventies.

Respondents described their race or ethnicity in various ways, including white, Caucasian, European-American, white Anglo, northern European, American/Jewish, Caucasian/Jew–Ashkenazi, and English-Irish-German-Latvian. Five indicated they were women of color: Native

American, African-American, Korean-American, Asian-American, and Asian. Four women did not answer this question. The one male graduate defined himself as Caucasian. None of the 88 women identified herself as Hispanic-American. (Questionnaires *were* sent to graduates with Spanish surnames.)

Two women, both from the same program, wrote comments that may apply to other schools' programs: "I felt marginalized as a woman of color, as someone who has interest in the practical application of feminist politics," one said. She described the program as "wrought with internal conflict, interdepartmental competition, racism, and homophobia." The other woman, who had not finished her degree, said, "The Women's Studies Program . . . is mostly white, middle-class, dominant-culture, and often painfully boring." Yet the women of color from other programs found their experiences to be quite different, as their profiles and other comments will show.

From the ongoing debates within Women's Studies over the last decade, it is obvious that much more work must be done to eliminate not only racism but also classism, ageism, ableism, and homophobia from our discipline. *Liberal Learning and the Women's Studies Major*, the report prepared as part of a review of arts and sciences majors initiated by the Association of American Colleges (NWSA, 1991), includes 14 recommendations, 3 of which speak directly to diversity initiatives. The task force that drafted the report recommended that programs identify specific locations in the curriculum where issues of race and ethnicity will be addressed, recruit faculty members of color, and enhance interactions between Women's Studies and ethnic studies programs or other programs where race is a prominent area of study.

In the aftermath of the Anita Hill–Clarence Thomas hearings, the issues of race and gender were widely debated, discussed, and analyzed. Rosemary Bray (1991) explained the enormous difficulties faced by black women as they confront issues of race and gender and concluded: "Despite the bind, more often than not we choose loyalty to the race rather than the uncertain allegiance of gender" (p. 94). A collection of essays edited by Toni Morrison (1992) provided additional insight into the relationship between gender and race. As Kimberlé Crenshaw (1992) observed in her essay, "[I]t was no 'Twilight Zone' that America discovered when Anita Hill came forward. America simply stumbled into the place where African-American women live, a political vacuum of erasure and contradiction maintained by the almost routine polarization of 'blacks and women' into separate and competing political camps" (p. 403). As Women's Studies moves toward its second generation of graduates, it is imperative that it make every effort to be inclusive and to celebrate difference so that students of every race and

ethnicity—as well as class, sexual orientation, age, and physical ability—will be welcome.

Although much remains to be done in this area, we also must acknowledge that enormous strides have been made. Westkott and Victoria (1991) found that 95% of the 62 major programs they researched offered a course or courses about cultural diversity. But they also found that these courses "are not required for the majority of majors" (p. 435). If our program at the University of Rhode Island is representative, that will change. As our number of majors continues to increase, we hope students will represent the nation's diversity. In the meantime, we revised our curriculum significantly in 1993, and among the new requirements is a course called "Race, Class, and Sexuality in Women's Lives." We also are working closely with the African and Afro-American Studies Program to build bridges between our disciplines. For example, during the spring 1994 semester we designed and taught "Walls and Bridges—Race, Gender, and Class" as the colloquium required by the Honors Program.

FAMILY CHARACTERISTICS

We asked graduates to describe the families in which they grew up. Of those responding, 64 said they were raised by both parents—sometimes in very happy relationships and sometimes in relationships filled with problems, among them physical and emotional abuse. One woman grew up in a foster home and never knew her parents. Twenty-one women said their parents divorced; subsequently they lived in various family settings. In 3 instances, the divorces took place when the women were infants and they stayed with their mothers. Eleven women lived for some time with both parents but remained with their mothers after the divorce. One woman stayed with her father, and 2 split their time between both parents. Four women lived with their mothers and stepfathers at some time during their childhoods.

When asked if their parents were employed outside the home, 54 graduates indicated that their mothers were—1 said her mother was self-employed, 17 categorized their mothers as employed sometimes, and 17 said their mothers were not employed. Eighty-three graduates said their fathers were employed, 1 said he sometimes was, 3 said their fathers were not employed. Two respondents did not answer this question.

Asked if they were raised by feminists, 26 graduates said yes, 3 answered that their mothers were but their fathers were not, 14 qualified their

responses and did not say "yes" or "no," and 46 said they were *not* raised by feminists. Eighty-five respondents consider themselves feminists, 2 do not, and 2 were noncommittal.

ROLE MODELS

We were curious about who inspires Women's Studies majors, so we asked graduates, "Who are/were your role models?" The numerous replies often included more than one citation from an individual graduate. What may surprise you is that those people who affected the graduates most were the people in their everyday lives. The individual mentioned most often was the mother; 32 graduates cited their mothers, including 1 who said she was a negative role model. Thirty-two respondents identified teachers, professors, and college advisers. Eight said their fathers were role models, 9 identified their grandmothers, 4 cited aunts, 5 mentioned sisters, 4 noted friends of their mothers, and 5 named their own friends.

Other role models mentioned were camp counselors, Girl Scout leaders, and women the graduates worked with. Twenty-two graduates identified some of their role models by name. In several instances they were Women's Studies professors. Others were notable women, including writers Alice Walker, Audre Lorde, Adrienne Rich, and Toni Morrison; teacher and activist Angela Davis; Golda Meir, the late prime minister of Israel; Raicho Hiratsuka, a Japanese feminist; politicians Geraldine Ferraro, Patricia Schroeder, and Shirley Chisholm; Spellman College President Johnetta Cole; singers Janis Joplin, Barbra Streisand, and Doris Day; actors Jody Foster, Marilyn Monroe, and Lily Tomlin; and director Anne Bogart. The graduates also cited several notable men, including author and Holocaust survivor Elie Wiesel; writer James Baldwin; Martin Luther King, Jr.; and Harvey Milk, the gay San Francisco supervisor who was murdered in 1978. Historical figures mentioned were Susan B. Anthony, Sojourner Truth, Harriet Tubman, Charlotte Perkins Gilman, Isadora Duncan, Amelia Earhart, Isak Dinesen, Dorothy Day, Eleanor Roosevelt, and Chief Joseph. Three fictional characters cited were Wonder Woman, Princess Leia, and Murphy Brown. Several graduates also mentioned "categories" of women — authors, politicians, artists, athletes, and activists.

GEOGRAPHIC LOCATION

Our respondents lived in 24 states, the District of Columbia, and Israel. The states most represented were California (20), Massachusetts (8), New

York (7), and Colorado, Connecticut, Virginia, and Washington (5 each), but all regions of the country were represented. Respondents also lived in the South—Florida, Georgia, and North Carolina; the Southwest—Oklahoma, Texas, and Arizona; the Midwest—Ohio, Illinois, and Minnesota; New England—Maine and Rhode Island; the middle-Atlantic states—Maryland, New Jersey, and Pennsylvania; and the West—Utah, Oregon, and Wyoming.

Seventy-four graduates told us that they were raised in 23 states, some additional to those in which respondents now reside—Indiana, Iowa, Kansas, Kentucky, Nebraska, and Tennessee. Ten individuals indicated that they had multiple residences while growing up. And 2 grew up outside the United States—1 woman in Japan and another in Argentina. Several other women spent parts of their childhoods in other countries—Germany, Japan, and Australia.

We also asked graduates to describe the type of community in which they grew up by selecting from a number of categories. We did not define the terms, but let respondents choose the designation that fit for them. Of the 88 who answered, 8 said rural, 19 said small town, 17 indicated small city, 10 chose big city, 2 said inner city, 28 indicated the suburbs, and 4 said they grew up in multiple locations.

RELIGIOUS AFFILIATION

We asked two open-ended questions about religion. The first was, "In what religion, if any, were you raised?" Fifteen graduates said none, 33 identified various Protestant denominations, 16 stated Catholic, 11 indicated Jewish, 3 were raised as Quakers, and 2 as Mormons. One respondent each identified Unitarian, Buddhist, Greek Orthodox, fundamentalist Pentecostal, and Christian Science. Two described their religions as vague Christianity, 1 as semi-Protestant, and 1 as "various."

We also asked, "With what religion, if any, do you currently identify?" Forty-nine graduates answered none, 12 gave various Protestant denominations, 9 said Jewish and 2 wrote Jewish as cultural heritage, 4 noted some form of feminist spirituality, 3 defined themselves as Christians, 3 were Quakers, 2 responded Catholic, 1 each said Greek Orthodox, Buddhist, and New Age, and 2 did not reply. Clearly there were major shifts for many graduates. But all those raised in the Jewish religion continued to identify themselves with Judaism, and those brought up as Quakers, Greek Orthodox, and as a Buddhist also continue in those faiths.

While several graduates continued to identify themselves with the faiths of their childhoods, for many others religious affiliation was not a

stable factor in their lives. The largest changes occurred for no religion, with an increase from 18% to 57%, while Protestants dropped from 38% to 13% and Catholics from 19% to 2%. These findings suggest that organized Christian religions have not been responsive to women's issues and, as a consequence, have not been able to retain many feminist adult worshippers.

EDUCATIONAL HISTORY

You might expect that the majority of majors attended all-girls schools. Actually, most respondents went exclusively to public schools. At the elementary school level, 72 respondents were educated in public schools, 4 spent all of their primary grades in religious schools, and 5 attended only private nonsectarian institutions. Three respondents spent some of their years in both public and private nonsectarian schools, and 5 had both public and religious school experiences.

Seventy-two graduates attended public high schools. Five women went to religious high schools and 7 to private nonsectarian institutions. Four spent some time in both public and private schools. Three women who attended public schools did not graduate; they later obtained the general equivalency diploma. One of our older respondents did not attend high school. She completed a prevocational program in 1942, obtained an associate's degree in 1985, and received her bachelor of arts degree in 1989. Of the 89 respondents, only 7 women were educated in all-girls high schools — 4 religious and 3 nonsectarian. One woman attended an all-girls school for two years, and another for only the twelfth grade.

The postsecondary education of the graduates is described in each individual's profile. As a group, our respondents had diverse experiences. Sixteen studied at community or junior colleges, 12 attended vocational or technical schools, and 5 earned associate's degrees before their bachelor's degrees. Fifty-two continued beyond their bachelor's degree (1 woman earned a second bachelor's degree): 26 have earned master's degrees, and 4 of them have pursued another advanced degree; 9 more were working on a master's degree. Six respondents had earned their J.D. degrees, 1 a Ph.D., and 1 a D.Ed.; 5 were in law school, 3 were in Ph.D. programs, and 1 was in medical school.

Only 3 respondents served in the military: 2 women in the United States and 1 woman in Israel. One woman had an application pending with the Army Nurse Corps Reserve.

The first of our respondents to earn an undergraduate Women's Studies degree did so in 1974. The graduating classes most represented are

1991 (17 respondents), 1989 (11), 1985 (10), 1988 (9), and 1990 (7). Six respondents graduated in 1987, and 5 in 1984. There are 4 graduates each from 1983 and 1986; 3 each from 1977, 1978, 1981, and 1992; and 1 each from 1979, 1980, and 1982.

As undergraduates, 39 (45%) of our respondents had a second major in addition to Women's Studies: 10 in psychology, 9 each in English and sociology, 4 in political science, 3 in history, and 1 each in speech communication, art, economics, and social science. Almost one-third had minors, with several completing two minors. The fields chosen were English (4); political science (3); sociology, philosophy, business, and French (2 each); and history, psychology, theater, modern dance, Spanish, economics, journalism, art, Russian, anthropology, racism and oppression, Jewish Studies, and film theory (1 each). As these second majors and minors demonstrate, students who choose Women's Studies have a wide range of intellectual interests. And for the majority of graduates, their educational interests have not ended with their undergraduate degrees. The graduate fields pursued also have been diverse, as you will see in the profiles.

OCCUPATIONS AND INCOMES

Among respondents, 19 were full-time graduate students and 9 were part-time students. Forty-nine said they were employed for wages full time; 19 were employed part time; 4 described themselves as self-employed; 6 were unemployed but looking for work; and 10, most of whom were full-time students, were not employed. Six graduates indicated that they were a "homemaker part time"; 1 indicated "homemaker full time" and noted that she was "working with spouse on noncompensation basis."

Not surprisingly, graduates reported a wide range of personal annual income. Eight indicated they had no personal income; 11 had under $10,000; 23 indicated they earn $10,000–$19,999; 25 were in the $20,000–$29,999 range; 11 had incomes between $30,000 and $39,999; 4 between $40,000 and $49,999; and 3 fell into the $50,000–$99,999 category. Two women indicated that their incomes varied widely from year to year, so they could not be categorized, and 2 chose not to answer the question.

ORGANIZATIONS

We asked respondents to list the organizations (community, professional, political, religious, etc.) to which they belonged. Seventy-five named at least

one, and the majority are members of three or more. Eleven respondents listed one organization; 15 identified two; 13 belonged to three; 10 named five; 9 named four; 6 listed six; 4 named seven; 4 named eight; and 1 person each was associated with nine, ten, and thirteen organizations.

Some graduates belonged to the largest national organizations: 16 to the National Organization for Women (NOW), 5 to the National Abortion Rights Action League (NARAL), 4 to the American Association of University Women (AAUW), and 2 each to Planned Parenthood and the National Women's Studies Association (NWSA). But most belonged to organizations associated with their professions (e.g., social work, library, business, or bar associations), environmental groups (e.g., Greenpeace, Sierra Club), or organizations focused on particular areas of interest. These included groups dealing with AIDS, sexual assault, peace, domestic violence, religious work, health, the homeless, human rights, reproductive rights, self-defense, education, and lesbian and gay issues.

SEXUAL ORIENTATION AND RELATIONSHIPS

We asked graduates to identify their sexual orientation as bisexual, heterosexual, lesbian, or gay man. Fourteen women indicated they were bisexual; 53 women and 1 man were heterosexual; 15 women identified themselves as lesbians; 2 women described themselves as celibate; and 4 women did not respond.

We also asked them to describe their relationship status. Among those who are bisexual, 3 were married; 4 were partnered but the gender of their lovers was not indicated; 3 were committed to men and 2 were committed to women; 1 woman was single and 1 was separated. Of those who are heterosexual, 16 were married; 7 were engaged; 9 were partnered; 11 were single; 6 were single and dating; 1 described herself as a single mother; 1 woman was separated; and 2 were divorced. One woman said she was in a relationship but did not describe it. Of the lesbians who responded, 10 were in committed or partnered relationships; 1 was "involved"; 2 were in exclusive dating relationships; and 2 described themselves as single. Of the 4 women who did not identify their orientations, 3 were married and 1 had been in a relationship with a man for four years.

Twenty-two graduates had children: 19 had biological children, 2 had stepchildren, and 1 was a co-parent with the child's biological mother. Eleven of the respondents had one child; 5 had two children; 3 had three children; and 3 had four children. The children ranged from 3 months to 44 years old.

One myth associated with Women's Studies is that women attracted to

it are lesbians. Our information indicates that sexual orientation had little to do with what brought these graduates into the major. What seems apparent is that Women's Studies has been welcoming to all regardless of sexual orientation. Obviously, the stereotypes have not kept those who wanted to study in the field separated from it or from each other.

Now that we have described our group of graduates, you will learn about each of them and their experiences with Women's Studies. Perhaps you will find individuals who are very much like you. Regardless, we hope you will see that anyone can major in Women's Studies; the only prerequisite is an inquiring mind.

2

LAYING THE FOUNDATION FOR LIFE

Education is most powerful when it is interesting and compelling to the student. I tell students to major in what they care about and what they will do will come clear later.

— Annie Thorkelson

Choosing a college major is not always easy; one's professional future seems to hinge on a decision traditionally made before the age of 21. Nor is a student's decision, once arrived at, always permanent. When you read our graduates' profiles in the next chapters, notice how often people came to Women's Studies through the back door. Often, it was enrolling in an introductory course that—for any number of reasons—proved to be the turning point. Students found intellectual challenge in confronting new material and in examining old material in new ways. They had "aha!" experiences. One course led to another and another, and a major (or second major) that felt right was declared. Still other graduates said they knew at an early age that they were feminists and so the choice of Women's Studies was simple.

Regardless of the path, justifying the decision to major in Women's Studies is seldom easy. When Dayna Bennett told a male professor of her major, he replied, "How narrow-minded of you." As our profiles of first-generation graduates will demonstrate, it was the professor who was being narrow-minded. Equally narrow-minded are people who pigeonhole Women's Studies as a major that limits students. As our graduates see it, the major opened the world to them. Their profiles will demonstrate just how, as will our discussion of graduates' answers to our question, "How do you respond to people who ask, 'What does someone do with a major in Women's Studies?'"

Before majors face that question, however, they often must confront people's lack of information, misinformation, stereotypes, and misunderstandings about the discipline. "What are you going to do with that?" "Are

12

you learning how to cook?" "Do you see any men?" "Don't you read any-
thing by men?" "Isn't Women's Studies exclusive?" "You must be learning
to be the next Gloria Steinem." Deborah McGarvey has heard all of those
comments. And Mary Ellen Ullrich has been met with the "blank stare of
ignorance that there is such a thing as Women's Studies . . . [and] laughter
at the pointlessness" of it.

"OUTSIDERS" RESPOND TO WOMEN'S STUDIES

When we asked graduates, "How do people respond to you when they learn
that you majored in Women's Studies?", many reported, in the words of
one, "polite interest, polite disinterest, puzzlement, hostility." They told of
being labeled man-haters or bra-burners. Others indicated their education
was dismissed as trivial or likened to basket weaving. What is clear from the
reactions graduates reported is that many—probably most—people have *no*
idea what Women's Studies is. What is also clear is that most graduates
are not intimidated by negative comments; instead, they view them as an
opportunity either to educate others about Women's Studies or themselves
about others. As Denitta Ward said, "Generally, when someone learns that
I majored they have one of two reactions: 'That's great! How interesting!'
or 'Women's Studies? Oh, I see' (change of topic). I've learned a lot about
people from their reaction[s]."

Women's Studies as an academic discipline emerged during the most
recent wave of the women's movement (Stimpson & Cobb, 1986). San
Diego State University in California established the first program in 1970.
Growth was rapid, with 78 programs listed in *Women's Studies Quarterly*
in 1973 and 276 established by the time of the founding of NWSA in 1977.
According to the directory we used for our study, there were 621 Women's
Studies programs nationwide; the majority offered either a minor, an area
of concentration, or a certificate (NWSA, 1990, p. ii). Despite the field's
rapid growth, it continues to be a well-kept secret. Potential majors and
others can learn much about what it is—and is not—by examining how
people react to its graduates and by listening to what graduates say to
skeptics about the major's utility.

Marianne Merritt observed, "As with telling someone, 'I'm a feminist,'
a woman gets different reactions when she tells people what she majors in.
I [am] proud to tell people; some other women may feel differently." A
1987 Mount Holyoke graduate said:

Men usually say, "I've been studying women all my life, Ha Ha Ha."
Or else, "What?" Women usually say, "Oh," as in "What the heck

is that?" They don't usually ask about it or say anything positive.
Women or men who seem progressive (politically) ask questions about
what I'm doing with the degree, etc. Some people tell me "that's fasci-
nating." I don't really know what to tell them. I feel like a rare animal
in a concrete zoo.

Kay Sodowsky said:

> From those persons who embrace or understand feminism, I often
> sense a certain respect for my willingness (courage?) to have taken a de-
> gree in Women's Studies. But a much more typical reaction is one of
> bemusement or skepticism. People who would never ask, "What is phi-
> losophy?" or "What is liberal arts?" feel free to exclaim, "What in the
> world is Women's Studies?"

Lack of respect for the major is reflected in many of the graduates'
encounters. As Patricia McGarry described, "From men: 'Oh, I study
women all the time' or 'My major was women in college.' I cannot tell you
how often I have heard these comments." A 1989 University of Richmond
graduate noted: "On some occasions, people have poked fun and have given
the impression that they didn't take me seriously. (I have heard the com-
ment that Women's Studies is something men do on the beach—the com-
ment was made by a man.)" And Keiko Koizumi has been asked, "Do they
teach you how to be a 'real' woman? i.e., sew and cook?" She elaborated,
"Generally, older men respond this way."
 More frequent than disrespect is ignorance, which takes some gradu-
ates by surprise. "Since I live in a world of Women's Studies, I'm still
surprised when people ask me what it is," said McGarry, a program admin-
istrator. Larisa Semenuk said:

> The most common response, especially by older people, is "what's
> that?" I get kind of sick of answering this question at times, but I fig-
> ure if I react harshly to their ignorance, it will just turn them off to it.
> Some who think they're funny say, "Why isn't there a men's studies?" I
> usually answer that most classes offered are "men's studies."

Alyssa Howe commented:

> Most people that I come into contact with in the Bay Area think it is
> admirable and important. However, when traveling around the
> United States or in Mexico or Central America, I get many confused re-
> sponses. I think most people don't know what Women's Studies is, or

its importance. This may be a signifier for the lack of importance people place on women. Why, I'm sure people must think, would you want to study about women?

A 1991 University of California–Santa Barbara graduate said: "Many tend to treat it as an 'un' discipline, and to not think of it as scholarly or relevant. Others are threatened, assuming that Women's Studies is either anti-male, anti-establishment, or both. Men frequently ask me, 'So, what do you think of men?'" Christine Bergeron finds that "99% of the people have never heard of it. Many think it's like a degree in home economics. Most people make fun of it due to their own ignorance." And Katharine Rossi has dealt with people who "believe it is a joke or an unreal major."

Mention of the very real major draws some very negative comments. These range from the dismissive (Leona Roach has heard, "Oh, that's nice, dear.") to the hostile (Heather Moss gets "a great deal of moans and groans. . . . Often people make comments about the *validity* of Women's Studies as a major and dismiss it as a way 'a group of angry women can console one another and gossip' for college credit"). Debra Nickerson found that the degree of negativity depends on whom she is dealing with:

> If they are people who are strangers to me, often times they assume I am a radical lesbian separatist. I have had several people question my sexual orientation and continue to question me about my feelings toward men in general. (The assumption is I am a "man-hater." Though I am not, I am open in saying that I abhor the way we socialize men in this society.) The more general attitude assumes I am a politically liberal feminist.

Nickerson, a teacher, added:

> Students of mine feel threatened and question my feelings toward the male population; they hint that they believe I am "against men" and then try to "push my buttons" by reciting typical "dumb female" comments. Colleagues, especially male colleagues, sometimes act a bit defensive and assume they will know what will bother me, and again may either make a "joke" to observe my reaction or comment on some social issue involving society's treatment of women and expect a diatribe from me.

This stereotyping of Women's Studies graduates is common. Philip Gütt has encountered the least insidious stereotype: Women's Studies is a woman's major. "Because I am a man, I believe some people have wondered

what I was doing in Women's Studies—the name suggests to some that the program is intended exclusively for women." Probably the most common stereotype is that cited above by Nickerson: All Women's Studies majors are lesbians. Majors also are assumed to be radical feminists. Yoon Park said the "best response" she has gotten was, "'You don't look like a feminist!' What, pray tell, does a feminist look like?!" Valata Fletcher, who was 58 when she began working on her degree, found that "most men seem threatened; they throw out the word 'feminist' as if it was a negative term."

Many graduates also stereotype "outsiders": they made a point of noting that "depending on who is asking" about their major, they know what to expect. Kaaren Boothroyd, an exporter, said responses are:

> divided generally by age, education, and nationality. For foreigners I've met, Women's Studies is virtually unknown in their countries (or, probably, confined to members of academia). Younger Americans (early thirties and under) seem to know about the major and seem interested as to why I chose it, what it did for me, and especially what kind of things I studied. Middle-aged Americans (to which group I belong) smile, usually, not knowing what to say. Perhaps a polite question will be asked, but I sense they probably don't want to hear too much. I feel categorized as perhaps a little weird.

"Augustine," who began work on her degree at 69, finds "most of my chronological peers want to know what they teach in Women's Studies. There is never any great discussion. Occasionally, when I'm trying to make a point, I'll be asked, sarcastically, 'Are there any men you respect?' Also, there is an assumption that one hates men being a Women's Studies major; that is far from the truth." Kay Paden reported that "feminists say, 'All right, good for you. I wish I had taken more Women's Studies courses—but there were not any (many) around when I was in school.' Homophobics say, 'Nothing like a whole crop of educated dykes trying to take over the world. Seems our education could go to something better than that shit.' Others say, 'That sounds neat, but what is it?'" Most often, graduates said, their major is greeted positively by women, especially those they refer to as feminists or progressive. Sometimes they noted how a second major tempered those who might dismiss their Women's Studies major. As Diane Maluso put it: "My feminist friends are impressed, jealous, positive. My family is happy that I also had a 'real' [second] major [psychology]." Although graduates generally did not talk specifically about how their major has been received in the workplace, several did report positive experiences there. A University of Rhode Island graduate said her major "has been a contributing factor in

my getting hired for a number of jobs—it gave me distinction." That also has been true for Elizabeth Bennett, who noted:

> Women's Studies and my other specific training/study of women and feminism have been considered [by nearly all of my employers as] a tremendous asset in all of my work settings since college (these past 10 to 13 years). At the least, people are interested. Often I've found employers seeking someone with expertise in working with women.

Only a few graduates seem to have been worn down by the frequent need to defend their major. "Although some people respond with genuine interest and want to learn more about Women's Studies," Megan Mitchell said, "because of many negative responses I no longer tell everyone I meet about my major. I 'choose my battles' more carefully than I used to and share my background with people I believe will be receptive." That is Lisa V. P. Hall's approach, too. "I actually have a hard time telling just anyone. I usually say 'liberal arts' and hope for no further comment. I get tired of defending it to just anyone. I save my 'sassy' and dynamic explanations for potential employers."

Dawn Paul's approach is the opposite:

> Some people dismiss [Women's Studies] as more of a hobby-major, like basket weaving, or assume it was my minor (I double-majored in English). I've taken to putting Women's Studies first if I need to list my major. People often think it is like "real college" only just about women. I try to explain that it is scholarship that takes anything you've taken for granted and turns it inside out and upside down.

Betsy Dollar is among graduates who learn about people from their reactions to her major:

> The ones who are genuinely interested become my friends and allies. Those who choose not to inquire, I keep at a safe distance. Those who use it as an opportunity to criticize or attack, I know to keep my distance. Often it is predictable who will respond in which manner; but, for the not easily categorized individuals I have been known to use it as a test.

Judy Bryant has learned not to take people's reactions personally. Instead, she responds from a position of strength. "Both men and women tend to back off" when they learn of her major, she said. "I often sense a feeling of [their] being threatened. In the beginning I took this personally;

then I learned to understand that I am a threat precisely because I ask questions, because I say no, because my primary relationships are with women, because I care and am committed to justice."

And when people question Carol Nallan about her degree, she tells them:

Women's Studies emphasizes philosophy, ethics, religion, law, and the liberal arts from a woman's perspective. That we as women have led civilizations in the past — and that this was disowned, that women have been heads of synagogues and this had been disowned. I respond by telling them that Women's Studies is the search for our past so that we can rebuild the present.

GRADUATES RESPOND TO SKEPTICS

As a 1984 Kansas State University graduate noted, "What does someone do with a major in Women's Studies?" is "a very common question, but reflective of a narrowness of thought. We have an idea in the United States that you get a degree so that you can 'do' something with it. It is possible to get a degree simply to be better informed, more knowledgeable, to become well-rounded." Eve Belfance agreed:

I guess I'm amused by the fact that people ask the question. It's like saying what do you "do" with your education? The answer is you live your life. You use your education to enhance the quality of your existence and to open your mind in such a manner that the ultimate result is, hopefully, a higher level of consciousness with regard to your life and what you're doing with it.

Sue Phillips concurred:

To me, college is about learning how to learn, it's about critical thinking, about applying methodologies to explicit questions or problems. Women's Studies affords students the opportunity to be truly critical — we are allowed the information that had always been kept from us personally and culturally about our lives and the lives of others who are not white, straight, class-privileged men. What one does with a Women's Studies major is continue asking the questions that get to the heart of matters: Who's benefiting from this situation? Who is being hurt? Where am I in all of this? Knowing how to ask and begin answering these types of questions is useful for every kind of work. And the im-

portance in Women's Studies of personal experience and reflection means (hopefully) that whatever work we do will be grounded in reality.

Judy Bryant said she "worried when I left college what I would do with a degree in Women's Studies, until I expressed this anxiety to one of my mentors. She said, 'You have laid the foundation, the work will follow,' and slowly it has." And Vivienne Finley advised: "You are not limited to a single discipline, and you can develop critical analysis and writing skills that will prove most valuable when you enter the work world. Women's Studies is a liberal arts education in its truest sense." Larissa Semenuk added:

The major allows/prepares one to do anything any other liberal arts major does but with deeper insight into issues of oppression and celebration of women. Hopefully, this insight carries over into important issues of other groups—making one more sensitive and therefore more prepared to do all things/jobs with greater attention to ethical standards. A Women's Studies major is taught to look for the hidden—like looking for the silenced voices of women in history. It's invaluable!

A couple of graduates alluded to the skepticism about the vocational value of *any* liberal arts degree, and a few, including Alyssa Howe, were more direct: "I explain that 'what I do with a Women's Studies degree' is the same as I'd do with a degree in psychology or sociology or anything—go out and try to find a job that will be satisfying for me economically and politically. In these difficult economic times, it seems that no B.A. is worth much." Such reservations, however, were rare. Clearly the graduates see the major as embodying the goals of higher education. Roxie Beyle suggested that it allows one to "learn more about one's position in life. It also prepares a woman for getting along at work, at home, and life in general. Like any 'higher education,' Women's Studies gives a person a wider vision of the world." Said Colleen Sandrin, "I believe that the major purpose of college is to teach a person how to put up with the bureaucracy of life—how to be patient. I don't think the actual knowledge gained in a specific class, unless extremely objective (i.e., accounting), is what is used primarily through life." What *is* used throughout life are the critical skills that graduates repeatedly cited. "I know now that what I 'do' with my Women's Studies degree has less to do with the content of what I learned, and more to do with the process of obtaining the degree," Heidi Boenke said. "I learned that I can design my own studies, my own career, my own business, my own life."

Central to the major, regardless of where it is studied or the specifics of the program, is the eye-opening nature of Women's Studies. Graduates look at the world in new ways. Philip Gütt explained:

> I feel there are huge portions of our collective reality that we tend to take for granted, i.e., because there is a historical momentum/inclination to make assumptions about specific issues, we tend to treat these issues as though they are universally and eternally true. Women's Studies challenges our social norms and cultural beliefs while at the same time creating new possibilities — re-vision. For those of us who are not satisfied with the dysfunctional and often abusive and oppressive beliefs of our culture, Women's Studies is one avenue that offers alternatives. Women's Studies has become part of my "repertoire" of tools for looking at and reflecting on my life, my relationships, my work environment, and my community.

Time and again, graduates talked about how their perspectives were enlarged by Women's Studies. "I believe we bring a more accurate perspective to whatever we do," Peg Daly said. "Standard education has ignored the contributions, realities, and views of women in our society, and Women's Studies goes a long way to correcting that bias. Overall, a Women's Studies major can provide confidence to a woman by learning of the many contributions we have made and are making." A 1985 Mount Holyoke graduate posited:

> What does someone do with a major in history, sociology, psychology, medicine, fine arts, anthropology, English, French, German, Afro-American studies, literature, linguistics, political science, classics, religious studies, or any other discipline? Because all these are Women's Studies, or can be. Women's Studies can be any discipline because the subject matter can be anything, only the approach differs. Studying something from a nonstandard perspective presupposes a mastery of the standard perspective, so that a discipline approached from a Women's Studies perspective is actually more challenging and requires covering more material — not less.

Other graduates, while not using the word perspective, echoed these sentiments. As Deborah McGarvey put it:

> I was taught to think critically and to question systems of power and privilege in society. I have learned to create new ways of living my life in such a way that I am constantly sensitive to and inclusive of the vast

diversity that exists in the world. Because of Women's Studies I remind myself that white, male, heterosexual, able-bodied, upper-class experiences are not the norm.

Many graduates said that with a Women's Studies degree, one becomes personally stronger and better able to deal with the world. "No matter what career one follows," Janet Fender said, "a major in Women's Studies will enable a woman to work better because she will understand the factors she is struggling with." And Lauren Eskenazi said, "Women's Studies makes you more confident as a woman. It won't bury you in stereotypes and professional 'ghettos,' and gives you the mindset to do what *you want to* without the need for approval."

Lili Feingold asked rhetorically:

What would I do without my major? That usually stops [skeptics] in their tracks! I am truly convinced that the major empowered me with the self-esteem and uniqueness to conquer any job interview. I have found my degree to set me out from the rest, creating intrigue and making me memorable. My resumé reads like a multicolored and multilayered person; I can't imagine any Women's Studies majors being flat!!

And "Ruth" explains, "What the major did was feed and stoke my spirit. With my spiritual fires lit, I was able to shape both my law and clinical careers. It gave me the spirit to fuel the later work."

For many graduates, "the later work" is directed at making a difference in the world. They cite the major as good preparation for that. "You can never go back to who and what you were before," Stacy Dorian said. "It makes you want to work for change, for equality, and for justice. It makes you confident in your abilities as a woman and reinforces one's belief that there is something seriously wrong with a world created and dominated by white men." Katharine Rossi suggested that graduates "think and view the world in a whole new light. You see how various social systems feed into patriarchy and perpetuate it. You get angry that people allow this oppression and then you act to change the systems of power and oppression." And Betsy Dollar warned: "Women's Studies is no place for the weak-spirited or undecided. When a student has successfully completed a Women's Studies program she has proven that she can think, observe, analyze, comprehend, and conclude from the world around her." Or as Valata Fletcher put it, with a Women's Studies degree one can "begin to live a better life. To think for oneself and to take action to change the status quo. My brother from the South asked me what I intended to do with my education. I told him I

planned to become a minister. In fact I am a minister in that I do everything I can to change the attitude of society." Alisa Clemmons concluded:

> I am grateful for the fact that the studying I did in college has not ended just because I've graduated. I do not pick up the paper, go to rehearsal, see events on the street, talk with my friends, read a book, view art without thinking. Thinking is an important act and one that is too often abandoned right out of college. Learning is one thing human beings do to keep going in life. Women's Studies taught me that learning is not confined to school and libraries. Learning is a political act.

INTRODUCTION TO THE GRADUATES' PROFILES

What *can* you do with a Women's Studies major? As our graduates suggest above and demonstrate in the profiles that follow, you can do whatever you choose to do—and that might include occupations you never have considered. The interdisciplinary nature of the degree, the fact that critical thinking skills are at its core, and the "revolutionary" effects it has on students' personal lives all contribute to making Women's Studies a versatile—and powerful—degree.

We have grouped profiles of graduates into four chapters organized around their occupations. These profiles provide a snapshot of each graduate; that is, they reflect the graduate at a particular moment in time—when she or he completed our questionnaire (ranging from November 1991 to January 1993). Each profile draws on information the graduate provided about family, education, and occupational history, as well as current life. Our intent is to allow you a glimpse of graduates' lives so you might have a frame of reference for their answers to three important questions: "Why did you major in Women's Studies?", "How has your Women's Studies major affected you professionally since your graduation?", and "How has your Women's Studies major affected you personally since your graduation?" For a fourth question—"If you had it to do over again, would you major in Women's Studies?"—many graduates answered simply: yes, absolutely, you bet, and so forth. Others offered expanded answers, and we include some of these.

We present the profiles in chronological order by graduation date, which allows you to experience the development of the field. Individually, the profiles show how the major satisfies a variety of interests and needs. In each, you are likely to find some bit of history with which you can identify, some statement that hits home, or something that causes you to exclaim

"yes!" You also will learn a bit about many Women's Studies programs and the people who study and teach in them. Collectively, the profiles reveal commonalities among graduates, who show that the major challenged them intellectually, broadened their horizons, enriched their lives, and enabled them to shape their lives in new ways. The reality of the feminist refrain, "the personal is political," reverberates throughout the graduates' lives. Some speak to it directly: "I learned through both my work at the [battered women's] shelter and my studies at the university that 'the personal is political.' I decided to incorporate my feminist beliefs with my work and tried to make a difference in the world." Many more allude to it: "Feminism is not a doctrine I bought into. Women's Studies does not affect my life. Rather, I live Women's Studies."

We have chosen to liberally use respondents' verbatim answers so that the primary "voice" in each profile can be the respondent's, not ours. Obviously, while all graduates were asked the same questions, not all answered every question or answered with the same specificity, depth, and breadth. But in each profile there is a richness and honesty that allow you to learn much more about those who have been the pioneers in this academic discipline. Throughout the profiles, the text contained within quotation marks is presented as written by respondents, except for occasional omissions, tightening for space reasons, rephrasing for clarity, and corrected spelling and grammar.

Some graduates asked to remain anonymous; their pseudonyms appear in quotation marks. Others asked that certain information they shared with us not be used, or that their names not be associated with certain information. We have respected all those requests. Finally, not all of our 89 respondents are profiled, although one or more of their responses are used elsewhere in the book.

To reflect the passage of time between our initial contact with a graduate and completion of the book, where possible we have provided a "postscript" with updated occupational and/or personal information. Postscript information was gathered in late 1993, when respondents also were sent drafts of their profiles for accuracy checks.

3

FROM AVIATOR TO UNION ORGANIZER—
A POTPOURRI OF OCCUPATIONS

We begin with graduates whose widely varied occupations demonstrate that their degree is anything but restrictive. Keep in mind, too, that our sample only represents the range of jobs graduates have. Women's Studies directors we initially contacted told us of scores of others, including VISTA volunteer, documentary filmmaker, freelance book editor, prison counselor, land surveyor, refugee counselor, gay-newspaper reporter, astronomer, and technical writer. As liberal arts majors historically have done, Women's Studies prepared our graduates not so much for a specific career but for the world. That is because, in the words of the first woman profiled, Women's Studies teaches majors "to think critically, to question assumptions, and to look behind the surface of things at the perspectives shaping them."

Cathryn E. Couch—Self-Employed Communications Consultant
University of Michigan—1977

Cathryn was born January 16, 1956, and grew up in the suburbs of Birmingham, Michigan; Carmel, Indiana; and Simsbury, Connecticut. She also lived in Pittsburgh, Pennsylvania, and Aachen, Germany. She described her family as "traditional." Her father worked full time as a sales engineer and then as a national sales manager; her mother was a full-time homemaker. Cathryn is the oldest of three children. She said her parents "definitely raised me to feel that I could do anything I wanted to with my life. They never gave me the message that my sex was a limitation, and so I've always innately believed that women were equal to men. As I grew up I began to discover/witness sex discrimination. After moving to Ann Arbor in 1974, I became more aware of the women's movement and began to read many feminist authors. Labeling myself a feminist was a natural outgrowth of the beliefs I'd always had."

24

Following graduation, Cathryn worked for the University of Michigan's Student Services Office as a human sexuality advocate for gay students. "It was a full-time position which I shared with a gay man (each of us worked half-time). Our primary responsibility was educating students and faculty about homosexuality in order to create a more supportive environment for gay students." She enrolled at the University of Michigan Business School in 1978, and during the summer of 1979 worked as an intern in the Worldwide Product Planning Department of General Motors. Cathryn earned her M.B.A. degree in 1980. From 1980 to 1983, she worked for San Diego Trust and Savings Bank, where she managed the market research department. She also was responsible for management information and coordinating the bank's strategic planning process.

In April 1983, she and her husband (she had married in 1981) quit their jobs and spent the next seven months traveling through North America in a small camper. Cathryn worked from 1984 to 1987 as an independent marketing research consultant in San Diego. For the next four years, she worked for the U.S. office of The Hunger Project, "a nonprofit organization involved in educating people about hunger and what can be done about it." She first managed fund-raising programs and then became the director of communications. Since early 1991, she has been a freelance consultant, primarily in marketing, written communications, and project management.

Cathryn said that in an average week she spends "about 20 hours working for money. Most of that time is spent in my office at home. My work is fairly varied—I might be preparing a budget, writing or editing copy, planning a timeline for a project, or talking with clients on the phone. I'm doing volunteer work for two groups—the Sonoma County Task Force on the Homeless and *Women's Voices*, a local monthly newspaper. I am also the editor for the monthly newsletter put out by the task force, and I do research for it—primarily preparing summaries of policy reports on homelessness and related topics." Cathryn is involved with numerous organizations, including NOW, the American Civil Liberties Union (ACLU), Greenpeace, Amnesty International, Project Open Hand (a meals service for people with AIDS), Sane/Freeze, and Media Alliance (a local professional organization). She and her husband live in Sebastopol, California, and she is expecting their first child.

"The primary reason I majored in Women's Studies is because that's what I was passionate about at the time. I had attended one year of college—after graduating from high school at 16—and then taken a break. After moving to Ann Arbor in 1974, I became active in the women's movement. When I discovered that the University of Michigan had a Women's Studies Department, I decided to go back to school and finish my degree.

I've 'followed my heart' most of my life, and this was just another example of doing that. My experience in the program was one of many things that shaped my desire to 'make a difference' through my work. When I entered the M.B.A. program in 1978, my goal was to learn business skills so that I could help the kinds of nonprofit organizations I had worked with to be more effective in achieving their missions. When I eventually moved back into the nonprofit arena in 1987, I found that the perspective I'd gained through my Women's Studies degree, coupled with my business experience, provided a rich place from which to contribute — in a wide variety of ways — to the organization I was working with."

Critical-thinking skills Cathryn acquired as a Women's Studies major "were a real asset during my two years in the M.B.A. program and during the period that I worked in a 'straight' business environment. My degree gave me a context for viewing the power dynamics in the business world — and the confidence to assert myself and gain the respect necessary to succeed by those rules. Because of my rich understanding of the factors that have limited women's participation, I had the confidence to challenge certain assumptions that I ran into within the corporate environment. While the outcome didn't always go my way, it was satisfying to raise the questions, and I like to think that I contributed to changed attitudes among many of the men I worked with.

"Fourteen years after graduating, I'm again working actively in the women's community where I live. I'm also in the process of starting a freelance writing and communications business with the goal of providing women's and other progressive organizations with professional services at reasonable rates. It feels good to be reconnecting with issues that I've cared about for a long time, and to be discovering what I can bring now to their resolution.

"It's hard for me to separate the personal and professional effects of having majored in Women's Studies, since work has had such a big impact on the rest of my life. Again I would say that the most important way that my major has affected my life personally is that I learned to look at the world critically, to question the status quo interpretation of what was going on. In that sense it has shaped everything in my life, from my marriage and friends to my politics and the way I interact with the larger world. It helped free me from any limitations I had about what I could or couldn't do as a woman.

"The man I've lived with for the past 12 years grew up in a household where his mother literally did everything for him. Although his heart was clearly in the right place about doing his share of work around the house, he had very little consciousness/awareness about what needed to be done and when. Despite the fact that it often seemed easier to do something

myself than to get him to do it, I was determined to create a long-term relationship where we truly shared in taking care of our home — just as we shared in earning money. I think my Women's Studies experience gave me a vision of that kind of relationship and helped me stay committed to creating it. I'm pleased to say that we have a wonderful marriage — we deeply respect one another and both take responsibility for all areas of our life together."

Cathryn "would definitely major in Women's Studies again. I gained enormous self-confidence in the program, I think in large part because of the small class sizes and closer working relationships with professors. Finally, I gained a rich historical/political context about the role of women that has helped me understand the struggles of minorities and the poor throughout the world. That, in turn, has shaped the kinds of contributions I'm trying to make toward human rights, peace, and human development."

Postscript: "My partner, Jeff Black, and I had a son in June 1992. He's full of life and quite a challenge! In early 1992, Jeff and I formalized the working relationship we had evolved into by starting a writing and marketing consulting firm. We work from home, sharing care of Hadley and stuff around the house, doing our 'for money' work, and supporting each other in our various other interests."

Colleen Louise Sandrin — Hospital Foundation Executive Director
University of Northern Colorado — 1977

Colleen was born October 28, 1953, the youngest of three girls in an "upper-middle-class" family in Boulder, Colorado. "Father was an elementary school principal/teacher. Mother was a homemaker. Family oriented. Semireligious oriented. Typical family strife. Nothing traumatic." Colleen attended the University of Colorado, where she majored in business, from 1971 to 1973. Then she quit school, moved to Washington, D.C., and worked as a secretary in the office of Senator Floyd K. Haskell. When she returned to college in 1975, it was as a Women's Studies major at the University of Northern Colorado [UNC]. "Worked while attending UNC in the Affirmative Action Office putting the university in compliance with Title IX of the Education Act. Worked for the Women's Option Center in Colorado Springs upon graduation as a community outreach worker. The center closed within six months of my employment. Hired on as public relations director of the Pikes Peak United Way in 1978. Worked in that capacity for two years and then switched to working within the campaign. Moved to Sacramento, California, where I worked as director of resource and fund development for the Sacramento United Way from 1981 to 1983. Served as executive director of the Sacramento American Cancer Society from 1983 through 1987. Accepted position of executive director, Wood-

land Memorial Hospital Foundation in Woodland, California, in 1987, where I still work today."

Colleen, who is divorced, lives in Woodland. "My weeks vary widely, depending on my work schedule. I travel, for business and for pleasure, about two months out of every year. Many of my days begin with 7:30 A.M. meetings. Many of my days end with evening meetings, and many are 10-hour days. Meetings are either my business or Chamber of Commerce volunteer business. I attend at least one Chamber meeting a week, usually two. When I'm not at work or volunteering, I spend most of my time at home tending to and enjoying my 90-year-old home, which I've been cosmetically renovating for three years. When I'm not 'puttering,' you can find me during the summer in the backyard laying by the pool. In the winter, I usually sit in the living room and have a fire going in the fireplace. Either season, you'll find me with a book."

Colleen "became interested in women's issues while working for Senator Haskell, and at the time I was planning on continuing my education in law school. Feminist issues/human issues was my area of interest in practicing law. I didn't realize I wanted to be a Women's Studies major, or even know that was possible, until I took an elective titled, 'Myth to Reality: Women's Issues.' That class, taught by Marcia Willcoxon, excited me, angered me, and made me want to learn more about myself and my history.

"My degree led both directly and indirectly to the career I have pursued for the past 14 years. When I first graduated from college, I wanted a job specifically working for a women's organization. At the age of 24, knowing it all, I applied for the executive directorship of the Women's Resource Center in Colorado Springs. I made the final interviews but, luckily for them and for me, I didn't get the job. I realized fairly shortly after that I was not ready for an executive directorship. Actually, at that point, I didn't even know what an executive directorship was! One of the interviewers for that job was the director of the Women's Option Center, a centennial–bicentennial project of Colorado. She hired me as a community outreach worker, a job for which I had to write my own job description. The center, as a centennial–bicentennial project, would receive $100,000 if they could match it by donated dollars within a year. They had been open for six months and had raised about $5,000. The center was supposed to be a 'one-shop stop' for all women's organizations to be housed. Unfortunately, the groundwork was never laid with the other women's organizations regarding their interest in all being under one roof. The project was a disaster. The staffing was wrong. The money had been wasted. After two months, it became very clear to me, and to the other staff person who was hired when I was, that the project needed to be shut down and the money redirected to something that was truly useful for women. So three months after being

hired for my first job out of college, I had successfully closed down a state project and put myself out of work.

"What I learned more than anything from that short-lived job was that you cannot effect change from the outside. You cannot dictate to others who you have absolutely no power, no control, and no persuasion over. And most important, I learned that you cannot lead people in one direction just because you happen to think you've got a good idea. Maybe I didn't like the 'old boys' network,' but I wasn't going to change it if I wasn't willing to learn about it and, as much as possible, become a part of it. And I wasn't going to effect change just because I happened to think it was a good idea. That's when I decided to look for another job in the movement.

"While looking for funds for the Women's Center, I met the executive director of the Pikes Peak United Way in Colorado Springs. When he learned the center had closed, he called and asked if I was interested in a job. I said yes, ending my postcollege unemployment period at one month. Working for the United Way allowed me to get involved with issues of interest from a different angle. I learned quickly that money talks, and those organizations with the biggest bank roll are usually the organizations that set the rules. (I now think rules are more like 'guidelines.' If you can't win under the current rules, change them!) After working a year in public relations, I asked that I be given campaign responsibilities. Since most campaign personnel in United Way at that time were men, it took a lot of persuading to get my boss to agree. He did. I had found my niche. I quickly learned that I was very good at raising money.

"I came to the Sacramento United Way as campaign associate, a low-level campaign position. Again, I was the only woman on the campaign staff. In some ways, it was a benefit. I was extremely visible and easily remembered, as many times I was the only woman in a meeting. I made some very valuable business contacts through the corporate campaign process, which I continue to draw on today. And, as a woman, I was not looked upon as major competition by the men around me. Their attitude, although never said, was 'We'll tolerate her until she gets married and leaves.' Within a year, I was promoted to director of Resource and Fund Development, with full charge of the integrated campaign. Those men who gave me opportunities because they didn't take me seriously, therefore not challenging my maneuvering, were now working for me.

"Again, at the age of 30, I knew it all and felt I was 'wasting my time' being a staffer. I wanted to be the boss. So I applied for and was offered the executive directorship of the Sacramento American Cancer Society. I had a staff of 14 women plus my secretary, a man. I was still making power statements with my feminist acts, aping the actions of my male colleagues. 'I'll show them' was an attitude that carried over to every aspect of my

career. I showed them all right. I showed them that I was just as good a manager as the next man. What I didn't know at that point was it's not difficult being a manager by intimidation, male or female. What is difficult is being a leader, gaining respect from my colleagues and subordinates by example, not by brute force. With all my 'training' in feminism, I was a chauvinist at work. Screaming women's rights on one hand, and treating the women who worked for me the same way I'd been treated by men on the other hand. I had become what I started out to change. Instead of using my position to be a mentor to other women, I used my position to further myself in the male-dominated workplace. I was so into being 'boss' that I forgot the important things in life—being myself and being happy with myself.

"After many, many thought-filled nights, I realized I wasn't happy at all with my life. I didn't like who I had become. I was tired of coming home saying, 'I am a nice person. I am a nice person.' I decided it was time to get back to the basics, and I drew on my inner strength to define those basics. Through that process, I regained a sense of 'me' and I started to like myself again. I accepted who I was as a person, not who I was defining myself as through a job title. I was an intelligent, successful, kind, attractive woman who wanted to make a difference in this world. And through that process, I started to look for a job that interested me, not for the title that job held.

"I'm a firm believer in faith and in prayers being answered. My faith led me to Woodland, a small community of about 40,000, half an hour outside of Sacramento. I accepted a position with the hospital foundation, raising money with a staff of 2.6 people. A valuable lesson I had learned from the Cancer Society was that I greatly dislike supervising a large group of people. I thrive on the personal contact of raising money for the causes I believe in. Working for the Foundation has allowed me opportunities to make a difference in the areas I strongly believe in. I have written and received over $300,000 in grant funding for prenatal care for low-income women. I have raised the start-up funds needed for a teenage drug and alcohol treatment center. I have provided funding for childbirth-preparation classes. I serve as an executive staff person for the hospital, giving me a voice in all aspects of our health care campus. I have gained the respect of my colleagues and my employees, and I've gained that respect by being myself—by being a woman who knows what she's doing and is comfortable with her own style.

"I'm not sure if my Women's Studies major affected my professional career. It's more realistic to say that the basic nature of my being, which drew me in to Women's Studies to begin with, has made me who I am today, both on the job and at home. I'm a person who gets angry over injustice. I'm a person who gets involved in an issue. I'm a person who takes

the time to care because I know that if I don't, I can't expect any one else to care. I want people to know me through what I've accomplished and through my dreams and plans for the future. My strength as a person is directed to my causes as a woman. My success as a woman is directed to my leadership as a person. Majoring in Women's Studies helped lay the historic groundwork for positive argument on the history of sexism and heightened my awareness on the extent of women's struggle. Majoring in Women's Studies didn't make me a feminist. It was a logical major for a feminist to choose."

Colleen said she doesn't think majoring in Women's Studies "has affected my life personally. However, being a feminist has. Especially in my relationships with men. When I was a child, I was my dad's 'little boy.' I was a tomboy, always finding new adventures. I hiked and fished and caught bugs. I rode a boy's red bike, and when I wasn't on my bike, I ran everywhere. Much of that attitude still remains today. I'm still a tomboy. But I'm also very much a woman, feeling comfortable in going from blue jeans in a pool hall to an evening gown for a black-and-white ball.

"While I've enjoyed great success in my career, my personal relationships have not been as stable and self-growth has not occurred as easily. I was married when I was 18 and divorced when I was 21. I've lived with men, married, divorced, and lived totally without men. I've loved, liked, hated, and totally misunderstood men. I used the men in my life to take out the hostilities I was feeling toward the world in general. They would be my scapegoats! I didn't consciously choose a career over a marriage. I didn't consciously choose a career over having children. My life has been directed by my beliefs, and those beliefs have driven me to want to get involved when I sense that something isn't right. My career has turned out to be my path to effect change.

"I am very strong-willed and independent. I'm very comfortable with who I am and why I'm who I am. I entertain myself easily and I enjoy my own company. I don't have a great need to have people around me, men or women, to keep me company. I've always been more comfortable sharing myself entirely with a few people rather than sharing pieces of myself with a lot of people. I've always been a 'giver' rather than a 'taker.' Unfortunately, the majority of men I've been involved with have taken much more than they've ever given. I find most men weak, an attribute beneficial to my career, but difficult to deal with on a day-to-day basis in my personal life. I find men much more of game players than women. (At least the women I spend my time with.) Honesty is extremely important to me. Men find it easy to lie by omission. I have little patience for games. Unfortunately, I'm a die-hard romantic. My expectations of men have always been higher than what they are capable of providing. As I get older, I have more confidence

in what I want out of my personal life and I'm not as concerned with what others think about how I lead my life, as long as I'm happy and I'm not hurting anyone else by my actions. I don't have a *need* to share my life with a man, although I would *like* to. But not at all costs. I would like to have a child, but I don't have a destructive biological clock clicking in me. I don't feel like a failure as a woman because I haven't had a child.

"How has my Women's Studies major affected me personally? If I hadn't had this major, I'd basically be the same person I am today, although I doubt if I could debate the issues of humanism as well without the fundamental background of the issues that I received in college. Being a feminist has affected me personally. But what came first, the chicken or the egg? I am who I am. I am who I always have been. I am who I want to be in the future."

Postscript: "My title is now Executive Vice President and my organization's name has been changed to Woodland Memorial Health Foundation."

Constance Tanczo—Self-Employed Artist
Iowa State University—1978

Constance was born April 18, 1944. She grew up with her foster family in the inner city of Buffalo, New York. Her foster parents were frequently on welfare; she never met or located her birth parents. Constance attended New York University in 1962 and Rosary Hill College in 1964. She enrolled at Iowa State University in 1967. She graduated (with a second major in English and minors in Russian and art) after a divorce and while working nights as a janitor. She subsequently earned an M.A. degree in English and Women's Studies and an M.S. degree in journalism/mass communication from Iowa State University. Constance now lives in Whitsett, North Carolina, where she is an artist, photographer, craftswoman, and homemaker who also writes and does consulting.

Her first job after graduation was as a coordinator of a university women's center. "Because my art and interests—and not a career plan—dictated work, I have held numerous jobs from journalist to photographer to college teaching to slaughterhouse clean-up crew. This past year, I have made only subsistence income while finishing a novel and having a one-woman show of my photography." Constance has been in a lesbian relationship for more than 10 years; she is the mother of three adult sons.

Constance is a feminist because "I believe that women have been historically and systematically oppressed and denigrated, and that the 'salvation' and humanity of humankind depends on the elimination of *all* repressive and prescribed sex roles." She majored in Women's Studies in order "to learn more about the past and possible future of women in the world. I

was newly divorced, with children (custody being contested because of 'lesbianism'), working as a janitor, and going back to college part time. It was the mid-1970s. Title IX was beginning to affect federal and state workplaces. The women custodial staff at the university where I was employed turned in their steel-toed pumps with the rhinestone buckles for more sensible work shoes, were no longer restricted to dusting and vacuuming, were promoted to supervisory positions in significant numbers, and given thousands of dollars in back pay. I wanted to know how the restrictions got there in the first place, and how to keep opportunities new.

"Professionally, Women's Studies led to my first job after my undergraduate degree. It provided the basis of research during my first graduate degree: 'The Woman as Androgyne in the *Alexandria Quartet*.' When I worked as a journalist and photojournalist, I had a background for recognizing and reporting stories that might have otherwise been overlooked. Now, Women's Studies still informs my research and realization of images and stories as a working creative artist."

Personally, "Women's Studies has given me a broader perspective for understanding and questioning the world around me. It is a rich paradigm for learning about, working to change, and accepting the society in which I love and live. I have been able to pull from facts and theories and the life stories of others during hard times the way some pull from, or hang onto, the Francis of Assisi prayer for peace. Because I have chosen such different roads from others, the details are too many. They have become the stuff of my short stories and recent novel. Ironically, Women's Studies provided the basis for a philosophy of life and learning not unlike radical Christianity— challenging when I'd like to be comfortable, making me speak or take action when it would be easier, safer, more popular not to, and helping me see change and growth as evolutionary when I'm disappointed in the 'success' of my efforts."

Dawn Paul—Energy Conservation Manager
University of Rhode Island—1979

Dawn was born September 17, 1954, and grew up in a working-class family in the small town of Coventry, Rhode Island. "Father—retired Navy— full-time worker at local glass factory for most of that time. Mother full-time homemaker; some work outside the home in my teen years. Two older brothers; one younger sister." After graduating from the University of Rhode Island, with a second major in English, Dawn worked for a year at the Ladd Center for the mentally retarded. From 1980 to 1982 she attended Boston University and worked at Public Radio Station WBUR and for a small publishing company. She earned her M.S. degree in 1982 and entered

the energy conservation field. In 1983 she worked in a low-income weatherization program, and in 1986 she joined Mass-Save, a nonprofit corporation running utility programs. Currently she is manager of residential operations. Dawn lives in Beverly, Massachusetts, with her "long-term partner."

About majoring in Women's Studies, Dawn explained: "I was just fascinated with the coursework—it was new, interesting, and exciting. It had an impact on my daily life and my view of the world. I had no idea where it might lead career-wise and assumed that if I excelled in coursework that was intellectually stimulating, career success would follow. It also put me in touch with women leading interesting lives and gave me role models and friends.

"I have done well professionally, largely because of the education I received in Women's Studies. I grew up in a neighborhood where a good job for a woman was being a teacher or a nurse—because you could go back to work after you raised the kids. A bad job for a woman was working in a factory, which is where I would end up if I didn't get an education. It turned out to be more complicated than that when I left home for college. Teachers were being laid off by the thousands. I didn't have the math skills to enter nursing and hated hospitals anyway. I heard on the news that engineers were driving cabs, and I thought it had something to do with Amtrak because I thought engineers drove trains. I wanted to build houses but knew that no one would hire me—I hadn't even been able to get into woodshop in high school. Then the world opened up a bit and I could see that there were more options, and 'Women's Lib' was in the media and it looked like women could start living just like men, but I didn't fit in there, either.

"Women's Studies helped me sort all this out: I learned that every career option was open to me by law, and that those laws were pushed through by women who felt passionately about equal opportunity. More important, I learned that feeling passionate about issues that directly affected me was fine. I also learned how to analyze and critique that 'man's world' out there that I did not belong in, did not want to belong in, but that held all the goodies of power and money. I learned how the machine runs in big ways and detailed ways, how to dismantle it and change it, how to protect myself from it and make a place for myself and other women in it. Wow—I was a societal engineer—redesigning the patriarchy. It was and is empowering, fascinating, and very, very practical.

"To be more specific, Women's Studies gave me the confidence to enter a nontraditional field—energy conservation—and to understand and diffuse problems that arise when women are entering new or different territory. What I learned was that if I wanted to succeed in a way that was possible and comfortable for me, I had to work to change the criteria for success. In the field, I showed that listening to customers was more important than being able to tell them every widget in their heating systems. And then, as a

manager, I hired people with 'people' skills over techno-whizzes. This opened up the field for women and made for a better program. Currently I manage a program that has a lot of staff, subcontractors, etc. I run it in a cooperative and open manner, what I consider feminism at work, analyzing power relationships and turning 'power over' into 'power to.' I learned this in Women's Studies. My company recently went through a reorganization that pushes power and responsibility out to the people closest to the work. It is referred to as the 'Dawn Paul School of Management,' according to those who attend the directors' meetings, and now the whole company is working that way (or trying to). Women's Studies taught me well. Thank you."

Personally, Dawn explained, her major provided her "with a supportive environment in which to come out as a lesbian, which saved me a lot of anguish. It also gave me positive role models of independent and interesting women who were choosing their paths in life. It seemed that so many women I knew up until that time had life happen to them rather than make active choices. It also gave me a sense of pride and appreciation for women's accomplishments that mainstream education had eroded. Women's Studies provided me with a sense of balance which I have carried on since graduation. In examining the cultural extremes of masculinity and femininity, I realized that a balance of the two makes a person adaptable and capable. And in realizing that, I came to believe that this balance was important in all aspects of my life. It has helped me make choices that have made for an active and fulfilling life. In this sense, Women's Studies prepared me for life and not just a career. It taught me to question and analyze, which is useful in all aspects of life."

Would she choose the major again? "Yes—Yes—Yes. I cannot think of another program that could have given me the skills and abilities that Women's Studies gave me. Where else would I have met such fascinating people? Had such an opportunity to feel that I could change my life, the university, the world? Been so challenged both academically and personally? Thank you to all the faculty and administrators of the Women's Studies program for giving me an education that I use every day—some of the toughest years of my life, but well worth it."

Heidi M. Boenke—Self-Employed Musician/Teacher
Oberlin College—1980

Heidi was born December 20, 1957, and grew up in the suburb of Cleveland Heights, Ohio, with her parents, older brother, and younger sister. "My siblings and I are very close in age—one and a half years or so between us. My childhood was very stable and happy. I'm the product of one of those rare 'functional' families. We were, and still are, a very close and loving family. We've been through our painful times (when I came out [as a

lesbian], for example), but I think the key was that we were all willing to trust and believe each other. My parents taught me to believe in myself, to respect and believe in others. I learned to be playful, and to be responsible. Politically my parents are fairly 'liberal'—they were active in local civil rights actions in the 1960s. My mom was/is the dominant figure in the home when it came to social–political things, and so when I say 'my parents' I really mean 'my mom.' I don't think my dad had *different* feelings; he was just happy to follow her lead. I found out in my early teens that mom *wasn't* so 'liberal' when it came to boy–girl stuff. I remember being shocked one evening when she chastised my brother for not walking his date to her door from the car, even though our whole family had been along on the 'date' and my brother's friend was perfectly capable of walking to the door unescorted."

Heidi attended public schools and enrolled at Oberlin in 1976. Since graduation, she has been self-employed as a musician/teacher. She also has worked at a public library, as a personal attendant for a quadriplegic woman, and as a secretary. In 1987 she earned a bachelor of music degree in flute performance from the University of Oregon. Heidi and her partner have been together four years; they live in Portland, Oregon.

Heidi said her great-aunt, Selma Mueller, is her role model, but added: "You know, the more I think about this, the more I can't find them. I think of some men who gave me an image I wanted to emulate, but no women (until my adult life—friends who inspire me). But I spent a lot of energy in fantasizing—people/places/whole lives. I think I *imagined* my own 'role models.' I built my own images of who I could be."

Heidi majored in Women's Studies because "it was the most fun thing to do at the time." She said she "gets the sense that my major somehow lends credibility to my feminism. In 1987, I published a catalog of 'Flute Music by Women Composers.' I have felt from friends and colleagues that they take me seriously in that field (i.e., respect) not only because of the research I did but also *because I have a degree in Women's Studies*." Additionally, Heidi said, "studying life from a feminist perspective did more to shape my personality and my perceptions than anything before or since. This is the biggest effect my major had on me. I gained confidence in myself, in my ability to communicate, in my ability to see the whole picture in a situation, and in my ability to decide for myself what I want."

Betsy Dollar—In Transition
University of Colorado—1983

Betsy was born October 1, 1956, into a "traditional American family of the 1950s and 1960s. My father worked to support us. My mother was a

homemaker. I have one brother who is five and a half years older. We were raised as two only children. Our experiences with the same biological parents were very different. Some contributing factors to this were different expectations based on gender and 'perceived' intelligence; my mother's growing alcohol abuse and dissatisfaction with life; and significant professional setbacks for my father while I was in high school."

Betsy's father was an engineer; her mother was "an artist who worked at home, but never achieved any commercial success." Betsy was raised in suburban Chicago and, for three years, in southern California. She attended the Minneapolis College of Art and Design for two years in the mid-1970s and enrolled at the University of Colorado [CU] in 1981. "Immediately after graduation I established an audiovisual production company with a female partner (we were two women under 30). After three years of successful operation and growth, my partner chose to move to the East Coast. After five more successful years of operation, I sold out [in spring 1991]. After a summer of full-time parenting, I am taking one graduate-level course, doing freelance design work, and attempting to establish myself as an artist in handmade paper." Betsy is married and lives in Boulder, Colorado; she has a four-year-old daughter.

Why did she major in Women's Studies? "After attending an art school for two years I had loads of studio credits, but very few academic. It made sense to focus those into another major. My first semester at CU, I took one Women's Studies class and was hooked. I felt for the first time a class was talking directly to me. The inconsistencies I had been observing and experiencing were actually being addressed. I was also pleased with the interdisciplinary aspects of the curriculum. I could hit on a lot of my interests with a common focus. Not a single class was easy. There was always a challenge. They always forced us to think through an issue and be able to defend our position. Often we were in uncharted territory that required looking at topics from many different perspectives. Later in the program I became accustomed to the support network of women, which I had never experienced.

"The effects of Women's Studies on my professional choices have been in my philosophy. I started in the animation/slide production industry when I was 19. In retrospect I just shudder when I think of the things I allowed my employers to do to me. I was naive and eager to please. I was also the first female camera operator in Chicago—it was 1978. By the time I reentered the field in 1982 I had the benefit of age, experience, and exposure to Women's Studies. I don't think I would have ventured into my own business without the information and motivation from those classes. I realized that I would not do well in a large corporate setting that was dictated by patriarchal style and hierarchy. I wanted to be in control, to

implement my own egalitarian management style. I made a lot of mistakes as an employer—the greatest of which was being far too trusting. I assumed that people would do the job they were asked, trained, and paid to do. My personal style tends to be that of a workaholic. Therefore it is difficult for me to understand people who are not motivated to work. As the worker, consultant to larger corporations—the expert—I avoided many of the pitfalls I would have encountered had I been an internal part of these companies.

"Despite my young appearance I had very few problems with being manipulated by middle-aged middle managers, male or female. I attribute that to two things. First, I was usually bailing them out of a problem situation and I proved to be reliable in that capacity. Second, I made it clear that if they harassed or demeaned me they would lose my services. Often I was competing for business with a woman who often uses her physical attraction and actions to get business from 'the big boys.' It has worked; she has made far more money than I. But I am convinced that some day it will catch up with her. If not, I am poorer financially but more comfortable with my ethics and 'strictly business' approach. We always dealt with clients fairly and equally. In the industry it is common to have separate price structures for different levels of companies. We produced the same product. It cost us the same, therefore, it cost the client the same. Equality, what a concept!

"I am embarking on a job search within the next few weeks. (My family cannot survive gracefully on one and a quarter incomes.) This is not going to be an easy process. After having my own company and the flexibility and control that comes along with that, it will require some compromises on my part, I am sure. I have made the decision that I need to work for someone else at this point, because I cannot be ultimately responsible for everything within a business and meet my family obligations. I am determined to not compromise on several points: My new employer must acknowledge the importance of a family (and the flexibility they require); they must recognize 'feminist' styles of management and utilize them; and they must compensate women equally across the board in wages, benefits, and positions. I could be looking for a long time."

How did her major affect Betsy personally? "For a while, it affected my marriage. My husband actually attempted to do his share of 'domestic' activities. Unfortunately, I spoiled him from the beginning and I am a perfectionist—he couldn't do anything right (on purpose I am sure). So I maintain control of the domestic profile of the family—by choice. The major impact on my personal life comes in the capacity of volunteer activities. About a year after I graduated from school I missed the women's network of the Women's Studies Department. At that point I joined BPW

[the National Federation of Business and Professional Women]. That was six or seven years ago. In that time, I have held numerous local offices including president, district offices, and state chair positions. My focus is women helping women. As president of Boulder BPW I helped create and implement a mentor program. The program is in its third year and growing each year. As a result of the mentoring program, we created the 'career closet.' We collect business-appropriate clothes from women throughout Boulder County and make these clothes available free of charge to women. This has really helped as a confidence builder for interviews and going to work. For many of these women it is the first time they have had a job, and there isn't any way they can go out and buy a new wardrobe for the event. Support of the mentor program has become my personal project.

"Finally, my exposure to Women's Studies has made me a far better person. I recognized my value system as a result of the program and I now act through the framework of my convictions. I think it has also made me a better parent to my daughter."

Postscript: "After a long, hard search and thousands of hours of volunteer work, I am now the director of development for Friends' British Primary School, a small, private preschool and elementary school. My daughter is a student at this school, which I originally chose because it was the most gender-neutral educational environment I could find. The BPW mentoring program I designed has won numerous national awards, including top honors from several divisions of the U.S. Department of Housing and Urban Development."

Sarah T. Luthens — Union Organizer
University of Missouri — 1983

Sarah was born August 12, 1961, and grew up "in a traditional nuclear white family in Des Moines, Iowa. Both of my parents had grown up in poverty, but they got scholarships to college, graduated, and very much strove toward a middle-class existence. During these 18 years my family was lower-middle class. My three brothers and I were raised Catholic (consisting mainly of weekly church and CCD [Confraternity of Christian Doctrine] attendance)." Sarah's mother was not employed outside the home; "she was pretty active in community affairs as a volunteer." Her father "worked full time as an insurance administrator and part time as a self-employed attorney."

Since graduating, Sarah has held a variety of part-time and full-time jobs: school bus driver, United Parcel Service manual laborer, YWCA Women's Center director, legal secretary, phone canvasser, security guard, nonprofit administrator, and "quasi-social worker" for a residential program

for women leaving prison. She has also worked as a nut-butter factory worker and hammock production worker in an egalitarian community, door-to-door canvasser and field manager for a nonprofit environmental group, phone-survey supervisor, union administrator, Equal Employment Opportunity Commission (EEOC) investigator, Women's Studies teaching assistant, law clerk, bar exam prep course sales representative, and telephone surveyor for a market research group. Sarah earned her J.D. degree from the University of Washington School of Law in 1991. Since April 1992 she has been a full-time union organizer with North West Service Employees International Union, "a health care workers union, primarily registered nurses." Sarah, who lives in Seattle, is a lesbian; she is "single but dating someone exclusively."

Ever an activist, Sarah is a member of numerous organizations, including: National Lawyers Guild, New Jewish Agenda, American Friends Service Committee, NOW, NWSA, Democratic Socialists of America, Seattle Municipal Elections Committee (gay/lesbian electoral group), Washington Women United, Gay and Lesbian Alliance Against Defamation, Rainbow Coalition, and Team Seattle (a lesbian basketball group). She considers herself a feminist "because I strongly believe (1) women of all races are oppressed, (2) we should not be, and (3) we must transform the primary oppressive forces—sexism, racism/anti-Semitism, classism, homophobia, ageism, physicalism, speciesism, and nationalism."

Sarah said the main reason she majored in Women's Studies "is because it appealed to my passion for social justice like no other discipline did. With my passion for women so closely interwoven with the quest for justice, Women's Studies seemed like the natural place for me. Another big drawing card for me was the dynamic women—professors, staff, and students—who were involved in Women's Studies. Individually these women impressed me greatly with their sense of dedication to feminism, their obvious intelligence, and their friendliness. Collectively, these women had a sense of community that seemed to offer great friendships, a lot of fun, and various opportunities for personal growth. It was also a lesbian-friendly environment, and that cemented my sense of feeling 'at home' in the program.

"However, in a sense it was a rather bold decision. The program wasn't very well established at the time. In fact, when I decided to major in Women's Studies, no one had yet graduated with this major at my school. I was the second person to do so. Actually it hadn't occurred to me very much to major in Women's Studies until an Arts and Sciences academic adviser suggested it. From there I did some research, met the new director and some of the others involved in the program, and it didn't take long for me to decide. It was such a relief and inspiration to have finally found a home at my university."

Sarah said her major "directly helped in landing" several jobs. These jobs were explicitly feminist, and so a background in Women's Studies was a real boost. "I believe that my major also was a significant factor in my admission to law school, especially since it was combined with a solid record of feminist activism, good grades (and a great LSAT score). To land one of the 160 seats in a field of 1,400 applicants, successful candidates need to be distinctive. Certainly Women's Studies majors are distinctive, especially with our passion for social justice. This is something law schools appreciate.

"Now my profession is union organizing, and my Women's Studies background has definitely influenced this choice. Years ago I read an article by Barbara Smith on 'professionalism' and how it often serves to divide people based upon elitism. This article, along with a fairly comprehensive feminist education on the importance of empowering the oppressed and redefining social institutions, helped shape the values and analysis underlying my choice to become a union organizer rather than an attorney. Choosing to become a union organizer reflects the feminist values of grassroots organizing, challenging capitalistic profiteering, and bringing women workers together. My union has a 97% female membership. Choosing not to work as an attorney is a rejection of professional elitism, the illusion of judicial objectivity, and the adversarial process. Nonetheless, I'm glad to have the tools that a legal education provided me. Combined with my commitment to feminism and the progressive labor movement, I feel more empowered to pursue the goals of my Women's Studies education.

"Undoubtedly my Women's Studies education has affected me personally in countless ways. Here are some that come immediately to mind (in no particular order):

1. Inspiration to continue in higher education. I was close to dropping out of school; I was making great grades, but I thought my energies might be better directed. When Women's Studies came into the picture, it felt right to complete my degree.
2. Tools for deep feminist thinking/feeling. The level of feminist analysis I am able to engage in regarding various issues and situations has been greatly enhanced by Women's Studies, and it has helped me validate my intuition and feelings in my decision-making process.
3. Affirmation for living as a feminist–lesbian multicultural activist. Since this way of interacting in the world is especially difficult, my major did me an invaluable service. It continues to be a source of hope and faith for me.
4. A feeling of community. Being part of the feminist community pro-

vided me with a sense of home, of where I belonged. It did so with a great amount of respect for me as an individual and in other healthy and loving ways. It was instrumental in keeping me alive and thriving.

5. Economic poverty. Unfortunately, as a student I did not realize I needed a strategy for being able to support myself economically and have suffered the psychic violence of poverty. Fortunately, I think I'm finally starting to make some real progress in this area."

Sarah would "absolutely" major in Women's Studies again. "However, I would do some things differently. I would push myself a bit more academically, take more ethnic studies courses, take labor studies courses, build better multi-ethnic coalitions, get into therapy, and prepare for paralegal or union-organizing training or other vocational options. I would also try to get to know my teachers better."

Postscript: "Hooray! I passed the bar exam. My immediate plans are to continue with union organizing. Right now I'm leading a team of 20 nurses (representing 650 RNs) in contract negotiations at a hospital. Also, I was interviewed on C-SPAN at the 1993 March on Washington for Lesbian, Gay and Bi Equal Rights and Liberation."

Nancy O. Arnold—Minister
University of Massachusetts at Amherst—1984

Nancy was born February 19, 1950, and grew up on Staten Island, New York. She was the oldest of four children in an Italian/Irish family. Her father "worked his way into middle management" and her mother "worked outside the home until she had me." Before enrolling at the University of Massachusetts in 1980, Nancy attended Albright College (1967–1969) and Holyoke Community College (1978–1980). For two years after graduating from college, she worked half time as a staff member in the Women's Studies Program at the University of Massachusetts and continued as staff administrator for the campus ministry. She entered Harvard Divinity School [HDS] in 1986 and earned her master of divinity degree in 1990. While a graduate student, she was an intern and summer pastor at the First Unitarian Society of Newton, Massachusetts, for two years and on the summer staff of the Social Justice Department of the Unitarian Universalist Association in Boston for a year. Since 1990, she has been minister of the First Unitarian Universalist Society of New Haven, Connecticut, and the Unitarian Universalist Church in Meriden, Connecticut. Among Nancy's many activities are the Anti-Racism Committee of Meriden, of which she is chairwoman; the Connecticut Peace Tax Fund; and several ministry-related

organizations. She is married and the mother of an adult son; she lives in West Haven, Connecticut.

Nancy chose Women's Studies "after getting a late start (or re-start) on my education. I went from English to journalism to social thought and political economic theory, finally settling on Women's Studies after taking a course in the 'Psychology of Women.' Women's Studies allowed me to pursue an interdisciplinary approach to my education. Because I returned to school for myself, I decided that studying what excited and interested me was primary. Through the lens of feminism and women's eyes I was able to make the courses relevant and pertinent to my own life." Had it not been for her major, Nancy explained, "I would not have pursued graduate study or the ministry. Although I settled on a 'general major' so that I could keep my options open, I found that many of the questions I was asking were of a theological nature. I was very fortunate to have Janice Raymond as my adviser. It was she who helped me articulate the questions and then provided the resources to find my own answers. Jan also encouraged me to go to Harvard, even though I was sure I 'wasn't good enough.'

"My identity as minister has been greatly shaped by my Women's Studies experience. While at Harvard, I critiqued my coursework from a feminist perspective and selected papers and projects which focused on women and justice. I set up my own course of study, for the most part, taking courses such as 'Collaboration and Empowerment,' 'Mutual Ministry,' and 'Living and Working with AIDS.' Because I had been an active lay leader in my congregation before going to HDS, I went with a vision of what ministry should be. I did not want to be at the top of some hierarchy; I wanted the congregation to participate fully in the life of the church with me. I had to work very hard at HDS to hold on to my vision of ministry as mutual and a partnership. My grounding in Women's Studies gave me the academic wherewithal to succeed and the tools to be able to stand my ground for what I believe.

"Since my ordination in 1990, I have been minister with two congregations. One has a very traditional view of ministers—they keep trying to get me on a pedestal. For them, I specifically include laypeople in the service and offer some services where we speak from floor level. I continue to try to empower those who feel they have no power, while working at the structural aspects of creating a more participatory church. The other church was quite divided about whether they even wanted a minister. No robes, no pulpit, no standing to deliver your 'remarks' (no sermon!) because even that places you above the congregation. With them I have worked to gain their trust and to shift their emphasis from fear of hierarchy to a respect for each other and for the congregation as a whole (e.g., people with hearing impairments need to lip-read your words; they can't do that if you sit with

your back to them). I also work very closely with a worship committee and include laypeople in each service, always stressing that we are all ministers here. My sermons or 'remarks' are heavily feminist and radical — although I don't always point that out. Rather, I approach topics and themes from a radical feminist perspective and present it as a 'challenge' to the congregations. Looking at our roots and the original meanings and intents of words we think we understand helps all of us change the way we look at our pasts and our present. I see my role as minister to help people look within themselves for their own truth and then encourage them to act on what they believe."

Personally, Nancy said, "I am not sure I'd be here if it were not for Women's Studies. I suffer from chronic low self-esteem and sometimes depression. Women's Studies and the faculty and students helped me to understand 'my' failings in a more systemic way. By looking at the cultural cultivation of myself as a woman, I was able to make sense of my life experience. Women's Studies, and particularly Jan Raymond, helped me to realize that we 'can't change the past, but we can change the way we look at the past' so it doesn't continue to hurt us in the present. I came to see myself as valid and worthwhile — even smart at times! — through what I studied academically and the women with whom I studied. Women's Studies helped me to find that voice within me that had been squelched for years. Translating what I learned into action was more difficult, but I found that the women, connections, and support did not end with graduation. When making decisions about family and graduate school, Women's Studies staff and faculty were ever-present and encouraging. It was probably due more to their belief in me than my own sense of self that I applied to and then attended HDS. I decided — for the first time — that I couldn't know for sure if I wanted to be a minister, but that I would know if I was in the right place once I was there.

"My understanding of myself as a woman has become inseparable from what I learned as a Women's Studies student. The battles I continue to fight within come out of my own ambivalence of wanting to know my own power and yet not to be 'the authority' over others. I constantly challenge and assess my motives for what I do and say. For a while this kept me standing still, but I finally decided that I could do the internal work while moving ahead. I decided to stay in my marriage while asserting who I was — not someone's version of mother — and let events unfold. (My husband has now returned to college, and he surprised himself recently by critiquing a female lawyer's presentation because she used terms like 'meet the guys' to include herself!) My son has an unusual self- and other-awareness because of my holding onto myself. We are very close, and very much alike — he is the cook and encouraging 'parent' with his girlfriend and friends — but he

also holds to his ground and beliefs. My fears that Women's Studies would drive a wedge in my relationships with men proved partially true. But I decided that any man who couldn't accept me as I was, wasn't someone I wanted to be with anyway. My primary relationships are with women as far as love and support, and I consider myself 'woman-identified.' This still creates conflict within me as far as my marriage, but I continue to let events unfold as I pursue my own truth."

Would Nancy major in Women's Studies again? "Absolutely!! In fact, I'm presently trying to figure out how to pursue a doctorate in Women's Studies/Religious Studies/Theology/Ethics. Women's Studies was the single most important effort I ever made in my life. It was the turning point for me both personally and professionally. And I firmly believe that if you pursue what is most meaningful to you in life, the rest will follow. It's the process that's important and key to our success. The job or goal will be there if we are true to our process, and true to ourselves."

Philip Gütt—Cooperative-Grocery Manager
University of California at Santa Cruz—1984

Philip was born May 31, 1955, and grew up in southern California. He had a sister two years younger than he. In 1974, Philip enrolled at Pasadena City College, which he attended for a year. In 1975 and again in 1980, he attended Palomar Community College. He enrolled at the University of California at Santa Cruz [UCSC] in 1981. After graduation, he went to work for Sundance Natural Foods in Eugene, Oregon—first as a produce clerk, then as a cashier, a stocker, and finally as merchandising manager. Since 1988 he has been general manager of a cooperative grocery in Corvallis, Oregon. Philip is married and the father of a three-month-old son.

He started UCSC in environmental studies. "I was taking a series of classes related to social and environmental ethics. A great deal of the subject matter dealt with looking at our historical, cultural, social, and psychological programming and how they have contributed to our current level of crises in many facets of the world, including the environment. Looking at the problematic aspects of human perceptions, beliefs, and relationships began to open my eyes to a whole new world of ideas. After spending two years in Environmental Studies, I realized the subject that I had the most interest in pursuing was the relationships between oppressor and oppressed—how and why they occur and what processes aid in dismantling them. In discussing this with my college adviser, she recommended looking into the Women's Studies program. She felt that it might have a great deal to offer me. After taking 'Intro to Feminism' with Bettina Aptheker, I agreed wholeheartedly and began signing up for other classes and ultimately re-

ceived my B.A. I guess I was also trying to gain a 'big picture' view of our culture. Often we look at our world in a very fragmented way and it is difficult to grasp what the underlying causes are for many of the dilemmas we find ourselves in. I felt Women's Studies was an incredible resource for gaining a clearer perspective.

"When I was hired at the co-op as general manager, I was among 100 applicants for the job. This was a very successful 'alternative' business grossing over $2 million a year in sales. The board and management were looking for someone who not only had the ability to oversee store operations but who also would bring a nontraditional approach to management. My major was definitely one of the factors that led to employment." Women's Studies also "has made a big impact in my personal life. In some ways it is difficult to measure because my education in feminist perspective evolved slowly over several years. I do feel it has enriched my life a great deal. It has given me a better understanding of the value and importance of diversity as well as the inherent flaws in attempting to reach a common unity by trying to ground ourselves in diversity. 'Unity through diversity' was a phrase that was thrown around a lot while I was at UCSC, while at the same time the feminist movement was bubbling with the acrimony of minority discrimination and factions. White, middle-class, heterosexual women were being criticized for dominating a large portion of the movement at that time.

"In my thesis I explored some of the problems with attempting to unify by gravitating to others with similar anything, e.g., beliefs, sexual preference, color, religion, social problems, political perspective, etc. When we 'unite' based on the circumstances/beliefs of our individual lives, we also create more separations and boundaries. As far as I am concerned the breakdowns that were occurring in the feminist movement were indicative of the recurring malaise of the majority of human cultures—the inability to find a true common ground. My criticism is not with the desire and legitimate need to come together as groups to work on the things that are important to us as diverse individuals. Rather, my criticism is with the breakdowns that so frequently occur when those on the 'inside' fabricate a structure of beliefs that suggest that their micro-unities (and I don't think it matters whether it is Christianity, Amway, or radical feminism) have some sort of presumed ultimate superiority. Those on the 'outside' are relegated (whether it is implicit or explicit) to the degrading status of inferior.

"Without attempting any further to encapsulate my thesis, I feel the above described issue/problem is *huge* in its impact on our lives. I feel that working toward resolution to it will bring us light years closer to resolution of many of the problems that feminism has done such an invaluable job of

identifying. I also believe that when we take away the layers of any revolutionary movement, including feminism, that the underlying core is the challenge to separation and all the atrocities that accompany it. For me personally, this has become an important awareness in my life. I look at the multifaceted relationships we have with the world and attempt to scrutinize how I/you/we divide ourselves up and perpetuate disharmony. Women's Studies helped me a great deal to get a better grasp on this."

Ellen R. Divers—Temp and Self-Employed Cake Designer
University of Richmond—1985

Ellen was born June 23, 1963, the middle child of Southern Baptist missionaries. She grew up in Argentina. She said her parents had "strong values about education (dad has a master of divinity degree and mom a master of education) and were not very conservative (for Southern Baptists!)." She described herself as "very close" to her brother (two years older) and sister (10 years younger). After graduation, with a second major in psychology, she worked three months in a psychiatric hospital with brain-damaged adolescents. Then came a bilingual educational videotape venture that "did not materialize as planned. Financial strain introduced me to the world of temporary services, and I worked as a temporary for six months before being hired as an administrative assistant by the company I was on assignment with."

After a year, that position was dissolved and Ellen went back to temping. She subsequently was hired by the agency as a personnel consultant. She resigned after three months "because of the hard-sell aspects of the position, as well as some ethical concerns (the department was disbanded in a matter of months). Since then (1988), I have chosen to retain my independence through temping and freelancing as a cake designer (novelty and wedding cakes). As part of my search for a suitable vocation, I worked for my agency training temps on word-processing software. Having developed significant skill in application software, I am now enrolled part time in a master of education program at Virginia Commonwealth University. I am concentrating in human resource development and training, and hope to eventually apply it to computer-based training and instructional design." Ellen, who is "single, unattached," lives in Richmond, Virginia.

How did she come to major in Women's Studies? "I received a brochure with the college catalog for the WILL (Women Involved in Living and Learning) Program at UR [the University of Richmond] and liked the emphasis on developing skills such as assertiveness and the focus on what it means to be a woman. Our class was the pilot for the program, and once I took a course

or two I was hooked. I developed a strong kinship with my classmates and faculty, as well as a commitment to women's issues. It didn't hurt that some of the classes counted toward my psychology major!"

Although she described herself as "professionally still somewhat undefined," Ellen said that "in the work environment generally, I have found that my major has sensitized me to the use of gender-fair language in the written and spoken word. It has also made me aware of my rights in the workplace, in the interview process, as well as in relation to male colleagues and supervisors. Although no book or seminar can prepare you completely for real-life situations at work, they can help you recognize familiar scenarios and therefore work through your thoughts/feelings about a particular situation more effectively. For example, we studied about discriminatory situations female secretaries often face, and I never understood how they put up with it. Little did I know that I would find myself depending on a secretarial job for my livelihood. The reactions and decisions are significantly more ambiguous under these circumstances. Fortunately, I did not have to deal with extreme cases of discrimination, but I did notice the subtle forms it takes.

"As part of our Women's Studies program, my classmates and I learned about resumé writing, interviewing skills, professional attire, all of which was invaluable as a new graduate. We also had opportunities to take various personality inventories, which have helped me understand my strengths and weaknesses in various work and social situations.

"Because I perceive my life as a personal venture more so than a professional one, this is where the major has influenced me most. First of all, I've been able to view from an academic as well as personal standpoint a woman's role in our history and in our culture. When this occurs, it is bound to affect social interaction with both sexes. With females, I find myself cringing when I hear discussions about what a woman should or should not do in a dating relationship (e.g., ask a guy out for a date). I feel uncomfortable when I hear comments about menstruation as an inevitable and uncontrollable state of mental and emotional dysfunction. Women's Studies educated me about health issues affecting women and gave me a clearer understanding of sexuality. I also notice when women attribute success to luck or anything but skill, and allow their partners and/or children to dictate their lives. It saddens me to see women relinquish control over their lives, and I do what I can to encourage and support them as valuable individuals.

"Women's Studies also has colored my thinking on everyday matters. For instance, instead of seeing an activity such as parents selecting cute toys and clothes for their children, I see the reinforcement of traditional sex-role stereotypes! With men I have become more assertive, even aggressive. In actuality, I am trying to practice being gentler and softer—partly because

I've found the earlier approach can backfire(!), but also because it concerns me that I've adopted traditional male attitudes and values which are just as maladaptive as the traditional female ones. Issues just aren't as cut and dry as they used to be! In any case, on an average date I generally still insist on going 'dutch' (though this is no longer a hard-and-fast rule, either), which is one way I try to establish my independence. I also state my preference, if the need arises, for being called a 'woman' versus 'lady' or 'girl.' I guess one could say that Women's Studies has made me more observant of social interactions; this is both frustrating (when surrounded by those who don't share my feminist concerns) and rewarding (when engaged in dialogue/activities with men or women who do understand women's concerns)."

Postscript: Ellen completed her Master's degree in May 1993 and began "my employment search."

Susan Hillsman—Public and Government Relations Manager
University of Richmond—1985

Susan was born October 7, 1962, and grew up in a small town in the Shenandoah Valley of Virginia. Hers was "a warm, loving family of four: Mom, Dad, me, and a younger sister. I was lucky enough to be exposed to *all* types of activities: those typically reserved for girls (such as ballet and dolls) and those typically reserved for boys (such as baseball and football)." Her father was employed outside the home, as was her mother, "but not for the majority of my years at home." At the University of Richmond, Susan had a second major in English and a minor in business. After graduation, she "immediately went to work as a sales representative for a Richmond-based company with which I interviewed on campus. I worked as an outside sales representative for them for four and a half years, until I was promoted to manager of public and government relations." Susan is engaged to be married. She lives in Richmond, where she is involved with numerous organizations, including the Old Dominion University Friends of Women's Studies.

Susan said her parents were not feminists, "but I was raised by a very strong woman who believed a woman could do *anything* she wanted to do, including raising a child alone (she didn't do that herself but gave me her blessing if I chose to)." Susan does not consider herself a feminist, either. "I did when I was in college, when its connotation was more positive than now, when I thought it meant a woman who believed in and promoted the rights of women, a woman who believed that women are equal to men and promoted the advancement of women. I am still that woman, but I'm not sure I want to be called a feminist anymore; today that word to me implies a radical female who believes women are superior to men, an unhappy

woman who dislikes men. I think the meaning of feminist has changed in the same negative way that the meaning of environmentalist has. I believe I am both, but I wouldn't want to be called either."

Like Ellen Divers, Susan arrived at Women's Studies via the WILL program. "I enjoyed the Women's Studies courses a great deal and decided it would not be too difficult to take some more classes and major in it. I felt the courses were informative, interesting, and worthwhile. It's difficult to say exactly how my major has affected me professionally. I believe it probably affects me subconsciously most of the time. It probably contributed to my believing that I could be successful as the only female technical sales representative for a company selling construction materials. It probably also helped me deal with some of the stereotypes and sexual harassment I faced in that job in which I worked with and sold to men predominantly. When I was offered a promotion that would entail moving and possibly ending a relationship, one of my Women's Studies textbooks was a big help. It discussed the feelings of pleasure and/or mastery women typically obtain from making various choices about careers, relationships, and family.

"As with my professional life, it's difficult to determine exactly how my major affected me personally. I do know that it sensitized me. As a result of my classes, I look at advertising, television, theater, media, literature, everything differently. Because of my heightened awareness, I look at these kinds of communication and see their impact on women. I look at what they say about women, what they tell us about how we should be or feel. I look at the messages that are said *to* women and the messages *about* women.

"I'm uncertain as to how much Women's Studies has contributed to my change of opinion about having a career versus being a mother. In college, I believed I would have a successful career, work full time, postpone marriage and family, and go back to work immediately after having a baby. I learned a new respect for full-time moms who work at home, however, and Women's Studies probably contributed to that. Now I think I might consider taking a few years off to raise children, eventually working part time and then full time when they're older. I see that option as a different way to 'have it all,' and I know I'll be equally, if not more, important as a mom than as a career woman.

"I've learned to play the game pretty well, I think—the game of women and men relating to each other and working with each other. But I continue to be amazed and aggravated by the many double standards that still exist (in and out of the workplace)."

If she had it to do over again, Susan would major in Women's Studies. "In fact, I wish I could do it over again. I'd probably take the same courses; I'd take a few more if I could. But this time I'd work much harder to read

all of the material and learn every single thing I could. I'd work harder, absorb more, and get everything I could out of it."

Postscript: Susan is now Susan Hillsman Hurley; she was married in August 1992.

Ali MacDonald—Writer/Homemaker
Sarah Lawrence College—1985

Ali was born November 21, 1953, and grew up in the northern Indiana city of Hammond. She described her family as "basically nuclear: mother, stepfather, brother, myself. Mother worked full time, as did stepfather." Ali left home at age 17 to join the Air Force; she served for one and a half years and attained the rank E3. In 1972, she attended Okaloosa–Walton College. Four years later, she spent a year at the State University of New York at Stonybrook. From 1979 to 1980 she attended Suffolk County Community College, where she was a Women's Studies major. She transferred to Sarah Lawrence and continued that emphasis along with writing. Ali is married and lives in St. Johnsville, New York. She is a member of the Democratic party and NARAL.

Since graduation, "I've done nothing to earn an actual regular paycheck. I've done volunteer teaching of poetry to local children as well as writing and publishing several pieces. I suppose it can be said I work for my husband, who is paying off my school loan. This is in return for the years I worked while he started a business." Ali said she does not have "a typical week. Seasonally my days change with gardening and sheep shearing. Most days I get up early to read and write. Some days we take off on the Harley with a notebook and camera. Some weeks I work on a painting, and others I sew."

Ali majored in Women's Studies "because it was one area where I did not feel half human for not being male. The traditional reading lists, of mostly dead white males, left me feeling uninspired. I originally enrolled to study computers, to 'make money.' For a change I took one course called 'Women in Literature,' and my world opened. It was like discovering a new continent. A country where I was welcomed.

"Perhaps the simplest and greatest effect of my years in Women's Studies is that I do not give in. I do not quit. There is also the great networking ability of Women's Studies people. Writers have their own cliques and groups, but those comprised of Women's Studies people seem just a bit more open to new ideas. There is a support function I find very necessary."

As for how her major has affected her personally, Ali observed: "I finally feel I am a useful, valuable human being, which is a great deal better than where I started. My husband took some of the Women's Studies

courses, too, and the change in him was very positive. He now understands much more politically and individually where I'm at. He is a biker and hangs out with other bikers, reads a biker magazine, and goes to rallies where guys shout, 'Show us your tits.' I've watched him evolve over 10 years to where he points out the sexism in his own group. I've actually heard him say, 'Sexist, man.'

"I've also gotten stronger in my ability to resist sex stereotyping of myself. I can pass the peroxide and hair spray counters without feeling 'unfeminine.' I can eat a good meal without feeling fat or like a pig. I can finally admit I'm just not 'into shopping.' I feel freer to explore and express the more masculine aspects of myself. My freedom allows John (my husband) a similar freedom. He likes to cook. He cleans the house better than I do. I swear like a sailor and like my leather boots. We do not worry who will carry out the trash or who will earn the money—whoever is ready, whoever is in the right place to accomplish it will do the deed. This allows us a great deal of leeway in decisions.

"Actually, in a funny sort of way Women's Studies gave me permission to return to 'the home,' where I do my writing. I had been working over 10 years steady before I went full time to college, and not earning a regular paycheck was a hard fact to deal with. I learned that liberation is where and how you find it. And that not all women need eight hours a day at the office to prove their worth. I think studying Virginia Woolf and Alice Walker influenced my current self-image the most. No, it was all of them, all the 'wonder women,' from Georgia O'Keefe to Esther Broner—they were all so varied and strong. I learned to value my own individuality and strength."

Postscript: "I have completed and been trying to interest a publisher in my first novel, *Iron Bones.* Currently I am completing my second manuscript, a mystery centered on the Iroquois Nation's civil war currently being waged in upstate New York and Canada. In April 1993, I was featured poet at the Westhampton Poetry Festival on Long Island."

Leona S. Roach—Yacht Broker
Wellesley College—1985

Leona was born February 5, 1964. She grew up in suburban Boston in a Catholic "two-parent family, heterosexual, two children, middle class, conservative." Her father was employed outside the home; her mother was not. Leona attended private nonsectarian elementary and high schools. After graduating with honors from Wellesley, where she had a second major in political science and a minor in economics, Leona worked a year for the Coalition for Basic Human Needs. She then became administrative assistant for the Women's Law Collective. Since 1986, she has been a yacht

broker with Norwood Marine, the family business. Leona is engaged to be married; she lives in North Quincy, Massachusetts.

She said curiosity initially drew her to Women's Studies, "and then it became the greatest intellectual challenge of my life to understand and interpret the world, history, etc., through the prism of Women's Studies. It was and is so exciting because it was like discovering the whole world again. All the subjects, issues, questions were suddenly imperative to me when reordered once more through the perspective of a women-centered understanding. Susan Reverby, director of the program, was the most energetic and inspiring woman I had ever met."

Leona "would not be doing what I am doing had it not been for Women's Studies. No one ever said you can't do this or that—so without any discouragement I am in a very nontraditional field as a yacht broker. It involves detailed understandings of heavy-duty engines, mechanics, vessel performance, captaining and managing vessels to 72 feet, as well as the art of selling a man's product to men in a male-dominated field." She sees Women's Studies' effects on her personal life, too. "I am involved in an egalitarian relationship and have been for eight years. Together we have forged a life together which is mindful of a nonsexist environment. He was a student while I was and we 'lived' so many of the struggles which we studied. I believe he has grown as much as I through Women's Studies."

Postscript: "In November 1993 I accepted a great position with Detroit Diesel Corporation to be 'marine sales manager' for the East. I am very excited and credit my Women's Studies education for the courage to embark on this new course in my life."

Kaaren E. Boothroyd—Export Business Owner
Pitzer College—1986

Kaaren was born August 10, 1946, and grew up in suburban southern California. She described her family as "traditional—mother, father, one older brother, one younger brother and sister; mother at home; upper-middle class; parents divorced when I was 16 or 17 (we were all relieved)." Kaaren attended Pasadena City College from 1978 to 1982, before enrolling—at age 36—at Pitzer, where she had a second major in English. During and immediately after graduating from college, Kaaren had her own personal management business and did temp work. Since 1987 she and a partner have owned an export business.

Kaaren is married and the mother of a 23-year-old daughter and an 18-year-old son. She lives in Sierra Madre, California. "For the past five years, since taking over the export business begun by my father, my life's pattern has been dictated by this work. We are at a crucial point in making

this business survive — primarily due to the political/economic events in the former Soviet Union. In 1990 my partner and I moved our offices into our homes — communicate with one another often by fax and phone. Monday through Friday I wake early and check the telexes/faxes from Moscow. If there's nothing urgent, my husband and I get in a two-mile walk with our dog in the foothills surrounding our home. I am at my desk by 8 A.M.; sometimes my day starts earlier. Since I work with suppliers, freight forwarders, and customers in a variety of time zones, I often need to be available during their business hours. The structure of my day is dictated by me — I'm usually in my office until 5:30 or 6:30 P.M. Having an office at home is both a blessing and a curse. I get to see my family when they pop in between school or appointments; there's no aggravation of commuting on Los Angeles freeways; I have more control of the running of my home; it's easy to return to work at night to finish up. But it's more difficult to separate home and 'private' life. Also, more weekday domestic responsibilities fall on me since I am 'at home.'

"We have one of those typical post-1950s kitchens — large with dining table, small TV, phone — where it's easiest for everyone's paths to meet. So in the evening I usually prepare dinner while watching local and national news and having a drink with my husband. In the evening we usually read — mostly periodicals. While I sorely miss novels and poetry, I find the rhythm of my days no longer seems conducive to that luxurious appropriation of time — or perhaps I've not allowed it. For what I do allow myself is several hours on the weekend of uninterrupted manual labor in my garden. There's the practical aspect — the work needs to get done. But there are also other satisfactions: an artistic satisfaction, playing with colors and shapes (always vulnerable to the whim of nature). Also, after a week of totally cerebral work — researching, negotiating, pricing, scheduling, writing, calculating, translating, solving — I am aching to use my own brawn.

"Every couple of months all of this is thrown into upheaval — as I prepare for my next business trip to Moscow. Then the pace steadily picks up; longer work hours are kept; work becomes more intense. I'm usually in Moscow for one to two weeks at a time, where I have to make every moment count. When I return it takes a few days to 'come down,' then a couple more weeks to follow up on all that was accomplished, then my routine returns to some normalcy."

Kaaren enrolled at Pitzer as an English major. "Exposure to Women's Studies courses certainly must have piqued my curiosity at first. Also, many of the literature courses I was interested in were crossover courses. I was drawn to those courses and professors with a feminist perspective. It soon became obvious and natural that I should major in both English and Women's Studies; they seemed to complement one another perfectly."

How has her major affected Kaaren professionally? "First, I knew exactly what I *didn't* want to do in terms of a career when I graduated. Before my college education I knew there were certain aspects of work or certain workplace situations that I did not like or did not feel comfortable in. However, after college I understood the source of the discontent, the dynamics, the historical and psychological context. I understood where I was vulnerable to failure or dissatisfaction, and why. On the flip side, I had gained confidence. Not just the confidence of going to a good college, having good professors, and getting good grades. I had gained confidence that ideas with a distinctly female or feminist bias were valid. Just because they'd never been used (or even considered maybe) didn't make them wrong. This ability to venture into the unknown was of enormous help to me. For example, I remember writing a paper on Joseph Conrad's *Heart of Darkness*. I can't remember the thesis, but I remember my focus was on the women in the book. I didn't see them as incidental characters in an otherwise male story, but rather as significant symbols, embodying major themes. When you first mention to someone—even an English professor— that you're writing about the women in *Heart of Darkness*, you see the person pause to think, '*What* women?' It was a difficult paper to write, as I knew I was treading on complex new ground. The paper was not perfect, but was one of the most satisfying I ever wrote.

"When I took over my father's export business with my partner (a woman), we faced considerable obstacles, as any new owners might. We hoped our customers would transfer their trust from my father to us. However, (1) The customers were all in the Soviet Union where, despite the press, women have little status in the workplace and few enjoy any positions of authority. Up until Gorbachev's time, it is safe to say that women in business (on their side or ours) in the old Soviet Union were rare. In other words, two still-rather-young Western women would be eyed with skepticism. (2) The customers had no experience in negotiating with women. While Russian men in general are very 'old world' in observing the rules of social etiquette with women, they seemed sometimes flustered in dealing with us across a negotiating table. We were treading new ground. That there were no rules to this game did not bother me. In fact, I relished the fact that we could 'make it up' as we went. I felt such a freedom to call upon every skill and bit of knowledge in me—and not to tailor it to fit someone's expectations."

Kaaren explained that "the impact of Women's Studies on my personal life is profound, subtle, and complex. Keep in mind that when I entered college I was 36 years old, had been married to the same man since I was 19, and had two teenage children. My inclinations were feminist; my upbringing was traditional; my marriage had successfully evolved with the

times. However, with the deeper knowledge and understanding of women's place in the world, my feminist philosophy became more articulate, substantive, and adamant. It was irresistible to reexamine life—my life as well as the lives of others. I could almost hear my mind chugging away, assimilating this new information.

"The changes I can easily recognize, however, have to do with my level of self-confidence and the ability to pursue my objectives—whether it's expecting the president of a bank to treat me with the same level of attention as a seven-digit depositor or expecting a better sex life at home. In order to accomplish things, one cannot be constantly hampered by making excuses, consciously or not, founded or unfounded, as to why you should be denied. Let me say very quickly that I don't believe in bulldozing or rudeness to get things done; but women succumb to too many reasons to deny themselves too many things. And in large part it's due to their upbringing. Girls traditionally have been taught to defer, acquiesce, mind their manners; the alternative we've been told is aggressive, shrill, unattractive behavior. The same dichotomy does not seem to exist for men.

"When you trust your instincts and inclinations to pursue your goals and dreams, you are given a terrific freedom to function in the world. I think a comprehensive Women's Studies curriculum teaches you that though you may be living in a patriarchal society, it doesn't mean it's right and doesn't mean that your ideas, though subtly insidiously denigrated, are less valid. You also don't have to be angry and beat people over the head with your ideas. The results are liberating. It's like a child running out onto the playground, knowing she can choose to play on the slide or swing, join a game of baseball or jacks, or bring a book and sit under a tree—she has complete freedom to develop or use whatever skill she's inclined to use. Without this freedom, she walks onto the playground with doubt and uncertainty—and without joy.

"I also found that this feminist perspective found its way into conversations with my children about their lives—from college plans to career expectations to peer relationships to the casual use of sexist language. During some formidable years in their lives they were exposed to important information concerning the roles of men and women, past and future.

"I am changed in that I feel more engaged in the world. I feel complete and self-sufficient emotionally and intellectually, which gives me the freedom to 'let go' and 'play' in life's playground to the best of my abilities."

Theresa Bartolero—Flight Instructor
San Diego State University—1988

Terri was born June 22, 1965, the youngest of three children. Her father worked full time as an insurance salesman and her mother was a full-time

homemaker. Her two brothers had moved out of the house by the time she turned 14. While in college, Terri was an administrative assistant for an aviation firm and later staff assistant to the student activities coordinator at San Diego State University (SDSU). From July to December 1988, she worked as a customer service representative for an aviation service in San Diego. Since April 1989, she has been a certified flight instructor at Bearden Flight Training in San Diego. She has logged more than 2,000 hours of flight time and is a member of The Ninety-Nines, International Organization of Women Pilots. Terri lives in San Diego. Her typical week is work-focused: "I normally work five to six days a week (six to ten hours a day). I am self-employed and dependent upon the schedule of others. On a good day I am paid for 50% of the time I put in."

She considers herself a feminist. "The term feminism to me means strength and empowerment of women. It is celebrating our greatness, individuality, and diversity while also acknowledging that we are discriminated against and treated like a subspecies." She said Women's Studies "challenged me to think in a new way. I learned to think critically and question the status quo. The department was small and I was able to get to know the instructors, which is rare in a school of 35,000 students. I started out as most . . . taking a class for general education requirements. Then I took another and another until I had enough for a minor. I still didn't have a major, so I finally took the dive and accepted that I was a Women's Studies major.

"I am working toward getting a job as a pilot with a commercial airline. It is a necessity to have a degree. A technical degree in aviation or aerospace may be more beneficial, but the important thing is to have the diploma. Airlines want to see that you have the ability and study skills to make it through their rigorous training programs. I believe that with or without Women's Studies, I would be working toward a career in aviation, but I know that it has given me the strength and conviction to enter a male-dominated field. Before I decided I wanted a career in aviation, a boss of mine, who was a retired airline captain, told me that women could not be airline captains. He did not think we were capable of making the kinds of decisions needed to be made in a cockpit. This is such an archaic attitude, but unfortunately many in the industry feel that same way. Women's Studies has given me the confidence to face these attitudes and believe in who I am. I do not feel alone in the battle. So many others have faced far worse than I will ever face and have succeeded, as will I.

"When I first started flight instructing, I had many cases when men did not want to fly with me because I was a woman. Fortunately, I have a boss who told them that if they did not want to fly with me they did not have to fly at Bearden Flight Training at all. My reaction to men with this attitude was to be as professional as possible and do the best job I could. Some

would not listen, therefore would not learn; others realized that I was a good instructor despite the fact that I was a woman. Women's Studies has given me the self-confidence to question their ignorance, not my lack of qualifications. Now that I have been instructing for over two and a half years I know that I am a good instructor and that they are the ones missing out if they do not want to fly with me.

"Currently there are less than 2% women pilots in the major airlines. Every day people say to me, 'You won't have any problem getting a job because you're a woman and the airlines need women.' I have been looking for a job for over a year and have had only one interview, with a commuter airline. I made it through their screening process and am now waiting for a class date. I was not any less qualified for the job than anyone else being interviewed, but the sentiment of my peers is that I was chosen because I am a woman and not because I am qualified. It is the quota mentality. Businesses are required to hire a certain number of women and minorities, so people think that we are stealing the jobs from the poor white boys without being qualified. There are a lot of us out there and we *are* qualified.

"When I was choosing Women's Studies as my major, I knew that I needed a degree and I loved the subject. I wonder now if I will face discrimination because of the degree. Will I be labeled a 'radical feminist,' a dyke, someone who will make waves? I personally do not find any of the above offensive; unfortunately, most others do. I worry about people's reaction to the degree. They do not understand what it means, and I worry that they will plug in their biased stereotypes. If they think I could be a problem, they could sweep my resumé to the bottom of the stack. They do not have to do or say anything to me directly, and I will never know. It is a risk I am willing to take, and I put my degree proudly on all of my applications.

"My greatest reward for studying Women's Studies is that it has given credence to my convictions. It has given me a language/vocabulary to describe the many injustices I have felt as a woman. Before Women's Studies I knew that I didn't like the way I was treated; now I am able to define it. I was able to back up the many arguments I have found myself in with 'facts' such as court cases, studies, and statistics. I had an instructor teaching an American fiction course who stood in front of the class and said that there just weren't any good women writers in the era that we were studying. A few semesters later I took a 'Women's Writers' course and found many examples. Now I read almost exclusively women writers, and they keep me quite busy.

"I am no longer afraid to see and speak up about the injustices women face in this world. Here we are 50% of the population making *none* of the decisions about our future. We have no voice of authority within our

government, decisions about our environment, not to mention personal control of our bodies. We live in a frightening time. Women think we have all of the options in the world. We tell our daughters they can be anything they want to be without seeing the glass ceilings lingering over our heads. I cannot sit silently when people tell me that this is a 'women's world.'

"On a more personal level, Women's Studies helped me deal with problems in my life in a way that gave me strength and understanding of the problems of all women. I worked in an environment where I was being harassed, and I was able to put an end to it because my classes gave me the tools to defend myself. If it is within my power, I will not be victimized again. Even though I have a great deal of anger and frustration about the position of women in our society, I have graduated with a tremendous sense of awe, appreciation, and love for the many women who have gotten us as far as we are today. I cannot describe the vision of strength and empowerment I feel when I think of the word 'women.' The Women's Studies Department at SDSU gave me a history, told me that I am a valuable human being because I am a woman, not despite it."

Postscript: In August 1992, Terri became a line captain with Ameriflight in Burbank, California, "flying for the largest Part 135 cargo airline in the United States and meeting rigid schedule requirements within California." She since has transferred to the company's Oakland operation.

Jennifer Powers Ligeti — In Transition
Wellesley College — 1988

Jennifer was born October 18, 1966. She grew up in New London, Connecticut, "in a nuclear family in which my father worked outside the home and my mother was a homemaker — until I was 13. At 13, my parents separated, and when I was 15 they divorced. My mother began working outside the home at that time." Jennifer attended private nonsectarian elementary and high schools. After graduating from Wellesley, she worked for two years at a nonprofit alternative mental health center for women in Boston. She was involved with fund-raising and direct service / advocacy. During that time, Jennifer also taught ballroom dancing part time. She then worked a year at a traditional mental health center in Seattle, where she was a case manager for the chronically mentally ill. She currently lives in Boca Raton, Florida, with her husband and is looking for work.

Jennifer majored in Women's Studies "because my courses got me the most excited and interested about what I was learning. I had excellent professors and I felt that feminist scholars were doing some of the most interesting modern work. I viewed education as an end in itself, something

that would enrich my life and help develop my thought processes and communication skills. I was not overly concerned with what kind of work I would do after college, or with preparing for it.

"I have had a longstanding interest in working with people, either as a counselor or teacher. For a long time I wanted to work with children. Women's Studies helped narrow that focus somewhat in that I found myself wanting to either work directly with women or girls or be involved in a program geared toward helping women resolve some of the problems they face as a result of their gender. I received a stipend from the Women's Studies Department at Wellesley to work for an alternative mental health center for women and their children in Boston during the summer after my junior year. The program appealed to me because its philosophy viewed women's emotional distress as directly related to societal stress, such as poverty, violence against women including rape and incest, and the housing crisis. The Elizabeth Stone House (the center) also believed that women ought to be able to get support without breaking up their families, so they allow women to bring children into the program with them.

"I worked there as an advocate that summer and loved it. The other staff members were warm and funny, and I felt that I was part of a program that really made a difference in people's lives. After graduation the Stone House hired me full time and I worked as a family advocate, with both women and kids, and then as a resource developer. As a resource developer I learned many valuable skills, such as grant writing, direct-mail campaign planning, special event planning, etc. Had I wanted to stay in fund-raising I would have been well prepared. But as it happened, when I left the Stone House to move to Seattle with my husband I decided to get back into working directly with people. I applied for many human service jobs and took a job with a community mental health center. I worked with adults, both men and women, but I was assigned to more women, and especially women with children, because of my experience at the Stone House. While my employer did not have an overtly feminist philosophy, I found I could apply much of what I had learned at the Stone House to my work in Seattle. Currently, I would like to do some research for a Women's Studies professor. I feel that I will do many different things with my degree. Some day I may go back to school to become a nurse-midwife, a field I learned about in Women's Studies.

"My major has affected almost every part of my life because it has affected the way that I think. I feel I have a sense of pride in women and in myself because I am aware of the rich history of women around the world. I firmly support the right of women to make any and all choices that are right for them, and not to be blocked from any options, or scorned by anyone, male or female, for the choices they make. I value work that has

traditionally been done by women, especially the caring work of raising children and the 'helping' professions of nursing and teaching. I understand that those fields are low-paid in this country because women have worked in them, and women were not supposed to be principal breadwinners, their wages were only meant to supplement a man's income. I understand and believe that the way our society values activities, through money, leaves out much valuable work, traditionally 'women's work.' This is important to me personally because I am interested in doing work that is traditionally women's work, and I struggle not to fall into measuring what I do purely on a monetary basis.

"Women's Studies has made me more aware of the need to strive for equality within my marriage. And by this I do not mean that my husband and I must share every family duty, but just that I must feel comfortable with the balances that we create. Although I grew up in a very traditional home, and it is easy to slip into patterns that are familiar, we try to make new patterns of our own. That we feel like equals and have respect for each other—regardless of who makes more money—is crucial to me, and not always an easy thing to attain when money is the main societal measure of success.

"I also think that Women's Studies and Wellesley, being a women's college, have definitely affected the value that I place on my female friendships. Although I no longer live close to my friends, I work hard at keeping in touch and would some day like to live close to some of them again. I believe women need a support network and that female friends are the best possible support there is. Women's Studies also helped teach me the value and importance of political participation and of the phrase 'the personal is political.' I am a registered voter, a member of NOW, and I have worked as a volunteer for Planned Parenthood."

Postscript: "It's November 1993, and I have applied to a master's degree program in mental health counseling. I had a daughter in September 1992; I am a full-time mom and enjoying it very much. I believe this could easily be the most challenging job I ever have."

Amey Stone—Graduate Student in Journalism
Yale University—1988

Amey was born April 15, 1966. She grew up in Greenwich, Connecticut, "in a nuclear family with one sister. My mother is a teacher and my father a small-businessman. Although not rich, we lived a fairly affluent lifestyle." Amey attended a private nonsectarian elementary school and a private boarding high school. Since her graduation from Yale, she has been an English teacher in Paris (for six months) and a newspaper reporter (for

more than two years). In September 1991 she entered the Columbia University Graduate School of Journalism.

Amey "went to Yale with the idea in mind that I might major in Women's Studies. After taking a few courses my first year, I realized the coursework I hoped to do would fit best with a major in Women's Studies. I also realized my freshman year that I would stand a much better chance of getting into the courses I wanted to take as a major. But perhaps the main reason I chose my major was because I wanted to be part of a small department where I could get to know the faculty and my contribution would be recognized."

She believes that "majoring in Women's Studies has been a boost to my career as a journalist. Not only has it helped me to get hired, but the sensitivity I gained to issues of gender, race, class, and sexual preference has served me well as a reporter. The editors who hired me all seemed interested and impressed by my choice of a major. I think having Women's Studies on my resumé has shown that I am interested in current issues and enjoy conducting original research from a fresh perspective. In job interviews and on my resumé, Women's Studies has helped set me apart from other journalism majors and liberal arts graduates. But, far more importantly, I think my major has given me skills that have allowed me to understand and appreciate the lives of the people living in the communities I've covered. I see colleagues flounder occasionally when writing about issues relating to class, race, gender, and homosexuality. As a major, I have studied these complex and sensitive issues and am comfortable writing about them. By majoring, I gained a social and historical perspective that I find many people I work with lack.

"It is difficult for me to analyze all the ways Women's Studies affected me personally. I think feminism and the study of it have been central in helping me make all kinds of choices about my life. Most of all, I would say it has given me confidence and pride in what women have accomplished, and in turn, what I can accomplish. I can remember in high school beginning to question the value of women's achievements in the world. But when I took a history course with a feminist teacher, I learned that the problem is not that women have not achieved, but that their achievements have been devalued or ignored. Learning to question the dominant perspective has been valuable personally and professionally.

"Rather than feeling a sense of frustration and confusion when facing gender-based stumbling blocks, I've learned to see sexism for what it is. Rather than becoming angry and bitter when confronted with it, I understand the bias and can better fight or avoid it. The major has given me an awareness of the way gender gets played out between individuals. This understanding has been important for improving my relationships at work,

with family, and with friends. I also thank feminism and Women's Studies for giving me a political motivation that has helped add meaning to the daily grind. The now-familiar concept of 'the personal is political' is the way Women's Studies taught me to live. The idea that I am making choices not just for myself but for all those affected by my decisions, has given me courage, strength, and pride."

Postscript: Amey received her M.S. degree in journalism in May 1992 and is a personal-finance reporter for *Business Week* magazine.

Valata Dakota Green Fletcher — Writer
University of Minnesota — 1989

Valata was born July 28, 1921. "My father was a tenant farmer until I was about 16. My mother had ten children [Valata was the sixth]. Due to the religion [Church of Christ] and culture of that region [DeKalb County, Tennessee], 'Papa' was head of the family. Mama complained. I vowed to take action." In the chapters of her autobiography that won a Hartung Prize for undergraduate writing in Women's Studies at the University of Minnesota (UM) in 1988, Valata wrote: "Mama's children came so fast that by the time one of us was between two and two and a half, he or she would be pushed away from mama's care by the newest baby. I cannot remember my mother cuddling or holding me. From my earliest recollection mama was a *voice*. She would be there supervising all the household. . . . For many years she seldom left the house, except to go to church with my father."

Valata dropped out of school after the eighth grade. Until the age of 18, when finally she could afford a pair of glasses, she was legally blind. "I felt I could not continue the fight for a public education without eyeglasses, food for lunch, textbooks, and other school materials that were necessary, and at least enough changes of clothing that I might keep clean," she wrote in her autobiography. She added that when she did not go to high school, "nothing was said by my parents." Her desire for schooling was clear, however. "I helped mama around the house, but was careful to stay out of sight when the school bus came by our house. It hurt too much to know that I should and would be on that bus, but my endurance had given out."

It was not until her own children were grown and her husband was near retirement that Valata made her way back to school. "I had scanned the children's college textbooks and had found nothing in them that I believed I couldn't grasp with a little thought and time." She met with a student counselor at UM and began the 10-year journey she calls "Valata's Adventures and Frustrations in Seeking a Higher Education!" Her first class was "The Law in Society," which she chose because she was about to help

settle her father's estate. She earned a C in that class—there is only one other on her transcript. "My blind eye occasionally flares up and is very painful. During this class two doctors suggested I have the eye taken out—so I felt lucky to have made a 'C' grade. Otherwise, no excuses!" Valata received an associate's degree in 1985 and four years later was awarded her bachelor of arts degree with a second major in English. She graduated with a 3.68 grade-point average.

Valata and her husband, John, have been married for 49 years and are the parents of three adult children; they live in St. Paul, Minnesota. Valata identifies herself as a feminist because "I am well aware of the discrimination against women. I am working for change." A proud grandmother, she said of her young grandchildren, "They are four more reasons for wanting to make changes." Since earning her degree, Valata spends her time with "my own study, research, and writing." About majoring in Women's Studies, she said: "I was 58 years when I enrolled. I had lived all those years under patriarchy. I had witnessed my mother, sisters, and all women suffer under this rule. I had felt trapped for years and years; every way I turned I found this bias against women; the religion, the public I had to deal with in everyday affairs did not give me an option. Especially I found the textbooks biased about women and our lives. Women's Studies was and is my lifeline. I felt I was really coming alive at last. For the first time in my life, I had women to study with and about. I began to breathe and *think* more clearly."

Asked about Women's Studies' effects on her professionally, Valata responded: "I'm not sure I fit in this class. I have not published, but I am working on my life story. Telling my 70-year story will cover many subjects. Women's Studies has helped give me courage to speak out about my life. Women in the program encouraged me in my studies and were first to comment on my writing. It was women professors who added notes of praise about my writing in required papers who finally made me believe in myself. I knew the message I wanted to write, but I was not sure others would be interested. Most male professors did not seem interested in a strong woman's view of life or values, especially an elderly woman. I found this an advantage. In the traditional classes I used my Women's Studies knowledge to challenge the status quo. This made university very exciting and at times difficult.

"I find my major has been very helpful in encouraging other women to attend university. Several women have told me that I have been their inspiration for continuing their education. This and the fact that I am now making time for myself to write my story make earning a major in Women's Studies worthwhile. I have been invited to write an article for a feminist quarterly, *Hurricane Alice*. I have taken part in a study by a psychologist. I used this as a chance to try to change the narrow view of the male psycholo-

gist—and the society. Women's Studies has encouraged me to write letters when I see injustices in the law, news media, or education."

Personally, Valata explained, "My major has affected my relationship with my husband, children, extended family, and friends. My words carry more weight now. Before, my husband had twice the formal education. This gave him more power in the family. The children seemed to be influenced by this difference. Then there was the economic difference. He worked for wages. I worked in the home. Children become aware early who holds the economic power. Maybe I was oversensitive back then, when the children were small and I had less education. Being older, wiser, and with a degree in Women's Studies, I stand firm on my values and worth. And I am very angry at the unequal life I have had to live. I have worked hard to change my position. I plan to spend the rest of my life trying to make a difference for other women.

"I have two friends who avow that I saved their lives. I understood their terrible living conditions. This was *before* I earned my degree. Now I want to help prevent the condition in this society that kills women both physically and mentally. I think my major has made me more aware of the terrible crime the traditional education system uses to control people's minds. Both of these women were under such stress they developed nervous breakdowns. Only through women studying women can we change society."

Would Valata major again? "Yes, yes, yes. I had lived 58 years under the patriarchy. I had challenged my father's religion—after I was out of his house. I resented the opinions of male authors on women. I found it difficult to find women authors, artists, or good movies. I found it hard to even find women to *talk* about these issues. I resented the power given my husband just because he was male. Plus the biased educational and economic advantage. Women's Studies gave me a fuller life. It was fresh air. I found women far ahead of me in thinking I could learn from them. I found good women authors and women's art. I found sisterhood."

Postscript: In June 1993, at the annual Spring Celebration of the Women's Studies Department at the University of Minnesota, Valata was on hand to present Valata Fletcher Writing Awards—an award she had endowed—to two women students who, like herself, returned to complete their education after years away from school.

MaryEllen Ullrich—Secretary
The Ohio State University—1989

MaryEllen was born January 28, 1952, and grew up in Columbus, Ohio, with her parents and three older sisters. "My parents agreed on child-raising methods typical of the 1940s and 1950s. These were basically caring and

nuturing, but I've had to unlearn some beliefs about self-honesty and communication on all levels in relationships. We went to church every Sunday. I played 'girls' games and had 'girls' toys." Her father was employed outside the home; her mother was not.

MaryEllen attended Ohio State University (OSU) for two years after graduating from high school, then returned in 1987. In the intervening years she worked at secretarial or waitressing jobs. "I graduated from OSU at age 37 and was immediately hired full time by a United Way agency working with women in prison, but the funding was for one year only. I then took a full-time, $6-an-hour job at the YWCA in a program housing homeless and/or mental illness victims (women). Four months there was more than enough time to realize I did not feel comfortable with that particular work. I gave up looking for work with people/women for the time being and took a secretarial job in the patriarchal, capitalistic, corporate world! I feel a little guilty about that." MaryEllen is engaged to be married; she lives in Columbus. She is a member of 12-step Adult Children of Alcoholics support groups and a women's support group for relationship addiction.

MaryEllen said she began attending Al-Anon because she was married to an alcoholic. "The program led me through a process which included wanting to get a B.A. I became more self-aware and centered. My issue was growing up, basically, and becoming responsible for my own happiness. The adviser I had at OSU between 1972 and 1984 (when I took an occasional class) was also the adviser for Women's Studies. She suggested I take the introductory class. I tried it, it was comfortable, and it held my interest. Women's Studies classes slapped me around a little and pushed me on my journey toward myself and reality. I did well in the courses and loved the teachers and the other majors.

"I thought my major prepared me for a career in social work or a 'people' profession. But instead of making me more tolerant, I found I was more angry at the situations so many women are in, and the helplessness and hopelessness at their possibility of finding serenity. I found that sharing about these issues at support-group meetings was a safe way to express myself and be of help. I learned to sort through my talents and interests and put them to use appropriately. As a result, I decided that a nonpressure, volunteer status for caring about people and wanting to teach what I had learned was best for the time being. Because I also like visual and task-oriented work, I realize that being in a business office provides a type of stress and performance I'm comfortable with and used to. Women's Studies taught me who I was in the scheme of things . . . where I fit in, what's acceptable to me.

"Wherever I work I draw on those experiences I had in Women's Stud-

ies classes and don't put up with unequal treatment. I voice my comfort level with certain tasks and ask for compromises. I correct verbal and written inequities or oversights, such as changing 'salesmen' to 'sales reps' (after all, we do have a female rep!). When a 'blond joke' was told I cracked on the teller because he was blond! A different perspective . . . ! I do eventually want to have a job that uses my potential and pushes me further.

"All the Women's Studies classes gave me support and courage to expect more from myself and teach people how to treat me. I wouldn't trade the liberal arts degree in Women's Studies for anything. It was a personal-growth experience. Just reading the homework assignments made me a more interesting person. I had opinions and an occasional fact to add to conversations. In fact, it gave me a personality, really. I was pretty wishy-washy about everything. Now I pay attention to the news and follow stories about anything from homelessness to abortion rights. I stand firm behind what I like and want for myself, setting boundaries and feeling important and worthwhile enough to deserve what I want.

"I fell in love with a man who is struggling along on his own personal journey. We met during the early stages of my journey, and he sees a big difference in me now. We are more intimate than ever because of these changes. By learning to be more of myself for *me*, I became more attractive to a mate, which was a big goal in my life. My friendships with women are more intimate, too. Of course, these are women I met mostly at 12-step meetings and support groups. I prefer to be in relationships with people who want to work on themselves as well."

In summary, "Women's Studies was an awakening, a support, an encourager. It was part—a major part—of my journey toward integration of animus and anima. I see Women's Studies as validation for being human. If I had 'it' to do again—knowing at least half of what I know now—I would have developed my right-brain artist/creative self. I'm not sure about doing Women's Studies again. It was a tool to help me achieve wholeness enough to continue with life. It was a personal achievement—not academic or professional. I tried out a major in photography but found Women's Studies more rewarding, fulfilling, interesting, important—and less expensive and time consuming!!! Maybe I should have had two majors, one career-oriented, and Women's Studies for balance."

Postscript: "I got married in June 1993. The secretarial job is ending, and I've accepted an evening job teaching typing at the same women's correctional facility where I first worked after graduation. And it looks like it will expand to teaching daytime classes for general office skills. I am opening myself to the universe and discovering more and more ways to help make changes for the betterment of women and the earth."

Katharine Rossi—Part-Time Store Clerk
University of Rhode Island—1990

Katharine was born August 17, 1967, and grew up in the small town of Bristol, Rhode Island. "I lived with mother, father, and sister until I was 13. Then my parents divorced. I lived with my mom and sister. My mother worked full time and went to college three or four nights a week." Katharine attended the University of Maine at Orono for two years before transferring to the University of Rhode Island (URI) in 1987. After graduation, "I worked at the Newport County Women's Resource Center for one year as a data-entry person in the legal department. I did data-entry and office work for a medical office for a few months. Then I was unemployed for two months, and now I work in a supermarket deli." Katharine is separated from her husband and now lives in Orono. She has a three-year-old son.

She described her mother as "a liberal feminist" and considers herself a feminist because "I believe that we live in a patriarchal society in which many groups are oppressed. I see feminism as a means of exposing the roots of oppression in patriarchy and as a means of eradicating the oppression of all groups/people." Katharine said she became a Women's Studies major "almost by accident. I was at the University of Maine and had taken a sociology class titled 'Sex and Gender.' It was really Women's Studies in disguise. I have never seen the world the same way since then. This class opened my eyes to a whole new world, the real world. I guess you could call it the 'click experience' that white women have. At the same time I was looking to go to school in Rhode Island. I saw Women's Studies as a possible major, and without really knowing what it was, I transferred to URI to major in it. It was the best decision I've ever made!"

As a result of her major, Katharine said, "I find that I am more critical and analytical of things around me. I detect sexism, racism, ageism, heterosexism, and all the other -isms in the media, libraries, stores, people, etc. I am more aware of connectedness of events in the world and how they relate to patriarchy. Sometimes this is difficult for me and I think ignorance is bliss. However, I am not ignorant and feel that I must do something to help change things and overturn the patriarchy. So I do what I can, mostly by volunteering. I also realized that I want to make others aware, too. Some day I hope to do that through teaching and social activism."

Postscript: Katharine has completed the coursework for her master of science degree in Women's Studies at Mankato State University in Minnesota. She followed that with an internship in the summer of 1993 at the Mabel Wadsworth Women's Health Center in Bangor, Maine. "It is a feminist health center funded by private donations; hence, freedom to do what they want but not money to do it." For her thesis, Katharine said she

intends "to examine the prevalence of battering/batterers within the lives of people involved in the animal rights movement."

Alisa A. Clemmons — Theater Worker
Yale University — 1991

Alisa was born November 3, 1969, in the southern Illinois town of Harrisburg. "A midwestern family with southern roots, we placed a great value on land. We were wealthy for the small town we lived in. I had a brother seven years older and a sister four years older. We were all pushed to be intellectuals. My mother is a high school teacher and my father works at the lumberyard my grandfather owns." After graduation, Alisa worked in a one-hour photo lab in New Haven, Connecticut, for a few months before moving to New York City. There she has done temp work and has been assistant director on two theater projects.

Alisa originally was a Theater Studies major, "but I found that I was taking more and more Women's Studies courses. When I finally took the introductory lecture course (after having been in many smaller seminars in women's history, women writers, etc.), I realized that I could learn much more about society, and therefore create better theater, if I studied many subjects under one particular heading. Being a Women's Studies major allowed me to take the anthropology, history, literature, sociology, and other high-level seminars; and it forced me to develop the skills to focus these various schools of thought into my view of performance. I was able to learn so much more in my four years at college than I would have had I focused on one field of study. I also appreciated the fact that the department required students to participate in its creation. I learned more about Yale as an institution than any other student I knew."

Alisa said that because she is a recent graduate, she cannot say yet how Women's Studies has affected her professionally, "but I do know of a few examples. My 'professional' life consists of working with friends or working for free in theater. But the plays I work on, although not all are political pieces — all deal with women in the forefront. My major has given me the ability to look at each play from many different viewpoints and then attempt to pull all of these viewpoints together to form a fully realized, 3-D play. To be more specific, let me give an example. I am currently working with a friend who has written a play about Valerie Solanas, the founder of SCUM (the Society for Cutting Up Men) and the woman who shot Andy Warhol. Most of the feminist bookstores my friend went to looking for the SCUM manifesto shunned her and told her that they did not carry the document. It seems that feminists as well as right-wingers are scared of Valerie Solanas and the ugly, violent side of feminist politics.

"My education taught me to never disregard any side of an issue. If Valerie Solanas existed—I want to learn what happened. What I learned in Women's Studies is how to look at every side—to look at every political fight—to look at all forms of struggle and see how to win. I'll never forget the course I took called 'Forms of Resistance.' Our goal was to study many different forms of resistance and figure out which one or ones work best and how to incorporate them into our daily struggles. I know this sounds like my 'personal' essay, but my studies taught me that my professional struggle, as a lesbian, will always be my personal struggle as well. My work in theater is part of my personal politics and the two cannot be separated."

About majoring again, Alisa commented: "Yes. I only wish I had taken more Women's Studies courses. I only wish more courses were offered. I only wish there were tenured Women's Studies professors. I only wish the university acknowledged the department with more than a slight acceptance. I only wish the classes could be more diversified—more men (straight and gay), more people of color in the courses not dealing with specific racial issues. More whites in the African-American, Asian-American, other race-specific courses. We must all work as bridges into each other's communities. And as a man once said to me, 'A bridge must expect to be walked on by both sides.' Let's try to listen to one another and work together. This is what Women's Studies taught me. No other major I know of could/ would have done that."

Keiko Koizumi—Baker
University of Connecticut—1991

Keiko was born July 20, 1968, the younger of two daughters. "Due to my father's career, we moved every three to four years between Japan and Connecticut. I lived with my parents until I was 18, at which time they moved back to Japan." Keiko's mother was a self-employed stained-glass artist. In college, Keiko worked for a florist as a retail consultant and floral assistant, a job she continued after graduation. In mid-1992, she began as a hotline worker with Hartford Sexual Assault Crisis Service. She was interim hotline coordinator for a month and was scheduled to become coordinator. She lives in Hartford and works as a baker for the Reader's Feast Bookstore and Café.

"I rarely have the time or the energy for social recreational activities (not even for reading a novel!), although I do take walks. I *have* been trying to give myself a few hours a week for rejuvenation. With my new job, I will have much more free time, which I hope to moderately fill with volunteer work. I have also been offered the opportunity to collaborate with a UConn graduate student in clinical psychology to co-author a research project on

lesbian, gay, and bisexual individuals. I have also been invited to collaborate on a performance piece on sexual violence, which I am very excited about. So generally my time is filled up with feminist activities." Keiko also is active in The Furies—Women Against Violence Against Women.

She explained her choice of major this way: "I was a philosophy major who never quite 'got it'—'it' being the philosophers (white male) and the philosophical inquiries which were chosen to be important. I took a course in feminist theory (special topics in philosophy) which was very psychoanalytic in focus, but I was stirred inside. After the course was over, I wanted more. I was amazed to find that I could actually study and explore topics and feelings that were real and crucial to my being—that education could reach my spirit. Philosophy, as presented to me, was so remote that it took excruciating effort to care enough to think about. I majored in Women's Studies because I was moved.

"My professional aspirations have come directly from my experience as a Women's Studies major. While in college, I was convinced that I would be going to graduate school for an M.A. in Women's Studies. For a while I did not see an alternative because all of my role models were graduate students and professors. As I collected information on graduate programs, I began to realize that I'm not ready. I am thirsty for real data. I want hands-on experience. Theory and analysis have been extremely beneficial and formative, but I felt and feel the need to do front-line work—to 'meet my constituents.' So I've put graduate school on hold, gotten training as a court advocate for domestic-violence survivors, and as a crisis intervention worker for sexual violence survivors. Through these front-line experiences, I'm hoping to gain insight on what further research needs to be done (for deep down in my heart is a desire to do research). What, how, why—research has to be useful. I want to be able to do research which will play a part in the movement to end violence against women. The Women's Studies program has offered me valuable tools through courses such as 'Public Policy and Feminist Research Methodology,' 'Women and Poverty,' 'Women and Violence,' and the internship program 'Women's Semester.' I would also like to commend them for their pioneering role in promoting Asian-American Studies by offering 'Asian-American Women—Changing Roles in Changing Society' as a permanent course.

"I am a feminist. At one point I lived, ate, and breathed feminism. I'm getting better at taking breaks, to let go of the struggle. Being employed as a professional feminist helps because it has gotten easier to separate myself from feminism in my private time. The reason I became a Women's Studies major was because the courses affected me personally. The types of questions which were being explored in the classroom were the same ones I could (and would) ask of myself. Issues of violence, sexuality, racism—

these are my own personal issues. Here was a degree which would allow me to explore and grow, to enrich my own life while moving toward enriching other people's lives. What more could a feminist activist ask for?

"The Women's Studies program has transformed my self-perception and has helped me gain self-confidence. There was a tremendous amount of support from the faculty members both professionally and personally. I was encouraged a number of times to submit research papers for conferences and/or awards. There was a particular faculty member who supported me through a crisis as I researched serial sex murderers. (The crisis was due to the enormous difficulty of the subject, which caused fear and anxiety in me.) I believe that in a large university setting, these types of personal attention are rare. But I would bet that in Women's Studies programs this 'rarity' is commonplace. For we all need each other. Everybody's future is at stake. Women, in this case the students, must succeed (succeed in this case would mean contributing to ending women's oppression), and that is why we must continue to be supportive of our sisters in all of the ways that we can."

Postscript: "I have been quite busy as hotline coordinator as well as keeping my job at the florist and at the Reader's Feast. I am organizing 'Women of Color Together for Change—A Connecticut Women of Color Coalition,' a networking forum for professional/activist women. I've also been working with the Task Force on Hartford Gay, Lesbian, and Bisexual Youth on anti-harassment in the schools. I plan to get a graduate degree in applied sociology (doing feminist research on sexual violence)."

Deborah Anne McGarvey—In Transition
The College of Wooster—1991

Debbie was born May 31, 1969, and grew up in New Haven, Connecticut, and Needham, Massachusetts. "I lived in a single-parent family that consisted of my mother and myself since I was 13 months old. My father was basically out of the picture for the majority of my life." While at Wooster, Debbie was a member of the Women's Studies Curriculum Committee, a student assistant for the Women's Studies Program, and co-director of the Women's Resource Center. An honors graduate, her senior thesis was "The Women's Resource Center: Organizing for Education, Organizing for Change." Since graduation, Debbie has been looking for a full-time job. She recently moved to Seattle, "where I am seeking a job in a nonprofit organization (preferably a women's organization). My focus is more in the role of an educator/program developer rather than a counselor. For my job search, I am networking as much as possible. I have been attending informational

interviews. I have also been going to lectures relating to a variety of women's issues."

Debbie, who is single, explained that "at this point in my life I do not have a 'typical week.' I have just moved to a duplex house, which I share with two women and one man. I moved here with a friend, and she is one of the women that lives on my floor. We have been friends since the age of 14. My mother and I are very close; since this is a transitional time in my life, we talk on the phone every day or every other day for an hour. I have signed up for an adult education course, 'Women and Literature.' I have also started volunteering at Planned Parenthood, working in the bookstore and helping with the monthly newsletter. I have also signed up to volunteer through an organization called The Benefit Gang, an organization geared toward 21- to 30-year-olds who are interested in volunteering at nonprofit organizations."

Debbie explained that "when I first came to college, I had never even heard of Women's Studies. I have always been interested in feminism and women's issues, however, and I was interested in taking a course on such topics. My first course was 'Women, the Novel, and Cultural Change.' From the moment I started, I became enthralled with Women's Studies. I really enjoyed the class discussions and the progression of learning that I experienced from class to class. I found the level of writing and the critical thinking in these classes a plus.

"Since graduation I have found it important to have a strong feminist community in a variety of areas of my life. I thrive on critical thinking and analyzing with other people who also find this fulfilling. Especially during the Thomas–Hill hearings, I needed people to discuss my frustration with and people who were interested in taking action surrounding issues of sexual harassment.

"During my job-search process, I have been encouraged to change the objective that I created for my resumé. I stated that 'I want to work for social change by raising people's consciousness concerning issues of racism, sexism, homophobia, etc., through educational means.' A woman who works at the local YWCA career service, as well as the director of women's programs at a local community college, suggested that I delete this statement because words like sexism, racism, and homophobia should not be mentioned on a resume. She also said I may be perceived as a troublemaker by some employers, and then I would not get certain jobs. I have little experience in the 'professional' world as yet, so I can only discuss my sense of isolation at this point in my job search. Because I am accustomed to having a community of women and men committed to working for feminist change in society, I am hoping to find a job in which I can immerse myself

with other people who are advocating such changes. I do not see a separation in my 'professional' and 'personal' goals. I want all aspects of my life to incorporate my continuing questioning, processing, and action working for change in the world in which I live. Women's Studies was not just a college major, but a whole way of thinking and living that I have incorporated into my life after college."

In her personal life, Debbie said, she finds that "I am quite sensitive to issues of sexism, heterosexism, and racism through discussions with housemates as well as images through the media and in literature. I am often frustrated by the blatant recurrence of discriminatory comments and images that I see every day. For example, my housemate is applying to medical school. She had to visit the schools and interview there. At one, the administrator she talked with congratulated her on her application and told her how excited he was to meet her. Then he said, 'Besides you are damned good looking.' Whenever I hear about experiences like this on either a personal, local, national, or global level I become frustrated and I want to do something to stop these comments and actions on the part of people with privilege. I think Women's Studies has affected me so strongly that I will never be able to look at the world in the same way, and I am grateful that this is the case.

"I have also learned the importance of being an active learner and participant. The necessity of speaking out in a way that is comfortable and promotes discussion is an important skill that I am just beginning to gain. Through Women's Studies, I have learned a great deal about researching and the importance of placing myself as a researcher. I am much more aware of the existence of hierarchy, power, and privilege, which often evoke certain assumptions that ignore major segments of human experiences in research. After participating in my own research project during senior year, I had the opportunity to create a research process that attempted to recognize diversity and difference and promoted feminist change."

Lannette Washington — Film-Casting Assistant
University of California at Los Angeles — 1991

Lannette was born March 21, 1967. She grew up in "a military family [her father was in the Air Force for 20 years] with both parents and two siblings." They lived in Texas and in Merced and Tulare, California. While Lannette was growing up, her mother worked outside the home part time and attended college, then was employed full time; in 1992 she ran successfully for the Tulare City Council and, according to Lannette, "she enjoys

the challenge of bringing change to a small town in which the 'old boys' network is very powerful."

Lannette studied at the University of California at Irvine (UCI) from 1985 to 1988 before transferring to UCLA, where she minored in film theory. She has been employed with the Hollywood Pictures division of Walt Disney Studios as a casting assistant since graduating. "This is the only job I interviewed for and was interested in. I was confident I would get the job because I network." By early 1993, Lannette had "decided that I want to leave the entertainment business, but I find myself frustrated in choosing a new career. After doing some research and talking to different women, I find myself interested in a job that I can earn a decent living with, and therefore will most likely pursue financial real estate. If I had the financial means available, I would start a company that helps women wean themselves off public assistance by going to school or becoming skilled in nontraditional work."

Lannette, who is single, lives in Los Angeles. Her role models are "women who make it in male-dominant fields." She considers herself a feminist because "as a black woman I believe I have no choice because I couldn't choose my race or gender." Lannette started UCI as a biology major, then became a film major. "I was one-half year short of fulfilling the degree when I knew I needed more from my college education. I chose Women's Studies because I couldn't learn about this very important field of study from a textbook. Most majors offered by universities you could learn and master for the most part by reading a text. Women's Studies is an experience of sharing and learning from *all* females about life, culture, sexuality, sexism, racism, your health, your existence. This major is also not 'traditional'—meaning developed by white males. This is a global tool of education."

Professionally, "I have to be honest and say my major has had a negative effect on future jobs in fields like investment banking. I recently decided that I would like to apply for jobs that are more business-oriented (corporate America) rather than creative. Employers have said that they are looking for someone with a major that directly affects the demands of the job. Others have said that to make it in the business world they need candidates with majors that are not so liberal. I send out two different resumés: one says major—Women's Studies, one says major—Life Science. The Life Science major gets better responses. However, I worked full time supporting myself through school, so my work experience is what I have been told draws the most attention to me. I believe that employers use any excuse to pay women less money, and having a liberal arts major is one of the excuses I've heard."

Lannette observed that "Women's Studies has given me all the tools I need to improve my self-esteem. Two years ago I was involved in a sexual harassment case at an investment bank. At the time this was happening, I was taking a course called 'Sexual Harassment in the Work Place.' The knowledge that I gathered from the course enabled me to stand up for myself and not fear job security. Women's Studies has also made me aware of the struggles of *all* women. Women have come together on so many issues but, unfortunately, we are still far apart.

"As an African-American woman, Women's Studies has shown me the parallels between how women and Afro-Americans have suffered and overcome stereotypes. An Afro-American does not choose to be so, just as a woman does not choose to be a woman. She just is. If you went back and looked at events in history, you can easily exchange the word 'sexism' with 'racism.' Minority women, including Jewish women, experience this notion on a first-hand basis. We have to remember that history repeats itself. No matter how hard we work to make situations better for women—we have a determined team of people (unfortunately including women) following behind us destroying everything we have accomplished."

Postscript: "I passed the California Real Estate Exam and will be issued a license to practice in California. I also started my own company, Constructive Resources and Development, to incorporate three small businesses. It has actually begun to make a profit. I manage an eight-year-old actor who has guest-starred on 'In Living Color' and shot a national commercial for General Mills. I also have transferred within the Disney Company to the Disney Stores division, where I work with the new business development team. My current boss is a male who hired me (as did my first—a woman) knowing that I majored in Women's Studies."

"Sara"—Yeshiva Student
University of California at Santa Cruz—1992

Sara was born April 6, 1970, and grew up in the San Fernando Valley near Los Angeles. "I fit into American statistics of an ideal family—mom and dad with '2.5 children'—though I must have been the point five as the youngest of three." Sara's father was employed outside the home; her mother was "sometimes—she also went to school and *studied*." While at the University of California at Santa Cruz, Sara worked in a psychiatric institute for a year and as a student coordinator in Hillel. After graduation, she went to Israel to study at the Institute for Torah Studies, a women's yeshiva. Although she does not "belong to specific groups" now, as a student Sara was a member of NOW, the Feminist Majority, Santa Cruz Hillel, United Jewish Appeal, Democratic party, Religious Abortion Rights Coali-

tion, and Campus Sanctuary (for Salvadoran refugee rights). Sara is in "a four-year relationship with a male—soon to be married."

When she was in high school, Sara said, "one of my teachers showed us a misogynistic article. Completely unaware of feminist issues, I laughed. I thought it was amusing—not degrading. When I met my boyfriend, he had just taken 'Intro to Feminism' and kept pointing things out which he thought were sexist. I thought he was overreacting. Finally, I took a class on women's self-defense. That class helped me to realize that as a woman I was unable to say no. Due to that realization, I began to become more and more aware of the sexism around me. With the encouragement of my boyfriend, I decided to take 'Intro to Feminism.' At that point I didn't have a major, but I knew what I wanted to be (a rabbi). I was interested in Women's Studies and felt that it was an appropriate major for my future plans.

"Women's Studies helped me keep my dream of being a rabbi alive. When I started studying at the yeshiva, I began to question my decision. There are a lot of Jewish laws about being a rabbi, and most of the people I was around did not believe in women becoming rabbis. With my major, I hope to serve as a rabbi on a university campus (preferably a women's school) or in a battered women's shelter. Because of my major, I think I will help women who have turned away from Judaism because they believe it is inherently sexist get back in touch with their Jewish identity and break stereotypes. Finally, Women's Studies will help me in my graduate work. My major helped me to analyze and think—skills essential in studying Torah and other Jewish texts. I taught a class for my senior thesis on 'Jewish Women's History,' which was the most rewarding thing I have ever accomplished."

Sara said her major also has "made my life challenging. I mean that in a positive way. Since beginning the major, I have learned to question every-thing. That can make life difficult—it is so much easier to just accept. Women's Studies has made my life so much richer. I find beauty and strength in being a woman. I have developed a strong bond with other women. I found meaning in women's groups and, most important, I have gained confidence and have been able to help other women feel more confi-dent. Before majoring in Women's Studies, I often felt depressed and sui-cidal. Learning that many of those feelings came because of ways I've been conditioned has helped me to channel the negative energy into positive change.

"It has also helped me to value Judaism more. Though much of the major has a negative view toward 'organized religion,' I find that the more I learn about Judaism, and the more I integrate the values and ideas learned in Women's Studies, the more I am able to see how I can be a strong woman

and a dedicated Jew. Finally, the major has helped me to be a leader. Though I was a 'leader' before, I became focused once I was a Women's Studies major. I led Jewish women prayer services and a Jewish women's lecture series."

Postscript: Sara was to be married in August 1993 and planned to start rabbinical school in Philadelphia.

Also responding to our questionnaire were: "Helen," a newspaper reporter in Raleigh, North Carolina, and a 1981 graduate of the University of Massachusetts at Amherst; Christine Bergeron, a store manager in Orlando, Florida, and a 1989 graduate of the University of Rhode Island; Roxie Beyle, a newspaper agency employee in Salt Lake City, Utah, and a 1989 graduate of the University of Utah; "Susan Anthony," a homemaker and a 1989 graduate of the University of California at Los Angeles; Roberta R. Gammons, an insurance company correspondent in Providence, Rhode Island, and a 1990 graduate of Rhode Island College; Lisa V. P. Hall, in transition in Coventry, Connecticut, and a 1991 graduate of the University of Connecticut; and Alyssa Cymene Howe, a self-employed distributor and 1992 graduate of the University of California at Berkeley.

4

HEALTH, SOCIAL, AND HUMAN SERVICES

When we categorized the occupations of our 89 graduates, one-fourth fell into areas that also might be called "helping professions." Although such jobs often have been stereotyped as women's work, you might be surprised at the range of occupations these Women's Studies majors have chosen. And while many of the graduates also pursued or are pursuing advanced degrees in specialized fields, as a result of Women's Studies all appear to have decided, as Dayna Bennett put it, "to incorporate my feminist beliefs with my work and to try to make a difference in the world."

"Ruth"—Psychotherapist
Mount Holyoke College—1978

Ruth was born in July 1956 and grew up in Washington, D.C., and Bethesda, Maryland. Until she was 8, she lived with her mother (a painter and commercial artist) and father (an attorney): "They had an unhappy, quarrelsome marriage." Her parents divorced, and she spent the next six years living with her mother and maternal grandmother and visiting her father every other weekend. After her mother remarried, Ruth lived for two years with them and two stepsisters ("with whom I am close"). She then lived a year with her father; since age 17, she has lived on her own. After graduating from Mount Holyoke with honors, Ruth enrolled at Northeastern University School of Law. She earned her J.D. degree in 1981, and until 1986 she was an associate in a general-practice law firm in Northampton, Massachusetts. From 1986 to 1989 she was a part-time law instructor at the University of Massachusetts at Amherst. She enrolled in the Smith College School of Social Work in 1987 and earned her M.S.W. in 1989. Until 1991, she was a psychotherapist with a social service agency, and since then she has been a psychotherapist in a hospital psychiatry department. She also is a part-time adoption consultant. Ruth is a lesbian; she and her

partner of more than 16 years ("we had a wedding!") are expecting their first child (adoption, by donor insemination). They live in Northampton.

Ruth "had hoped to major in sciences and become a doctor — particularly a psychiatrist. But I loathed labs and didn't feel up to enduring something I hated for so long. I began a major in psychology (at a women's college) and during a course purporting to be an overview of the whole field (taught by a male professor) there was nothing in the syllabus having to do with women!! I raised my hand and objected to this, to which the prof replied that he knew nothing about women and psychology, but I could present something if I wished.

"At the time, Mount Holyoke did not have a Women's Studies major, or department, or even a minor, but there was a way to design your own program. So I gathered courses, relying heavily on UMass's well-established program and other area colleges' resources, assembled my own thesis committee, and became a Women's Studies major. My reason was that my feminist consciousness had begun to awaken in many areas of my life and I could no longer tolerate a curriculum which treated me as invisible. My thesis was a biography of a woman sculptor (deceased); I gained a lifelong friend when word of being among the first Women's Studies majors was published in the college's *Alumnae Quarterly*. The artist's longtime friend saw the notice and my thesis topic, asked to read the thesis, and we've been dear friends since.

"In law school, my Women's Studies background emerged in the focus of various papers I wrote (women and criminal justice, girl 'juvenile delinquents,' incest and the law). I became drawn to tort law — accident law which centered on women's medical injuries (DES suits, Dalcon Shield cases). After law school, I joined a small private-practice law firm where the men and women (four in all) were mostly feminist.

"By being a Women's Studies major, I received an early lesson in integrating my heart and mind. When litigation grew tired and I became much more interested in passing on the gift of healing from trauma (thanks to my own therapy), I took a courageous leap by leaving my law practice and entering social work school. During this time I developed a course on child abuse and neglect which integrated both legal and clinical issues. This has been the only course integrating these disciplines taught at a local law school and a university psychology department in this area. After social work school, I've continued to teach part time and now I work full time as a psychotherapist. I do not study or work in the field of Women's Studies directly, but I've found an answer, or a beginning answer, to my question about women and psychology. I treat adults, primarily women; they have a therapist with a grounded vision in both the personal and political factors which have helped shape their lives.

"The opportunity to develop my own major came at a very particular time in my life. While I had always been a spirited girl, my heart and spirit were very badly bruised if not, at times, also broken when, at age 16, a male relative sexually abused me (jumped me in my bed). I ran away from home and got into college based on my pre-rape grades. I had a high school guidance counselor who suspected abuse (he told me years later), but who did not report it, as he feared my relative would cause him trouble at his job. I blamed myself for the abuse and sudden changes *until*, while standing in the college reading room browsing through the new books, I read a passage by Susan Brownmiller in *Men, Women and Rape* about how incest-perpetrators should be called rapists. I literally felt the world of feminism lift the weight of oppression off my shoulders. In that one passage I knew I was not at fault for what he'd done.

"I was a very angry woman between 18 and 21. I don't know what I would have done without Women's Studies. I felt completely allergic to courses where only male authors were read, nauseous over courses taught to a class full of women where women's contributions were not acknowledged. In one year alone, my anger fueled my efforts to create the college's women's center, lead the lesbian support group, offer a women's radio show, write the college's first rape-prevention pamphlet, and be a founding member of a campus group, Women Concerned About Rape. I 'came out' as a rape survivor, but in the late 1970s no one admitted to being an incest survivor.

"Women's Studies offered me a way to study psychology, anthropology, literature, political science, and not have to deny my gender's existence. It also provided a forum within which to speak about the silencing of women, the abuse of women, and the overall plight of women. I felt heard and legitimate, less and less the unfortunate runaway whom adults treated as an 'acting-out' teen, more and more a woman who could name the truth and be damn articulate about it. My senior year I published my first essay, a rather scholarly essay (legal, stats, clinical) on incest. I was on my way to law school."

Postscript: Ruth and her partner had a daughter.

Jill R. Tregor — Advocate for Hate-Crime Victims
University of Massachusetts at Amherst — 1981

Jill was born May 4, 1959, and grew up the oldest of three daughters in Marblehead, Massachusetts. She describes her family this way: "Third/fourth generation Eastern European Jews. Lower-middle to middle class. Fairly traditional family (at least by Jewish standards). Powerful, controlling mother; tyrannical father. Everyone an addict of some sort. Just the

usual! The community was mostly upper-class WASP, yet with a strong and visible Jewish presence. There were only two families of color in the entire town."

After graduation, Jill pumped gasoline for several months at a service station in Northampton and then parked cars for a hotel in Santa Fe, New Mexico. In January 1982, she was hired as a research assistant in the San Francisco office of the California Attorney General, where she did "mostly clerical work." She joined a San Francisco law firm in October 1983 and was the legal assistant for an Indian-rights case, a gay-rights case, and a death-penalty appeal. Since November 1987, she has been program coordinator for Community United Against Violence in San Francisco. She organizes and advocates for victims of anti-gay and anti-lesbian violence. A "national expert on police/community issues," she also designs and leads training about homophobia and hate violence.

Jill, who is single and lives in San Francisco, does not call herself a feminist: "I don't identify with the term. It represents white, straight, middle-class concerns. I never really liked the term—now I just don't use it at all." She majored in Women's Studies "because the material and people were exciting and engaging. Because for the first time in a long time I could get excited about learning. Because the atmosphere of the classroom was such that I could be acknowledged as a smart, powerful woman. I had never really had that experience before—where what I thought actually mattered. Where what I felt had some relationship to what I thought and did. Where students were acknowledged and encouraged for what they did and who they were outside the classroom. And finally (and perhaps most important), in my first Women's Studies class I met all these beautiful, strong, intelligent lesbians—and I wanted to be with them (and be liked by them!)."

Jill said that "in some ways, I don't think being a major has affected me professionally at all. No one has ever hired me because I was a major! Actually, my employers at the law firm seemed both intrigued and afraid—they thought I was the 'type' of person who would be interested in an Indian law case because of my degree, yet conversely, they were afraid I wouldn't get along with male clients and male attorneys because of my degree. I had to assure them that I didn't 'hate' men.

"Women's Studies encouraged and honored my work outside the classroom. I worked on campus doing student organizing around women's and lesbian issues. I also did considerable antiracist work. I was allowed to connect that work to my classroom experience in a way that probably few other majors/departments could have accommodated. And that experience helped me define what I wanted to do professionally, as well as teaching me the skills needed to actually do the work I wanted to do.

"I do not underestimate the effect Women's Studies had on me in terms of boosting my self-esteem and self-confidence for professional work in any field. My professors valued my intelligence and were downright flattering about my abilities to articulate myself both verbally and in writing. I don't think most women ever have that experience. Professionally, I think this has resulted over time in my ability to do really challenging, truly valuable work—work that I could not have previously even dreamt about. In some ways I think that getting a degree in Women's Studies is like getting a degree in reading between the lines. And now I get paid to read between the lines—to ask: What's missing and why? It is also, to me, a degree in caring about people other than yourself, while at the same time putting more value on yourself—than you ever have before. And finally, it's a degree in making connections between different things. Again—I get paid to do that now. I don't want to oversimplify here, but I didn't have any real skills to do any of these things before—I had the intelligence and the intuition, but not the skills. Women's Studies helped me structure my thoughts, organize–refine– identify my skills, and taught me whole new ways of thinking. All of this very directly corresponds to the work that I do now.

"Obviously, the boost in self-confidence and self-esteem affected me personally as well as professionally. I don't think that I can really estimate, to this day, the enormous changes that occurred in me as a result of the respect I received in the Women's Studies classroom. I don't think that I had ever really felt valued before. Previously, I had often felt that I wasn't a woman because I had never identified with the women I saw around me. In fact, I often felt that I hated women, and I certainly felt betrayed by them. It's not that I liked men so much either, but I actually felt I could relate to them more. My drinking buddies were all men, and I tended to think of myself as more like a man than a woman (because I wasn't at all like the traditional women I saw around me). So, imagine my delight in discovering, during my participation in my first Women's Studies class (which I signed up for in a divinely inspired fluke), that there were women I could identify with. They were powerful, smart, and exciting. And they were lesbians. Well, it was really just a short leap from there to identifying myself as a lesbian. And the women (students and faculty) couldn't have reached out more, in support and friendship, during that leap.

"Additionally, Women's Studies gave me a sense of community at a time that I desperately needed that. I felt that there was a community of women looking out for me, watching me, caring for me. If I told someone I needed assistance with something, the word would spread, and soon there were women offering to help. This blew me away! I was at a huge, alienating school—yet being in Women's Studies was like living in a small community instead of urban squalor. There are women from that community that

I am still in touch with, who still comprise 'my' community, my family. It was a powerfully transformative experience!"

Would she choose the major again? "Probably. I do wish I had taken even more classes in other areas (e.g., legal studies, African-American Studies), although since my major was Women's Studies with a focus on racism I did take a good deal outside the major. Now I might be a Women's Studies major, or perhaps I'd be a social science major with a focus on gender and race (is there such a major?). I do think I would have liked to focus on gender and race more equally. If I didn't major in Women's Studies it would be because I sort of have a reaction to it now of the type I described having to the word 'feminist.' That the discipline is white, middle-class dominated. That the way questions are framed is too often racist. On the other hand, if I were in school now, Women's Studies would probably still be pretty much the only place where anything I cared about was being discussed at all. So, almost by default, I'd probably end up there. Women's Studies was and is the locus of much if not most of the stimulating dialogue on a campus."

Postscript: "After one year as director of public affairs for the Planned Parenthood Association of San Mateo County, I am now executive director of Intergroup Clearinghouse, a public–private partnership working to develop a comprehensive system for addressing hate-motivated violence in San Francisco. Additionally, I am a member of the board of directors of Break the Silence Coalition Against Anti-Asian Violence of the Bay Area."

Victoria L. Pillard — Medical Student
University of Massachusetts at Amherst — 1983

Victoria was born August 5, 1959, and grew up in Cambridge, Massachusetts. "Mother and father divorced when I was 7. Father is gay. Mother remarried when I was 8. I lived with mother, stepfather, and two younger sisters. Saw father regularly in Boston. Father has had three significant, about-10-year relationships over past 25 years. Also have stepbrother and stepsister." Her mother is a teacher, her father a psychiatrist. Before enrolling at the University of Massachusetts in 1980, Victoria attended San Francisco State University and junior colleges in Oakland, California. At the University of Massachusetts, she completed all premedical requirements along with her Women's Studies major. Following graduation, she worked a year for the Western Massachusetts Food Bank. From 1984 to 1986, she was the lesbian and gay awareness educator at the University of Massachusetts. She earned a master of education degree in psychology from the Harvard University Graduate School of Education in 1987 and entered the University of Massachusetts Medical School in 1988. Now in her fourth year, Victoria is applying for a pediatric residency, "which will entail 80

hours a week in hospital work. Now my priorities include school/work, family, friends, mental and physical health, and fun. I envision more political activism in my life in the future." Victoria is a member of Physicians for Social Responsibility and Physicians for Human Rights.

She selected Women's Studies "because it was a small individualized program within a large impersonal university that provided a home, safe space for me to be while attempting to overcome my fears and feelings of inadequacy about science, writing, studying. I was *very* insecure as a student when I started school! I felt the Women's Studies courses were demanding, stimulating, and supportive. I was able to design my own personalized course of study—Women and Health Care—and get some credit for my premed courses. Their political/feminist philosophy was similar to mine."

Victoria said Women's Studies "certainly has not stood in my way ever in my somewhat traditional path in Western medical education. It took me a while to decide that I really wanted to go to medical school, because of my fears of hierarchy, Western medical practice, etc., and meanwhile I pursued human services and anti-oppression work—a very clear extension of my education. Women's Studies helped me think on my own, articulate my thoughts and politics, and feel I could creatively figure out how to handle sexism—even from doctors!

"When I applied to medical school, I liked myself enough that although I worried I might be rejected due to my major I knew that would be their loss. I knew I had something special and unique to offer—a commitment to women. I was accepted 'early decision' to UMass the first year I applied and was quite open in my interviews about me and my beliefs. I believe that many places are beginning to value diversity and commitment to serving the underserved. I have not felt isolated in medical school as a lesbian/bisexual, as an 'older' student, or as a progressive person. I have certainly not been as politically active as I would like, but that comes with the territory and my commitment not to burn out. Also, my women friends, many of whom I met during my Women's Studies training, have been key supports over the years." Personally, Victoria said, Women's Studies "was an empowering, supportive experience that gave me skills and tools to use in pushing, shaping my life and relationships as I want them."

"Kate"—Director of Program for Inner-City Teenagers
University of Rhode Island—1984

Kate was born August 20, 1964. She grew up in suburban New Jersey and Illinois along with one sister (four years older) and four brothers (one younger). "My younger brother and my sister were adopted by my parents

when they were 3 years old and 9 months old, respectively. I grew up mostly with the three siblings nearest my age and my parents in a household that was often characterized by tension and tiptoeing around my father (who was prone to out-of-control fits). My oldest brother left home when he was 16 and I was 4, and then my second-to-the-oldest brother left home when I was 7. My parents divorced when I was 12, and I lived with my mother, two brothers, and sister for two tumultuous years—until my older brother and sister left home and we became more adjusted to the divorce. My father remarried (a woman with two children) when I was 13, and over the next two years they had two more children. When I was 14 my mother remarried (a man who had three children from a previous marriage). His kids were either grown or in boarding school. When I was 15, my second-to-the-oldest brother came to live at home while he tried to get into Navy flight school. That was a great time for me. Tony was very supportive and encouraging of me. At 16 I left home to go to URI [the University of Rhode Island]."

Kate's father "spent all of his work life in one company and was mostly unhappy. Because he had difficulty getting along with others, he was demoted and stayed stuck until he got on full disability." Her mother worked outside the home "here and there before my parents divorced. After the divorce, she made a lot of money in a job she didn't love (but loved the money and had fun with the power that went along with it). She left her money job, moved to Rhode Island and did contracting (which she loved), lost a lot of money, and is now successfully selling real estate in a very challenging market."

After graduating with high honors, and with a second major in psychology, Kate moved to California, and from March 1985 to August 1986 she worked at the Pregnancy Consultation Center in Oakland. Her duties included presenting family planning concepts to unwed adolescents and their partners, and counseling individuals about birth control. In November 1985 she became a volunteer counselor with AIDS Project of the East Bay in Oakland, a position she held until July 1987. Kate earned an M.S.W. degree in 1989 from the University of California at Berkeley, and from July 1989 to August 1990 she was a social worker with the East Bay Activity Center, whose population includes severely emotionally disturbed children. Since January 1991, she has been the director of a hospital-based program for inner-city teenagers. "My projects/responsibilities include individual, group, and family counseling; health education; family planning; community outreach; and training medical staff how to work compassionately with adolescents and families. I'm in the process of setting up an anonymous HIV test site for youth. I do my job four days a week. I also have a private psychotherapy practice."

As a child and young woman, Kate said, her role models included her

mother, Harriet Tubman, and Women's Studies Professor Mary Ellen Reilly. "Now my role models are more like people whom I admire for their talents/strengths: singers Tracy Chapman, Roseanne Cash, and Nanci Griffith, Faye Wattleton, some women athletes, my husband, many women writers. I respect Madonna's and Oprah Winfrey's business sense, but I don't necessarily like their politics or how they use people and images."

Kate said Women's Studies helped her "make sense out of a world that can be baffling. My mother always told me I could do anything I wanted to do, and I kind of believed her. But the belief didn't fit in with what I saw of women's experiences. Women's Studies named the discrimination that I saw and felt and gave me the social, political, economic, and historical explanations. It was reassuring. I felt that my reality was being acknowledged and not denied. The Women's Studies Program, especially Mary Ellen Reilly, was welcoming and made me feel as though I belonged. URI seemed so big and impersonal. It was a blessing to be part of a small department where I was treated with respect.

"My experiences in the department and as coordinator of Speak Easy Peer Sexuality Counseling Center on campus helped me to get my first job at a family planning clinic. I think the major enabled me to view the world holistically and influenced my decision to become a clinical social worker rather than a psychologist. For me the personal is also the professional. Integration is important to me. I've found a profession where my personal, political, and professional beliefs are not at odds. If I speak strictly 'personally,' my education in Women's Studies freed me from the burden of 'having to do it all.' I remember being struck by how much housework working women do and thinking 'uh uh.' My mother trained me to be a competent housekeeper (and I've run a successful housecleaning business), but at home I 'forget' how to do things or just don't do them (my mother's second husband proved a valuable role model in this technique). My husband recently read *The Second Shift* and thought it would be useful for us to tally our household chores. It came as no surprise to me (but was for him) that he does 75% of the work. Unfortunately, I'm now taking on the finances and the grocery shopping, but that beats the hell out of the laundry, cleaning the litter box, dumping the garbage, and preparing breakfasts.

"Women's Studies gave a name to issues that were important in my day-to-day existence, but so far in my education had been ignored: institutionalized racism and sexism, lesbian/bisexual/gay relationships, family violence, women's economic status, women in intimate relationships with men, etc. The education, and some of my other experiences (including encouragement from my mother), empowered me to make a life for myself based on my goals and beliefs and validated my desire to live in a 'tolerant' community where a wide variety of experiences are valued."

Postscript: "My work continues to be interesting and rewarding. I'm

thinking about doing AIDS prevention research with city youth and am meeting with the physicians in the clinic to put together a research team. I'm still doing weekly trainings for physicians on how to work with young people, and devote one of my talks to working with lesbian, gay, and bisexual youth. Most of the residents eat that one up because it is training that they don't get in medical school or in their other rotations."

Kristin J. Chandler — Advocate for Domestic-Violence Victims
Colgate University — 1985

Kristin was born June 14, 1963, and grew up in rural Maine. Her father was a lawyer, her mother a nurse who "went back to work when I was twelvish." She has a sister who is four years older than she and a brother who is eight years older and "was off to college when I was 10." After graduating, Kristin spent the summer as a river-raft guide in Alaska. She also has been a receptionist, café cook/manager, and co-op manager. For three years, she was legal outreach coordinator of Seattle Rape Relief. She enrolled at the University of Puget Sound School of Law in 1989, and in 1990 became the domestic-violence-victim advocate in the King County (Washington) Prosecutor's Office. She is a member of the Washington Coalition on Crime Prevention, the King County Coalition Against Domestic Violence, the National Lesbian and Gay Law Students, and the Central Co-op. She also writes and publishes a newsletter for gay/lesbian/bisexual alumni of Colgate. Kristin is "in a committed lesbian relationship"; she lives in Seattle.

Kristin majored in Women's Studies "because of the help of the director of Women's Studies. I had declared a major in sociology/anthropology, but discovered I had taken nine or ten courses in Women's Studies. Colgate did not offer a major at the time I graduated, but with Ann Lane's help I petitioned the school and was granted a double major in sociology and Women's Studies. I had taken the Women's Studies classes because they interested me; they covered topics which seemed much more pertinent to me than anything else I had taken. I had taken quite a few classes and had not done very well academically — until I took my first Women's Studies class. I did well in all of those classes because the subject interested me and because it seemed much more reality-based than anything else.

"My degree has affected me professionally in many ways; I know it helped me to get hired at Seattle Rape Relief. My major taught me much more than just about women or women's history. It taught me a lot about diversity, unity, and the importance of making connections. The knowledge I acquired about oppression of minorities gave me an advantage at my position at Rape Relief. It was in my Women's Studies classes that we

discussed racism, homophobia, ageism, etc. In order to do my work effectively, I had to be open to all different types of people—open and accessible. My degree taught me about the importance of making no assumptions, and that is something which I have to do on a daily basis in order to perform my job effectively.

"Now, as I am becoming a lawyer, making no assumptions is still critical to my doing a good job. Because of my degree, I will be better able to specialize in domestic-violence and sexual-assault prosecutions. I know more than just the law; I am aware of the history around these crimes against women and can see beyond just the law as to why these crimes happen. In short, I will be more sensitive to women who have experienced domestic violence or sexual assaults. I know that my degree set me apart from my classmates when I applied to law school. I believe it helped me to be accepted at many different law schools. It is a unique degree and offers a great deal of flexibility.

"My degree has affected me personally by helping me to realize how many wonderful women have contributed to our history, something I would not have known if I had only studied 'traditional' history. It has also contributed to my self-esteem in connecting me to many other women in a struggle to be heard in a man's world. And when I was struggling with my own identity and coming out as a lesbian, my studies directed me to many wonderful books, role models, and ideas for living peacefully in a world destined to frustrate me!"

<div align="center">

Dayna L. Bennett—Director
Battered Women's Center/Rape Crisis Program
University of Northern Colorado—1986

</div>

Dayna was born November 15, 1957, and grew up in Englewood, Colorado, a suburb of Denver. She has two half-brothers and a half-sister, all of whom had left home by the time she was 7. Her father was an artist, her mother a homemaker. Dayna attended community college for two years and enrolled at the University of Northern Colorado in 1980. After graduation, she was a counselor at a battered-women's shelter in Aurora, Colorado, and worked at a day-care center there. Currently she is director of the Goshen County Task Force on Family Violence and Sexual Assault in Torrington, Wyoming. She is a member of the Wyoming Coalition Against Domestic Violence, the National Coalition Against Sexual Assault, and the Health Advisory Committee. She also belongs to Greenpeace and NOW. A single mother, she lives in Torrington with her 7-year-old daughter.

Dayna "originally went back to school to double major in elementary education and special education in order to work with emotionally dis-

turbed children. While living in Greeley, Colorado, and going to school, I discovered there was a battered-women's shelter and they were seeking volunteers. I became involved and liked it so well that I decided to change my major to Women's Studies and wrote my own program through the interdisciplinary studies program. I took an 'Introduction Seminar in Women's Studies' my first quarter, and my consciousness was raised to the point that I decided to pursue that type of career. I learned through both my work at the shelter and my studies at the university that 'the personal is political.' I decided to incorporate my feminist beliefs with my work and tried to make a difference in the world.

"Since I went to work immediately upon graduation in a feminist-oriented environment, my degree was not an issue. In fact, the women I worked with were impressed with the fact that I had written my program around the issue of violence against women. This was in an inner-city shelter. I moved to Wyoming in 1987, where I am living and working in a small rural community which is about 30 years behind the times. Doing the work I do is difficult because the attitudes here are very much antiwoman, let alone antifeminist. Because of this my work and my philosophy are challenged every day. Being a Women's Studies major has increased my awareness of oppression, not only of women, but of all minorities. I have now worked with battered women and sexual-assault victims for ten years; I am experiencing a great deal of burnout as a result, especially from doing crisis intervention. I have been considering returning to school to either obtain a master's degree or attend a school specializing in holistic healing/massage therapy. I am very much interested in alternative health care, especially for women. I feel I will probably always want to work with women, and I would like to have my own practice. I also enjoy working with children, although most of the children I work with have either been physically, sexually, or emotionally abused. I have always considered myself a feminist and I am very vocal about this, even here in Wyoming. I am probably lucky to still be alive here!"

Her major also has affected her personally: "Again, my awareness has increased and probably will continue to increase. At the time I began my major, I was married to a man who seemed to support my feminist philosophy and academic endeavors. We had a child together, and our marriage fell apart largely due to his heavy drinking. He also turned out to be very emotionally abusive. I filed for divorce when my daughter was a year old. He attempted to gain custody of my daughter and tried to use my major against me by saying that if I raised her I would turn her against men and she would grow up being a lesbian, clearly suggesting that lesbians are somehow inferior people and bad mothers. This further infuriated me and

convinced me that he embraced sexist attitudes in direct conflict with my own beliefs and convictions.

"I have experienced oppression in my personal life as well as my professional life. All women are oppressed in this society whether they acknowledge it or not. Working in a field that attempts to eliminate violence against women is the epitome against this oppression. I am trying to raise my daughter to be independent, to make her own decisions, and to understand that women and girls are oppressed in our society. She spends a great deal of time at the shelter where I work; therefore, she sees it first-hand. Since she is only 7 years old, I am not entirely sure of how much she understands or internalizes.

"Since I am heterosexual, my relationships have been very interesting. I am very up-front about my feminist philosophy, my commitment to my work, and my friendships with women. Some men have been very threatened by this; others have accepted it; some have not been sure about all of it. I have more awareness probably than most people about women's issues and my commitment to changing attitudes—working professionally and dealing with it all on a personal level. Once you gain this awareness, it is difficult to ignore the oppression and inequality all around you."

If she had it to do over again, Dayna again would major in Women's Studies. "I was very frustrated with the double major in education/special education and I felt I would not make a big difference in working with emotionally disturbed children. I felt I would burn out much quicker than in the field I have chosen. I had wonderful advisers and professors who helped me write my program, and I feel I have been successful in my work, even with all the obstacles I have had to face. I feel no matter what career changes I make, my major will enable me to succeed."

Postscript: Dayna now is living with her daughter, her boyfriend, and his teenage twin sons. "I recently took a course on the psychosocial implications of AIDS, and have thought about the possibility of working with people with AIDS."

Yoon Jung Park—Program Associate at Human Rights Organization
Pitzer College—1986

Yoon was born January 28, 1964, and grew up in Los Angeles. Her Korean-American family included her parents, maternal grandmother, two younger sisters, and a younger brother. "Very close family—especially sisters and mom. Family female-dominated. Mother and father have worked together for over 20 years in own small business." While attending Pitzer, Yoon volunteered at a battered-women's shelter in Pomona, California,

and for two years was on the shelter's weekend relief staff. Her undergraduate thesis was titled "Feminist Perspectives on Motherhood."

After graduating, with a second major in sociology, she worked for a year as a research assistant for the Evaluation and Training Institute, a small management consulting firm in Los Angeles. In the fall of 1987, she attended school in Mexico for intensive Spanish-language study and coursework in Latin American Studies. Yoon then taught English to fourth-graders at a bilingual school in Cuernavaca, Mexico. She enrolled at the Fletcher School of Law and Diplomacy at Tufts University in 1989 and earned her master of arts in Law and Diplomacy in 1991. She currently is a program associate with Cultural Survival in Arlington, Virginia. She described it as "a small nonprofit agency working with and for indigenous peoples on human rights, development, and environmental issues." Yoon recently moved to Rockville, Maryland, where she expects to participate in community activities "once I am settled." In the past, she has volunteered at homeless shelters and soup kitchens; she has also worked with inner-city youth and the elderly.

Yoon originally was a sociology major in college. "Beginning of junior year, I realized that I had enough credits in Women's Studies that I could add it as a major without too much extra work. . . . It was kind of an accident. During and since college, all that I learned via my Women's Studies courses (and at the shelter for battered women) has shaped my professional interests. At the management consulting firm, I was placed on projects which focused on women's issues, in particular on an evaluation of California's Single Parent/Sex Equity Programs. Women's issues and women's rights are always an aspect of any job that I remain interested in. Currently I am working with indigenous peoples' issues, and there are many similarities with women's issues: empowerment, disenfranchisement, and oppression; control over bodies, lands, and languages; economics. In other words, both professionally and personally, values which I learned as a college student—many through my Women's Studies courses—form a core part of my philosophy of life, my purpose and goals. They are to help disadvantaged, oppressed groups find a voice, improve self-images, and become politically and economically empowered."

Personally, Yoon said, her major has made her "much more aware of sex roles; differences in behavior, attitudes, priorities between men and women. Many of my friends would probably say I overanalyze, but in most cases I feel understanding these issues is very important. And I try to have a sense of humor about it. Since college, I've mellowed out on the 'feminist' stuff quite a bit on some levels, and have become much more serious about issues on other levels. I'm differentiating between arguing with everyone

who makes sexist remarks—to really making an effort to change or educate where I feel that I can have an effect."

"Molly B."—Human Services Administrator
Mount Holyoke College—1987

Molly was born November 4, 1964, and grew up in Simsbury, Connecticut, a suburb of Hartford. Her parents, two brothers, and she "were close to both sets of grandparents, two first-cousins and nine second-cousins. We have an intimate, social, supportive, enthusiastic family." Her father worked outside the home, as did her mother (first part time, then full time). After graduating, Molly went to work at a women's bookstore in Northampton, Massachusetts, for three months. "Next I worked odd jobs painting, building, etc. (two months). For three years I worked in an apartment complex as a maintenance assistant. These past two years I have been assistant to the director of admissions at a long-term health care facility." Molly earned her M.A. degree in human development and gerontology from St. Joseph College in West Hartford in 1992.

Molly said she "couldn't decide what to choose as a major. I started with biology, then English, then psychology and Women's Studies, then settled on Women's Studies. I was not thinking of what I would use it for after graduating. I was thinking only of my own development, personally and politically (and sexually). I took the major because it was an interdisciplinary program and appealed to my interest in and hunger for the female perspective on religion, history, sociology, psychology, development, creativity, expression, and spirit. It was essential to my development as a young bisexual feminist. It was self-serving.

"I think if my degree hadn't been from Mount Holyoke it wouldn't have affected my professional life at all. A degree in any major from a prestigious school is noticed and influences people positively. Having majored in Women's Studies helped in my employment at a women's bookstore because I had read many of the books, either for courses or personal interest related to the major. It has not positively affected any employment since then.

"Having been a major made me not only a feminist (which I had been since youth) but a literate, 'cerebral,' intellectual feminist with facts and theories underpinning my beliefs. This made me a kind of professional feminist. My background in Women's Studies also gave me a special insight on my next degree in gerontology and human development. I felt I had a unique perspective to offer on issues of spiritual, sexual, social development, and related influence of the patriarchal dominant culture. Fortu-

nately, our texts included equal numbers of male and female researchers, and discussion always included feminist and even radical views of development as well as feminist critiques of male theorists. My master's degree is another of the 'What do you do with *that*?' genre, and I answer that by saying: 'I am now educated enough to hang around with old women.' This suits me just fine."

Personally, Molly said, Women's Studies has made her "feel terribly aware of things, both facts and theories, of which no one around me has any clue. I feel like I spent four years in another land, where how people dress, talk, behave, move, walk, sit, work, and smile has been studied and analyzed and revealed to be a huge scheme designed toward or resulting in the subjugation of women. No one in this small town where I grew up has any idea that any of this is going on. Women in my workplace feel terribly daring when they wear pants, and one has even been 'only doing it to annoy' the male executive director. On 'Casual Day' I wore my 'We Believe Anita Hill' T-shirt, and people acted as if I were wearing obscenities on my chest. A few women complimented me on my choice.

"I must say that having an education in Women's Studies has given me a heightened awareness of the role women are expected to play in heterosexual relationships. Even after 10 years of exclusive lesbianism, I find it hard not to 'go with the flow' in my first relationship with a man. He does not have any such expectations of me and knows I am a bisexual feminist who will walk away free before 'honoring and obeying.' Nevertheless, he and his family come from a rural, working-class town where no one questions anything. I find their sexist, heterosexist, homophobic, and racist comments (which they would never recognize as such) painful, and yet I feel I can't say anything. None of them ever expresses any dissent, opinions, or original thoughts anyway, so it would seem completely inappropriate and hostile. Merely having a post–high school education puts me in a skeptical light in their eyes, I feel, and adding feminism to it ups the ante.

"I feel that despite last-minute efforts in one of my classes, we were given all the bad news and nothing to do about it. I get mailings from every feminist organization in the country, but I cannot afford to support all of them, or even a few now. Is *money* the only thing that can make a difference? We need ideas on how to cause change and progress after being told all the bad news.

"How have I been affected personally? I feel like I am left standing alone with a big, juicy secret and no one to tell."

Molly believes that without Women's Studies, "I wouldn't be the woman I am today. I don't like to imagine what I would be like. I just know that I wouldn't be the same; I would be compromising myself. As far as I can tell, however, it was not a professionally advantageous choice. It has

not put me ahead in the running for any position, nor has it enhanced my jobs. It has given me the challenge not to forget it all and dive back into ignorance. It embodied the Mount Holyoke motto: the challenge to excel. But would I do it again? No. I would choose a major in another field and minor in Women's Studies, or I would double-major."

Postscript: Molly married in October 1993 and has a 6-year-old step-son. She and her husband are building a house in Belchertown, Massachusetts. "I don't know where I will be employed once I relocate, but please describe me as a feminist gerontologist. I hope that I mentioned that my mother is the same (also a nurse and educator), that she has inspired me, and that she continues to do so!"

Bernadette M. Hoppe—HIV Educator
State University of New York at Buffalo—1987

Bernadette was born September 25, 1964, and grew up in the small, rural town of Pine Bush, New York. Her father was a sales agent; her mother was a nurse who earned her B.S.N. and M.H.A. degrees "after age 40." Bernadette described them as conservative. She was the second of four children. "We were all emotionally and physically abused. My family is working class economically, but identified as middle class. We never had money, which was a source of great stress."

Bernadette has worked since she was 13. "I joined the Army to pay for college. I was in the reserves and worked as a home health aide as an undergraduate. I then worked in a shelter for battered women for one and a half years, until I started graduate school at State University of New York at Buffalo (SUNY–Buffalo). During graduate school, I had an assistantship, so I taught, and I also worked part time in an abortion clinic. I worked at Planned Parenthood for a year while looking for other work" after earning an M.A. degree in American Studies/Women's Studies. She now works as the HIV Education Coordinator in a community health center in the inner city, "servicing poor, primarily African-American patients." All of these positions, Bernadette said, "have been significant in determining my career direction and in my understanding of feminism. Those of us who worked throughout college and graduate school may have a very different experience of the working world. I know what it's like to do unskilled, menial labor and get shit money. It makes me appreciate management and administrative positions *more* and helps clarify my analysis of classism and sexism."

Bernadette is a bisexual who described her current relationship status as "involved, living together." She lives in Lockport, New York. She considers herself a feminist "because I put women, as a group, first in my life. I'm committed to social change." Her commitment is evident in her numerous

activities. She is a member of the education subcommittee of the Western New York AIDS Network, steering committee for Community Action for Sex Education, and NWSA. She is a founding member of the Fat Oppression/Body Image Task Force; volunteer producer and host for "Focus on Women," a public-access TV show; and a member of Ladies of the Lake, a feminist satire/political humor guerrilla theater troupe.

Bernadette majored in Women's Studies "because it instantly connected for me. It put many things in my life in perspective, it made complete sense to me. So I continued taking classes to complete a major, as well as completing my psychology major. On the graduate level, Women's Studies offered me the freedom to explore what was important to me (issues around food, fat phobia, the politics of beauty, and the relentless pursuit of thinness) as well as disciplining my mind and honing my analytical and critical skills.

"The most important thing majoring has done for me professionally is given me the confidence to pursue my ambitions. My background has not necessarily gotten me jobs, although it has helped. What it did was to challenge me to discover my own innate abilities and interests, and to interact with the world in a different way. My skills of critical analysis and learning to look at issues from a variety of perspectives are quite valuable in the working world. I learned how to pay attention to dynamics in group situations, and to believe in the power of my voice.

"Personally, in some ways Women's Studies changed my life. It clarified many thoughts and feelings, and helped me articulate my experiences. It did all of the things mentioned on a professional level, which has had a profound impact on my personal life. I can now look for the hidden messages in everything, and not accept anything at face value. It has helped me reexamine my priorities, and constantly reminds me to examine them and change them, if necessary. I devote lots of time to feminist organizations and causes, and this has opened up different worlds to me. It has also boosted my confidence and helped me to learn to take myself seriously. I have no regrets about choosing this major, and am actually very grateful that I 'found' Women's Studies when I did."

Postscript: "I am the HIV education coordinator of Geneva B. Scruggs Community Health Center. I have developed a niche in lecturing on women and HIV. As a feminist, I'm ten steps ahead of everyone who's still trying to figure out how women's lives are different and why traditional models of care need to be changed. Also, I'm now chair of the education subcommittee of the AIDS network, and I am an adjunct instructor in Women's Studies at both SUNY–Buffalo and SUNY–Brockport. I'm living in Buffalo after breaking off a relationship of nine years; I'm enjoying 'singlehood.'"

Amy Myslik—Community Educator/HIV
Counselor for Planned Parenthood
State University of New York at New Paltz—1987

Amy was born March 11, 1965. One of three girls, she grew up in a "nu-clear" family in the New York City borough of Queens. She described her mother and father as "politically liberal parents who were old-fashioned, from the Depression generation." Her father worked outside the home, as did her mother—but "not until I was 16." After graduating, Amy went to work for Planned Parenthood in Boston, where she was a medical assistant and birth-control counselor in the abortion and birth-control clinics. She later was unemployed for six months and worked as a temp before taking a job as a case manager at a shelter for runaway adolescents. Since 1989 she has been a community educator and HIV counselor for Planned Parenthood in New York state. Amy is in a "committed" relationship with a man. She lives in Rosendale, New York, and is active in the Ulster County AIDS Consortium and the Radical Women's Action Team.

In college, she said, "I was doing poorly in my freshman year and my academic adviser (Professor Amy Kesselman—one of my role models) told me to take classes that would interest me. Two years later I had to declare a major. Women's Studies classes were abundant on my transcript, as well as sociology, so I doubled my major. I was interested in Women's Studies classes because I knew they would help me grow, in all ways, as well as get an academic grip."

Professionally, Amy said she has been "blessed with the job I have now. I work mostly with women. It's very difficult to describe what won-derful feelings I get from my job and what kind of impact my job has on other people's lives. I guess you could say graduating with a Women's Studies major gives you a vehicle to bring social change and a professional life together. Granted, I have the ultimate job for that. I teach people about their reproductive health. I teach women how to control how many children, if any, they have. I teach people ways to talk to their sexual partners and children about sex, which includes HIV and safer sex. I was given the knowledge and self-esteem (confidence) to do this through the Women's Studies Department. Knowing I'm doing this to help people in general, but specifically to empower women and educate men, came from the department. It helped me to realize no matter what job I ended up with, that would be my goal."

As for the personal effects of Women's Studies, Amy said: "The answer is a book, but I'll shorten it. I have a feminist perspective of the world— which to me means a humanistic or humanist perspective as well. To sum it

up, I would like everyone in the world to be at peace with themselves and everyone around them. I also am a feminist consumer. I try to give my money to women's businesses or corporations that have policies that benefit women. My friendships with women are cherished, and I'm aware of the spiritual bond we all have. I have few genuine friendships with men, but those I do have are with men who educate or try to educate themselves on what women go through and try to open their hearts, and who take risks. Part of my free time is spent trying to keep laws and social norms in favor of women. Also, the children in my life are given gifts that affirm androgyny. I let them know what my values and opinions are regarding gender character-istics. They know that I think competition is evil. I look back at my years at college and know that I couldn't have grown so much then or now without Women's Studies.

"Anne" — Graduate Student in Nurse-Midwifery
Yale University — 1988

Anne was born August 11, 1966. She grew up in Chicago, "various cities and towns" in Australia, and Memphis, Tennessee, generally living in the inner city. She described her family as "nuclear — mother, father, me," with the Institute of Cultural Affairs serving as "kind of an extended family." She explained that her parents worked with the Institute for 14 years; "the living arrangement was communal." After graduating, Anne spent 15 months doing temporary work, "primarily in Silicon Valley microelectron-ics firms." She was a research analyst for the Santa Clara County (Califor-nia) AIDS Program for nine months before returning to Yale to study nurse-midwifery.

Anne said her parents were feminists, "but they certainly didn't call themselves feminists until the last five to eight years." And she is a feminist because, "I just am. I was raised within a community/family that cared deeply about peace and justice. Feminism is an essential component of a peace and justice perspective." At Yale, "art and Women's Studies were the only majors I was interested in," Anne said. "After taking a good look at my artwork, I realized I probably wouldn't make a living going that route. The summer between my junior and senior year of college I decided to concentrate in women and medicine (which I would now call women and health care) with the thought of eventually becoming a nurse-midwife.

"Women's Studies certainly hasn't hurt me professionally. Given the line of work I am going into, I think a feminist perspective is actually essential. Personally, the effect has been subtle. The perspectives I gained through majoring in Women's Studies may have made me a little more

irreverent—toward men, toward social structures, toward 'the Canon.' (I am very sensitive about language, which, while important, can be a pain.)"

Postscript: Anne received her master of science in nursing degree in May 1993 and is a nurse-midwife at Parkland Hospital in Dallas, Texas.

Janet D. Fender—Battered-Women's Advocate
University of Massachusetts at Boston—1988

Janet was born April 15, 1941, in Melrose, Massachusetts; her family moved to Reading when she was in the seventh grade. One of seven children, she described growing up in a "nuclear family—traditional structure—middle class—many problems." After graduating from high school, Janet attended the University of New Hampshire. With the sudden death of her father in 1961, she returned home to help her family. She enrolled at the University of Massachusetts at Boston in 1986, with a second major in sociology. After graduation, she worked for a year as a counselor with battered women. She became a legal advocate for battered women in a shelter and today does public education and training as well as advocacy. She earned a graduate certificate in conflict resolution from the University of Massachusetts at Boston in 1990 and is working on a master's degree in human service. Janet is married and the mother of five adult children; she lives in Brant Rock, Massachusetts.

About her choice of Women's Studies, she explained: "I took one course because it sounded interesting, and it opened up an explanation for my frustration with my life. I was 45 at the time, and all that I learned fit the patterns my life took. I continued taking courses because they empowered me and excited me. I wanted to declare it a major and own the importance of this major. I felt I needed the education for myself and all women I loved.

"I chose to work with battered women because of an internship for Women's Studies. In this job I wrestle daily with the institutionalized effects of sexism in the legal and welfare system. My major has given me the strength to keep fighting the injustices. I also find that my major allows me to do education of other professionals of the seriousness of women's oppression. Many co-workers struggle with the system but never understood the social, political, and historical constraints for women. I find it helpful to be able to point to these factors when dealing with battered women themselves or in advocating for them. My major has meant that I can no longer settle for the status quo—I am always pushing for change—in my organization and in the systems. It also meant that I joined many groups working for change—which is exhilarating. Women's Studies put

my life on a fast track of working with others who fight the system. I have risen to the occasion of fighting for women by learning to speak in public, confront authority, and having compassion for women.

"Personally I have become someone entirely different. I have become a fighter. I have my own opinions and I can explain them. I take myself very seriously and strive to do better daily. I have slowly separated myself from the wife and mother role to become a person who is interesting and involved. I have overcome a fear of public speaking and have gone on TV. I have continued to pursue education to help me better understand women's issues. My major sensitized me to myself, my daughters, my mother, and my friends. It allowed me to start carving my own life and to take responsibility for my self. It has made me often obsessive with the need for change and a relentless critic of the media. Many say that I can't just let things go— that is true—I no longer can and I don't choose to. I feel a constant need to point out the dangers of the system and the media for women."

Postscript: "I have taken a new job as one of four domestic-violence consultants hired by the Massachusetts Department of Social Service. My job is to help to integrate the perspective of the abused woman into the child-welfare system. I do trainings, supervise social workers, and sit on an interdisciplinary team of professionals who consult on high-risk cases." Janet earned her master's degree in May 1993.

Sue Phillips—Social Justice Employee
Colgate University—1988

Sue was born June 29, 1966. She grew up in Glen Ellyn, Illinois, in a "fairly typical suburban upper-class white family. Interpersonally loving, fairly supportive, much interest in children's (three) activities and interests." From Colgate, Sue went directly to Episcopal Divinity School and earned a master of divinity degree in 1991. Since then she has been employed at two part-time jobs: office assistant at NETWORK, a national Catholic social justice lobby, and Partners for the Common Good Loan Fund, which she described as a $3.25 million fund that gives low-interest loans to "so-called women-and minority-owned businesses, credit unions, and low-income housing, rehab/development programs." Sue lives in Takoma Park, Maryland.

She majored in Women's Studies "most significantly, I think, because I knew from the start something important happens in Women's Studies classes. The juxtaposition of theory and praxis appealed to me—learning how to use what I was learning in very profound ways. Perhaps most important, I sensed the depth of the commitment, friendship, and community of women involved. Women's Studies is a moving, growing, vibrant source of information and personal and political growth. It is much more

grounded and 'real' than most other academic disciplines. This community provided an important locus for campus political action/involvement—Women's Studies really was the ideological glue and empowering push that made such work on an incredibly conservative campus possible. I majored because I knew that I was going to be challenged, not just for the sake of the challenging itself, but because it took my own and other marginalized people's experiences seriously, and as an explicit starting point for important sociopolitical analysis."

Sue said it is difficult to describe her major's personal effects "because my master of divinity concentration was feminist liberation theology/ethics; Women's Studies and this concentration have become inexorably tied together. That said, I'd break down the professional ramifications into categories: skills, theory, political commitments, and personal involvement/investment in my 'profession.' First of all, my major gave me specific skills: critical thinking, learning to apply sociopolitical analysis to a given problem or context, writing experience, public speaking experience, political organizing expertise along with knowledge of how to identify, use, share, and ask for resources, and learning how to organize information and form a strong argument.

"In terms of theory, my major helped me organize things I know to be true about my own life and my culture into tangible and usable sets of assumptions and beliefs. It empowered me to see the theoretical connections between my experience as an individual and larger sociopolitical and economic institutions. It taught me that *I* could theorize, that *I* have the power to think critically and apply my beliefs to broader questions. This theoretical base provides an important background to all of my professional commitments and skills by putting them in a context that helps me to understand everything from office dynamics to budget priorities to organizational strategies and goals. My major taught me, perhaps above all else, to question what, culturally speaking, is considered 'true.' The myths started tumbling down the first day of class and never stopped. In the midst of this deconstruction arose radical *reconstruction*. And this reconstruction is the groundwork for many of my professionally oriented political commitments. At the most basic level, I want to involve myself in what I think needs to happen to realize my personal–political dreams. My major gave me the wherewithal to do this—the skills and theory as well as the political commitment."

A question about Women's Studies' personal effects "is virtually impossible to answer," Sue said. "My sense of self is so tied up with things I learned in classes and from the community gathered there. When classes are woman-denying, they are self-denying to women. This seems pretty clear. But the revolutionary implications of placing oneself and one's experiences

in the center of what is learned—in an accountable rather than hegemonic way—reverberate and bounce around everywhere.

"My classes helped me personally because I learned to take myself radically seriously: to understand how *my* life is impacted by oppressive socioeconomic institutions; to help see how I benefit from many of them; to dig around in the roots of my experience and, exhausted and dirty, find out where they intermingle with others'. My major also helped me to see that I wasn't crazy—that the way I see things is grounded in a tradition and history of struggle, that I do none of the work I choose alone, that I have the strength to keep on keeping on, that I have a brain and fists that work, and a powerful woman uses both/either when necessary. My major helped me to trust my own voice and to listen—I mean really listen—to what other women say." In short, Sue said, "My major was the most significant and important learning experience I have ever had."

Diane Kraynak—Graduate Student in Art Therapy
University of Richmond—1989

Diane was born February 21, 1967. She grew up in Germany (for three years) and Hampton and Manassas, Virginia. "I consider myself a 'latch-key' child—both parents always worked, and consequently have been very supportive financially. Only child. Dad, military, got out but retains military thinking. Women are in charge in our family." After graduation, Diane "took the summer off, took a job as a secretary to justify my existence. I wasn't allowed to wear pants, had to serve lunch, make coffee, do dishes, etc. Incredible learning experience I wouldn't trade. I also followed the Grateful Dead for a year." Currently she is completing an M.S. degree in art therapy at Eastern Virginia Medical School. Diane lives in Norfolk, Virginia, and interns at an alternative Virginia Beach high school.

She majored "by accident. I was accepted into a women's leadership and development program my freshman year of college. To be in this program I had to complete a number of Women's Studies classes. After figuring out I had almost enough for a minor, I realized with 12 more hours I could have a major, so I double-majored [political science]. In the end, it was the best decision; my Women's Studies classes were much more challenging and stimulating, and I've put my Women's Studies degree to better use. Looking back, political science was a big waste of time.

"My first job after graduation was with a *very sexist* company. I feel that if I had not had a Women's Studies background—I would have been eaten alive. I feel I understand more about the dynamics between men and women, employer/employee, etc. My major got me into graduate school

because of the psychology courses I took. My first internship in graduate school was at a battered-women's shelter. I chose that internship because I was a Women's Studies major. Since then, I realized that it seemed like 'everyone' wanted to help women but no one wanted to work with the perpetrators. Because of this, I asked to be at a high school with conduct-disordered adolescents. These boys may be future batterers. I feel my Women's Studies background is helping me work with these kids by opening up their minds as far as sex roles and gender roles go. I like to think that something on some level is sinking in. Feminists have developed their own theoretical approach, which I am incorporating into my own theoretical approach for clients. I don't agree with all of it, but I'm glad feminists have given another option. In a nutshell, I plan to professionally use my major by incorporating it into my philosophy to work with clients."

Commenting on the personal effects of her major, Diane observed: "Relationships—I've concluded that men are dumb and predictable and easily manipulated. It's made me realize I am No. 1 and my mental health comes first—*always*. It doesn't make me less caring or less romantic—just more equal. (Madonna was a big influence there—you just can't go wrong with 'second best is never enough, you'll do much better baby on your own'). Friends—I've mellowed out a little bit but I've found that educating through kindness is more effective than some militant protest. I get *nowhere* with statements like, 'That's so sexist!' What I find more effective are reflective statements or paradoxes commenting on the male equivalent. I think because of the nature of the field I'm in—I am who I am professionally and personally and they often reflect upon each other. Therefore, for me, I can't really separate the two. I've tried to incorporate feminism into a humanism that's integrated and holistic, and since that's a part of me it reflects upon my friends and colleagues."

Postscript: "I completed my master of science degree in art therapy in May 1992. My goals include developing my thesis into a dissertation, for my next step is a Ph.D. I am living in the Philadelphia area and work at a community mental health center as an art psychotherapist. I work in a public high school, where I run a partial-hospitalization program for emotionally disturbed and conduct-disordered adolescents. I also see individual clients."

"Kristen Williams"—Claims Reviewer for
Dalkon Shield Claimants' Trust
University of Richmond—1989

Kristen was born September 25, 1967, the middle of three girls. She grew up in suburban North Carolina and Virginia, where she attended public

schools. "My father has always worked [as a professor] and my mother returned to work [as a nurse] when my youngest sister went to primary school. On the outside, my family appeared perfect, but in reality we were rendered dysfunctional by co-dependency and poor communication." After graduating, with a second major in English, Kristen worked for six months as an administrative assistant at a temporary agency. Since then, she has been a claims reviewer and settlement conference representative for the Dalkon Shield Claimants' Trust. She lives in Virginia and is engaged to be married.

How did she come to her major? "UR [the University of Richmond] has an excellent program called Women Involved in Living and Learning. The program requires academic as well as extracurricular participation. I became a member during my freshman year—my sister had been part of WILL five years earlier and encouraged me to participate. I'm so glad that I did! The classes that I took for the WILL program were *always* interesting and rewarding. By my junior year, I realized I would only need a few more classes to have a major in Women's Studies (all the WILL classes were Women's Studies credits). Because the classes had been so meaningful, I decided to pursue the major."

Professionally, Kristen said, "the effect of my major is not readily tangible. However, it has afforded me a different level of awareness, or raised-consciousness, which has played a role in my professional development. I entered the work force with some understanding of the dynamics between men and women and how that can affect a woman's position. Being aware of stereotypes and expectations helped me to be equipped to deal with them, whereas some women didn't realize what the problems were or how to handle them. Recently, I have learned more about the differences between male and female communication styles; I am reminded of other information I studied in college about such issues. I have observed women being hesitant to speak up in front of male colleagues—as well as women being interrupted by them. I have also observed women in upper management showing favoritism to young men who give them attention and play their games. The philosophy of women needing to work twice as hard as men to reach the same level seems to be true, but both men and women have contributed to this dilemma. In addition, the insights I gained during my courses prepared me (to some extent!) for what I face in the 'real world.' Some of the abstracts of the classroom have become real in the world. In my opinion, such knowledge or awareness is the first step in tackling some of the problems/issues that arise for women in the 1990s."

Personally, "One of the most important principles I learned is the necessity of self-sufficiency. I had always envisioned myself as a wife and

mother; I'd work if I had to, but would be taken care of by my husband! When I went to college, I began to see just how much of a fantasy my vision was! I was taught about how crucial it is to have the ability to take care of yourself—to pay your bills, manage your money, change a tire, and assert yourself in a variety of areas. Dependency tends to debilitate women—to hold them back—to keep them in unhealthy situations/relationships. Self-sufficiency is a key ingredient in women's efforts to make the most of themselves; it is also evidence of a whole, healthy person.

"I am engaged, but the situation is certainly different than the one I envisioned as a teenager. My fiancé and I are partners. Rather than expecting him to take care of me—and him having the pressure of doing so, etc.—we both bring the ability to care for ourselves. We share responsibilities and future plans. The relationship is rich and rewarding and healthy because it is the union of two self-sufficient people who love each other and who are able to contribute equally to the relationship! I am much better off and much happier in this relationship than I would have been in the one I initially imagined. In this respect, my major has had significant, life-changing impact for me—thank goodness!"

Postscript: Kristen was married in March 1992. In May of that year she resigned from the Dalkon Shield Claimants' Trust to begin a full-time graduate program at UR, where she is working toward a master of teaching degree in special education. She hopes to teach students with learning disabilities.

Peg Daly—Planned Parenthood Clinic Coordinator
State University of New York at Buffalo—1990

Peg was born November 14, 1963, and grew up in Iowa City, Iowa, home of the University of Iowa. She is the youngest of the seven children of "Roman Catholic working-class parents." At 15, she lived with a sister for six months, and at 17 she "left my parents' home with an older sister and moved to Philadelphia. Some of my best parenting has been from my sisters." Her father was employed outside the home, and from the time Peg was 11, so was her mother. Peg did not graduate from high school but earned her general equivalency diploma. She attended the Community College of Philadelphia part time in 1981–1982 and enrolled at the State University of New York at Buffalo in 1986, with a second major in psychology.

Since graduation, "I have been fortunate. My first interview was with Planned Parenthood of Buffalo for a position as a family planning specialist, and I got the job!" Peg lives in Buffalo, where she is a member of Ladies of the Lake, a feminist satirical theater. How did she come to be a Women's

Studies major? "I took an introductory course and was struck by the truth of it. Many vague thoughts and feelings were validated and given form and description. I became more involved in the program and never stopped feeling the 'aha!' of uncovering what I knew was there but had previously lacked voice for. I found support and nurturing for academic and personal growth. I developed skills and confidence in a community that understood women."

Of Planned Parenthood, Peg said, "I felt very lucky to be given the opportunity to work my philosophies. I also feel more comfortable discussing my Women's Studies/feminist background than at any previous employment—we like feminists! A few months ago I was promoted to clinic coordinator. I am grateful to my major for helping me to develop confidence, leadership, and organizing skills. I feel that my experience at Women's Studies has been a major factor in my professional success. Skills of critical analysis have helped me to revise policies; teaching experience has helped me work well with others to help them grow and learn; study of institutional/systemic oppression has helped me recognize and address bias; nonhierarchical process has taught me to value my own and others' opinions regardless of position.

"Planned Parenthood has satisfied much of my desire to put my feminism to work. I can have influence in the agency to help it better address the needs of all women (I worked to get dental dams through committees, and they are now available to clients). I am happy to be a part of an agency that provides health care to women, by (mostly) women, regardless of their ability to pay. We believe in women's rights to control their bodies and help women learn more about their bodies. I am impressed by our integrity: turning down Title X funds and affirming a woman's right to informed choice. I feel that I bring a strong commitment to my position at Planned Parenthood, a commitment that was fostered by my experience at Women's Studies."

Personally, Peg said, "I am sure that I see the world through different eyes because of Women's Studies. I see more, not just more critically. I question more. I more freely address bias—heterocentric-, class-, race-, or sex-related. I consider the implications for women and others of the evening news or proposed legislation or funding cuts for programs. I take action. I must be involved in a women's community politically and socially. I need that energy now. My closest friends are feminist, not because I picked them that way but because we find understanding and common interests together. I must be involved politically. I need to have input in the community which I reside in and have my voice heard. I write letters, vote, and attend rallies on issues that are important to me. These are realizations that I may not have come to without Women's Studies."

Tracy Beth Kopf — Recreational Therapist
Temple University — 1991

Tracy was born March 26, 1967, and grew up in Philadelphia. "My mother and I are very close. My relationship with my father is strained; he has never been open with me, and treats me with very little regard and respect. My brother and I can talk to one another, but still there is strain." Tracy enrolled at West Chester University in June 1985 and left in May 1987; she began studying at Temple in January 1989. Since graduation, she has been employed as an assistant director of recreational therapy in a nursing home. Tracy lives in Bala Cynwyd, Pennsylvania. Her activities include Greenpeace and Mothers Against Drunk Driving.

When Tracy transferred to Temple, she explained, "most credits I earned were liberal arts. I wanted to go into social work but was afraid I would lose credits. I talked to a counselor who told me that my credits would fit into a Women's Studies major. Learning about women's past interested me. I had always considered myself a feminist, and had thought that Women's Studies would be interesting. After taking a few required classes, my goals had changed. I wanted to work primarily in a field with women, e.g., a rape shelter, a women's law office, perhaps even practicing law.

"Professionally, my degree has not helped me find a job. I have been looking for a new job for one year and have had no luck. I will not leave my job in the nursing home because I know that there are no jobs out there. But when I have had an interview, the interviewer does not take my degree seriously. I have experience working in a women's center and I quit because of school. I applied for a job at another women's center and I thought because I have a degree in Women's Studies I might have a better chance of getting the job, but no such luck. The facility wanted a degree that would be more useful and had a stronger background in social services than history."

If she were to do it over again, Tracy said she would minor in Women's Studies and major in social work "because I find that Women's Studies is not really regarded as an important degree." However, Tracy said, "personally my degree has given me a stronger sense of myself and women. I respect the struggles that women go through every day in the work force, home, and life. I also get very angry when a man or a woman takes for granted what a woman does every day. I feel stronger that my degree made me appreciate my sisters who struggled to get the vote and that today I have a voice that can be heard in issues that affect me."

Postscript: "My relationship with my father has improved; he respects me for myself and the choices that I make. I now live with my fiancé in Philadelphia. With continued searching for another job, I decided to attend paralegal school and graduated as a certified paralegal in November 1992.

Unable to find a job, I was promoted at the nursing home to director of recreational therapy, with a staff of six under my supervision. I plan to marry in October 1994 and hope to return to school to earn my master's degree in counseling or social work, with hopes that eventually I can help the elderly in some form of social work or therapy."

Carol Barbara Nallan — Nurse
University of South Florida — 1991

Carol was born December 20, 1945, and grew up in New York City with her parents and two sisters. Carol attended all-girls Catholic elementary and high schools. In September 1964, she entered the Bellevue School of Nursing in New York; she received her diploma in nursing in 1967. In 1978, she enrolled in Hillsborough Community College in Tampa, Florida, earning her associate's degree in 1981. She studied at St. Joseph's College in North Windham, Maine, and the University of Tampa before enrolling at the University of South Florida in September 1989. Currently she is enrolled in the master's-level gerontology program at the University of South Florida. Carol is the mother of two adult sons. "I typically work 45 to 50 hours a week and attend classes at night. My mother is in a nursing home with Alzheimer's and I am her guardian of person."

Carol came to Women's Studies indirectly: "I initially had declared prelaw but was told by the dean that prelaw was a concentration, not a degree. I checked the listings and chose Women's Studies for the classes which were offered—specifically 'Women in the Law,' 'Ethical Issues,' and 'Philosophy.' I have always wanted to know why. Not even 12 years of Catholic school had relieved my need to know why. Why were women channeled to be mothers, teachers, and/or nurses (back in 1959–1960)? Now women are entering law school, medical school, engineering, and seminaries. Our choices have grown—I eventually wish to complete law school. The conservative element in this country would have women warp back in time to the 1950s and 'Leave it to Beaver.' I feel it is my role as a professional nurse to demonstrate the progressive attitude of the true activist." Because of Women's Studies, Carol said, "I have been able to listen and discuss concepts with my friends and cohorts in an intellectual manner. The women and law classes have given me the foundation to build upon." Personally, the major "has enhanced my image of myself as a positive, life giver."

Larisa Katherine Semenuk — Health Clinic Medical Assistant
Cornell University — 1991

Larisa was born November 25, 1969. She grew up in Lawrenceville, New Jersey, "with a mother (who was a full-time homemaker until I was 15), a

father (who works for a pharmaceutical company), and two older brothers." Since graduation, she has worked for a health clinic in West Philadelphia, "a mostly black, disenfranchised community." In addition to family practice, dentistry, and physical therapy, the clinic does abortions. "Believe me, there are no pro-lifers picketing outside our door—they don't want the black babies." Larisa is married and lives in Narberth, Pennsylvania. Her typical week is work-centered: "I don't have time to take a part-time class now, although I'd like to. No time for volunteer work. No religious activity. My *job* is very *draining*."

Larisa said she was "the first and only Women's Studies major at Cornell in 1991. I was majoring in English and I had already taken more classes in Women's Studies than in English by senior year, when I found out there was a possibility I could major in it. It made sense to me because the classes I really loved in college were the Women's Studies ones. My best professors were my Women's Studies professors. The issues were all so interesting to me. . . . I'm very proud of my accomplishment.

"I am surrounded at work by many people who have not had a liberal arts education. Most of them didn't go to school post–high school, and the ones who did have very vocational, medical training. It's hard to understand unless you've experienced it, but without that kind of training and education, the kind of conversations I participate in most do not demonstrate critical thinking. None of the people I work with would describe themselves as feminists. There is much ignorance about homosexuality, gender issues, oppression of women. Most of the people I work with are black. As opposed to the academic setting, they describe themselves as black, not 'African-Americans' or 'people of color.' For all these reasons, it's hard for me to express my feminist insights.

"I have no allies at work. Still, I try to do as much as I can, such as challenge homophobia, sexism, etc. Even though I have little opportunity to use my major in a direct way, it does help me to think critically about issues going on at my work such as: the dynamics between our male boss and female employees, the reason so many of the girls/women come back for repeat abortions, etc. The fact that it is a clinic that offers inexpensive, safe abortions makes it a locus for women's issues. However, the clinic is not very feminist in philosophy—something I am fighting to change. The cultural/racial blocks make it difficult for me as a white, middle-class woman to handle. Some of the experiences of these women are distant from my own, and the walls that hinder communication are very strong for protection. I'm beginning to feel that class is a much stronger divider than race or sex.

"On a personal level, my major has affected me very deeply—to me, that's the more important aspect of a liberal arts education. I learned a lot about myself, especially in terms of gender roles. Although the seeds were

there for me to be a feminist, they did not grow until I took Women's Studies classes. In all my relationships, including my marriage, I stand up for myself. I always challenge my prescribed gender role. I try to make all those I love and like understand my politics and why they are so important to me. The personal level alone seems enough justification for being a major. I carry myself much more strongly physically due to my Women's Studies 'enlightenment.' I cared enough about myself to take a self-defense for women course in college. I saved the board I broke with my bare hand. It symbolizes my new-found inner strength."

Postscript: Larisa left the health clinic in May 1992 to become manager of a Planned Parenthood clinic. In fall 1993, she enrolled in the School of Nursing at Case Western Reserve University in Cleveland, Ohio. "I want to be a midwife. I feel that profession combines my political/feminist interests with my desire to do hands-on work of empowerment."

Erica Gutmann Strohl—Sexual Assault/Abuse Educator
University of Pennsylvania—1991

Erica was born January 18, 1969. She grew up in suburban Minnesota and rural and urban Iran. She was an only child until her parents adopted a Korean girl "in the second semester of my senior year of high school." Both her parents worked outside the home. Since graduation, Erica has worked part time as a community outreach educator on sexual assault and abuse, primarily in public schools, and part time at the nursing home where she has been employed since high school. She is looking for a full-time job.

About her choice of major, Erica said, "I was drawn to it, found it interesting. Had been exposed to it and excited by it in high school. Believe it gives one a very well-rounded education because it takes classes in all disciplines, with women being the major theme. Enjoy being in classes with mostly women. Enjoy having mostly women profs. And studying issues and subjects in a way that pertains to me. Also wanted to write a thesis, and Women's Studies was one of few departments that offered it.

"Many jobs I have applied for have listed Women's Studies as a preferable major. I believe I have gotten many interviews by virtue of my degree. I haven't applied for anything where having Women's Studies would be viewed as a negative or nonacademic major. I must say, however, that throughout college I had been very aware that having a resumé filled with internships at women's organizations could be harmful. Although I know women aren't a special interest at 52% of the population, others don't see it the same way. I'm sneaky, though! I spent all my summers in college working at the state capitol—for elected women officials! However, on my resumé I don't use names, rather the headings—State Office Building or Of-

fice of the Lieutenant Governor. And I did a lot of work on child-care and abortion rights while I was there, but I release that info only when useful. Further, because my second major — non-Western history — is seen as somewhat left of the mainstream, I choose to list it simply as history on my resumé. Again, I can be more specific in my cover letter if necessary or useful.

"I believe Women's Studies enabled me to think critically and debate well. Further, my experience writing a thesis was wonderful, and I believe I truly improved my writing skills as a result. Obviously, this will be useful in any job. Contrary to what many suggest, Women's Studies does not give the student an extremely narrow view of a particular discipline. Instead, a Women's Studies scholar must understand clearly the discipline as it has been shaped without the lives, opinions, and experiences of women. For example, many conservative peers in the history department suggest that because I studied so much women's history, I couldn't possibly have a clear grasp of 'real' traditional history. But you must have an extremely strong base in the traditional to do a feminist critique.

"I have very high career aspirations and fully expect that some of them will be attained. I look forward to some day being able to attribute some of my success to my Women's Studies degree — perhaps to an audience of all-white men who had always questioned its legitimacy."

As to the major's personal effects, Erica explained: "First and foremost, Women's Studies is meant to be empowering. I chose to be a major midway into my first year at college. At the time, I wasn't real clear on the various splits in the women's community, for instance, the questions about how 'activist' Women's Studies should be. There were times over the four years when I wondered what I was doing in the department, especially after a director told me Women's Studies was not — should not be political!?! I consider myself an activist feminist. I maintain that Women's Studies came out of the women's movement and therefore was historically activist and grassroots and should continue to be so. (Lest we forget, at Penn Women's Studies received funding only after a three-day sit-in in response to a series of rapes.) I believe we are losing our roots when women feminist scholars become stuck in the Ivory Tower. When feminist theorists write in a manner inaccessible to all but the most highly educated, we're losing something. How can feminist writings elicit the 'clicks' and epiphanies they do if no one can understand them? We're buying into the male concept of academia when we are inaccessible. Feminism by definition should be accessible.

"As an acquaintance-rape-prevention activist, I often appreciated the work of scholars in this area. Their studies proved what we knew from working the trenches but never had time to document. So, in many ways feminist activism and feminist research and studies can be very useful to

each other. It would be nice if Women's Studies research was generally done with an eye toward possible activist uses for it. Research on women's health is an excellent example. It is also wonderful, on some levels, how diverse Women's Studies is becoming—not only ethnically but critically. We now have Marxist, socialist, liberal, etc. critiques of various issues. It's great that we have grown so large as to have debates within our own community: profs, classes, materials, classmates.

"I believe I benefited greatly from the many women role models I came into contact with. I probably had 75% women professors during my undergraduate years. On the other hand, my roommate, an engineer, never had *one*! I also enjoyed classes which were almost exclusively women. We had lots of great discussions merging the personal and the political. Finally, Women's Studies was always interesting because we studied things that had connections to my life. I was able to bring my learning from the trenches in and use the classroom stuff in public speaking, etc."

Postscript: Erica now lives in Minneapolis. She is the education director of Pro-Choice Resources and a part-time consultant for the Stillwater Biomedical Ethics Committee.

Sandi Gray-Terry—Graduate Student in Clinical Social Work
Mount Holyoke College—1991

Sandi was born January 28, 1953. She grew up in Gloucester, Massachusetts, the youngest of three children and the only girl in a "white, middle-class, college-educated family." Her parents divorced when she was 13, and there was "a court battle for me to remain with father. Father lost business and home when I was 17 . . . from middle class to underclass before age 18." Sandi dropped out of high school at age 16. She worked at "menial restaurant and retail jobs, then governess, and at 26 got involved in commercial construction (hospitals, university buildings, etc.). Worked my way into on-site middle management before resigning and deciding to pursue an education (formal, that is)." She studied sociology and English at Meredith College in Raleigh, North Carolina, from January 1987 to May 1988, and then enrolled at Mount Holyoke, from which she graduated magna cum laude. After graduation, Sandi entered the Smith College School of Social Work and is pursuing a M.S.W. degree. That program has her spending summers in Northampton, Massachusetts.

"During the summer (for three summers), I take 10 or 11 courses in 10 weeks, which leaves little time for anything else, except listening to National Public Radio as I get dressed and occasionally meeting friends for a lunch or dinner. I am the student government representative at school for the 'Human Behavior Sequence,' which includes our courses on oppressed

populations, socioculture concepts, and racism. During the 'normal academic year' I am in a full-time clinical placement (with no pay). Last year I also was required to do a community service project. This year I will have to complete my master's thesis in addition to my full-time placement. I am also coordinating care for two elderly relatives as well as trying to maintain a long-term relationship."

Sandi, who lives in Raleigh, North Carolina, majored in Women's Studies "because I expected my life's work to be with women and because I wanted the broadest education possible. My interests are vast, and an interdisciplinary major gave me the range of humanities and social sciences that I wanted. As an older student, I had a clear direction when I began my undergraduate work. I knew that my final goal was an M.S.W. in clinical social work. I also knew that I wanted to work primarily with women because my experience of living in this society as a woman would allow me to have more experience, insight, and empathy in counseling other women. Because of my major, I have both a historical and contemporary awareness of the political structures that impact women's lives. Although my single-minded focus has been leading toward clinical work with women, my background in Women's Studies has also assured that I will be involved in policy issues that affect women. My major deepened my political commitment to women's issues on a global scale, strengthened my voice, and cemented my beliefs and values. Now that I have a voice, I will not sit down, and I will not shut up! I have been told that I am a powerful public speaker, which I hope I can use to benefit women's causes.

"At Mount Holyoke, I was taught to become a critical thinker and to utilize the lenses of race, class, gender, and age. Psychological theory lags behind the other social sciences in these areas, and my background in Women's Studies (including politics, sociology, literature, and religion) helps me to fill in the gaps. Psychology is beginning to open up in regard to gay and lesbian research, ethnic and racial issues, and developmental and relational theories of women—but we have a long way to go. I have continued to confront, or try to raise consciousness, both in the classroom and at my placement. Women's Studies means more than being concerned with women—it's about humanity, it's about ethics, it's about dignity and equity. Women's Studies gave me the language, the analysis, and the voice to work for social and political justice in a comprehensive way."

Sandi said she "could probably write a dissertation on how I have personally been affected by my major . . . but given my time constraints I can only articulate a small fraction of its impact. First of all, the courses were validating and made me feel less unique, bizarre, or crazy. I came to realize that my struggles in contemporary society were, for the most part, not personal, individual struggles or failures, but representative of the struc-

tural aspects of sexism. My experiences of being ignored, silenced, re-
pressed, suppressed, and oppressed were not just individual experiences,
but a part of the collective experience of women in America, and women
worldwide. This was enormously freeing and allowed me to transform my
internalized guilt and self-hatred into externalized anger and action. Once I
got the anger (which had been used self-destructively against myself) *out*, I
was able to move from a depressive, passive stance in my life to an active,
activist stance, using my anger as a motivating force. From my own experi-
ence, I was able to truly understand the maxim 'the personal is political,'
and extend my personal understanding of sexism to all areas of oppression
(racism, classism, heterosexism, ageism, ableism, etc.). Women's Studies
made me look at my own areas of structural privilege and made me aware
of how I could *use* my privilege to effect change. Women's Studies made me
more humane and facilitated my knowledge of how I could build alliances
and coalitions to help create a better world.

"Having powerful women mentors and peers, and studying the lives of
women, helped me to find my voice and honor myself and my experience.
Pushing myself to get beyond the patriarchal construction of 'reality,' I was
able to access my inner strength and resources—even access a personal
spirituality—which the patriarchy had worked hard to silence, and I, in my
ignorance, had covertly accepted and assented to. Women's Studies was
truly transformative in my life! I am a strong advocate of both Women's
Studies *and* women's colleges (also Black Studies and black colleges). If you
can have the opportunity to get the oppressor 'off your eyeball,' you can use
all your energy to try to define yourself rather than being the *object* that is
defined *by the oppressive forces*. This, I believe, results in true empower-
ment."

Would Sandi major again? "No doubt at all. I began as a double major
in sociology and English—and took every Women's Studies course that was
offered, but at Meredith (a women's college!) there was not even a minor
offered in Women's Studies. When I transferred to Mount Holyoke, I
switched to Women's Studies. On top of this interdisciplinary major, I
accrued four minors (politics, religion, sociology, and English), but I could
only list one minor on my transcript so I chose the conservative, balancing
minor of English."

Postscript: "I completed my M.S.W. in August 1993 (my thesis was
'Southern Cultural Influences on Lesbian Identity Formation'), and I was
honored to be one of two students who spoke at graduation. That same
week, I was offered a job as a child outpatient therapist in a rural commu-
nity mental health clinic. I expect to remain here for two years, until I am
fully certified, and then I hope to make the switch to working with adult
women. I am no longer in a relationship."

5

EDUCATION AND LIBRARY SERVICES

Today, teacher and librarian are occupations most often associated with women. You may assume that people who choose these professions trained specifically for them as undergraduates. To the contrary, many of our graduates came to their professions indirectly, and their Women's Studies major has been an important asset. What you will see in the graduates profiled here is how their major influences what they teach and how they teach. You also will see how valuable the interdisciplinary nature of the major was in preparing those who hold other positions in the educational community. And for those who are librarians, Women's Studies has been a wonderful resource, informing their work and helping them open up feminist resources to the larger community.

<p style="text-align:center;">
Lindsay Rahmun—Part-Time Community

College Instructor/Full-Time Parent

Pitzer College—1974
</p>

Lindsay was born in 1952 and calls the "small town" of Claremont, California, her hometown. "My parents married after WWII and are still together. I have a younger sister and two older brothers. We lived in a college town and had enough money without being rich or wasteful. My dad was a teacher, then a principal. My mom was a part-time bookkeeper." Before enrolling at Pitzer in September 1972, Lindsay studied at U.S. International University in England for a year and at Scripps College in Claremont for a year. For several years after graduation, she traveled, homesteaded, and held "many small jobs." She supervised the California Conservation Corps (CCC) in 1977–1978. For about six months in 1979, she attended a carpenters' union training program, then "quit because of harassment." From 1980 to 1983, she was a preschool teacher. Lindsay enrolled at Oregon State University in September 1983 and in June 1987 earned a master's degree in interdisciplinary studies (speech, psychology, and business) with

an emphasis on conflict management. Since 1988 she has been "a community college instructor, consultant, mediator, and mostly a mother." Lindsay is married and has a 4-year-old biological daughter; she and her husband plan to adopt another child. They live in Corvallis, Oregon.

Lindsay said that "in some ways" her parents were feminists: "They wanted all four children to have unlimited professional and academic opportunity. At the same time, they gave their daughters and sons different chores and they made my brothers help with outside jobs (e.g., building a brick patio) that they assumed I would not be involved with. When I ran up against sexism in school, they did not support me or try to make changes. (We didn't know the word 'sexism' then, but I certainly knew unfairness when I saw it.)"

As an undergraduate, Lindsay "had tried some other majors and found them unsatisfying. I'd studied several foreign languages and then moved to fine art, but wasn't sure where to go. While still unsure, in fall 1971, I chanced to find Robin Morgan's *Sisterhood Is Powerful*. Feminism came into my life and suddenly I understood a lot that had been unclear. After about a year, I heard about the concept of majoring in Women's Studies. Pitzer didn't offer it, but it did allow students to create their own majors. This seemed like the only area that could really interest me, and it certainly did. I developed the major for myself, and a few years later some younger women students reworked it and successfully petitioned to have it declared an official major.

"From graduation until the early 1980s, I wanted to do practical things: homesteading, carpentry, gardening. My focus on feminism, of which my major was a big part, encouraged me to try these things—to break into the world of physical labor, even the areas considered 'men's work.' I did apply for an administrative job in fall 1974, as the one exception to these practical jobs. On paper my B.A. in Women's Studies, plus my experience on a student–faculty–staff committee, made me the perfect candidate for the job: assistant to a university affirmative action officer. For about a week I felt smug about having majored in such a useful, career-oriented field. Then the bubble burst; I didn't even get an interview. So much for that career track. However, my B.A. did help me to get a supervisory position with the CCC. A bachelor's degree in anything, plus my hands-on experience in homesteading and carpentry and some volunteer experience leading women's support groups, gave me what they wanted. So in a roundabout way, Women's Studies helped me professionally."

Personally, Women's Studies "deepened my feminist analysis. I studied American women's history and literature, anthropology, sociology, art history, and the history of feminism. It was great. I researched a paper on male lactation—a major project—and I wrote and directed a videotaped feminist

drama. My major gave me a forum for focusing on feminist issues, taking them seriously, and surrounding myself with women who were doing the same. There was a tremendous amount of excitement in my classes, and I built wonderful relationships with other students and with several of my professors. Women's Studies gave me the basis for a thousand thoughts, discussions, arguments, and dreams that have come in the years since."

Postscript: Lindsay and her husband adopted a daughter.

Kay M. Sodowsky—Librarian
University of Kansas—1981

Kay was born July 23, 1959, and grew up in suburban Derby, Kansas, "the only child of older parents in a white, lower-middle-class, midwestern family." Both her parents worked outside the home. Were they feminists? "Not really, although my mother bought me my first issue of *Ms.* magazine in 1977, is pro-choice, etc." After graduation, Kay worked as a benefits authorizer for the Social Security Administration in Kansas City—"a career-ladder position, they called it." She left for library school at the University of Illinois in 1985, and received her M.S. degree in library and information science in December 1986. She has worked as a librarian at a public library since 1987. She also works a few hours a week as an on-call librarian for a community college and is associate editor of an annual fiction index. "Yes, it takes three jobs to support myself as a librarian!" Kay, who is single, lives in Palos Hills, Illinois.

She said Women's Studies "was the logical major, since I'd spent my teens devouring feminist literature and women's history books. Although I was initially leery of it because it didn't sound 'scholarly' enough, I was relieved to finally enter the program. I did double-major in sociology as well. It was a nice combination. The interdisciplinary nature of the Women's Studies curriculum was a perfect foundation for a reference librarian, since we are often generalists who must be familiar with research and resources in a wide range of disciplines. As a professional in a public library setting, I must also be an expert in finding information about contemporary social issues. The names in the headlines may change, but the basic issues (i.e., gender roles, discrimination, sexual harassment, etc.) are still the same.

"Women's Studies also opened my eyes to the many 'informal' sources of support that are available for women. Knowing that these grassroots type of organizations exist gives me an advantage over someone who assumes that all worthwhile information is found in big published directories and traditional reference books. My department required a lengthy thesis as a requirement for graduation. Completion of this grueling research project

increased my confidence in my own academic abilities and also proved useful as an example of what could be accomplished with discipline and advance planning! Women's Studies coursework also expanded my social consciousness and sensitivity toward other groups in society. This broadened outlook has proven essential for a public service career like librarianship."

As for the effects of Women's Studies on her personally, Kay explained: "First of all, it gave me a history—names and faces from the past that I had never known before. I finally felt that I had some sort of 'context' in the midst of the Founding Fathers, the Father-Son-and-Holy-Ghost, etc. My studies gave validation to my personal experience and helped me tie together the reality of being a woman in a patriarchal culture. Truly, the personal is political. In a less uplifting light, the unvarnished study of women's past and present also revealed the undeniable reality of oppression. Like the suffragist who never lived to see the 19th Amendment, I know that the battle for reproductive freedom will likely not be won in my lifetime.

"My perceptions are more critical and finely honed now—I know about female circumcision, women in poverty, domestic violence, the Dalkon Shield, the Salem witch trials, the hysterectomy epidemic, etc. How can I ever not be pained by the reality of women's lives—I know too much. I also know that my chosen profession is devalued and underpaid because it is largely done by women. Of course, most of the powerful library leaders are still men and the Librarian of Congress (not actually a real librarian) is always male—this in a profession that's 85% female. (Amazing how those few men seem to spring right to the top of the field!) Because of my major, I know 'postfeminist' backlash when I see it, and I understand to what lengths a male-dominated society will go to protect the status quo. Yes, I'm a lot wiser now, which I suppose is what education is for, but do other 'educated' persons spend the next 60 years of their lives with the weight of this kind of wisdom on their backs? Not being a ceramics or home economics major, I suppose I'll never know."

Elizabeth L. Bennett—University Staff Psychologist
University of Massachusetts at Amherst—1982

Elizabeth was born February 25, 1959. She grew up in New Bedford, Massachusetts, the middle of five children (two older brothers and a younger brother and sister). Both her parents worked outside the home. For the first four years after graduating from the University of Massachusetts, where Elizabeth also had a concentration in racism and oppression, she was a community organizer. "The most primary" of three jobs was with the Rape

Crisis Project of the New Bedford Women's Center, "where I provided community education about sexual assault as well as counseling to survivors." She enrolled at Boston University in 1986, earning a master's degree in education in counseling (1987) and an Ed.D. degree in counseling psychology (1992). While in graduate school, she also spent two years as a counselor at a community mental health center and as a consultant to a women's center and the AIDS Office of the Department of Public Health. From 1988 to 1991, she was a counselor at two universities and a psychiatric hospital. Since 1991 she has been a staff psychologist at the University of Texas. A lesbian, Elizabeth is in a "partnered" relationship. She lives in Austin, Texas.

Elizabeth "was drawn to Women's Studies in the late 1970s. It made sense to me. I liked the courses that were offered, the students in the program, the professors, and the staff." She said her major "has and continues to benefit me professionally. Employers have always considered my background an asset and a strength, and thus it has opened many doors for me—both in places one would expect, such as women's centers and other feminist-priority settings, and also in more traditional settings such as community mental health centers, university counseling centers, a psychiatric hospital, and graduate psychology programs.

"I believe that in all but the most repressive settings, people crave people who speak the truth and are true to their inner strength and to universal justice. Women's Studies helped me to articulate that truth, strength, and justice. It prepared me to go out into the world and maintain my integrity as a woman and an activist. It helped me to understand the past and the general background in which we live, and it helped me envision future directions for my sisters and for the younger sisters coming along. I have chosen a feminist/womanist professional path since Women's Studies—working for three years in New Bedford, Mass., with survivors of sexual abuse, providing community education during the aftermath of a woman being gang-raped in a city bar in 1983. I worked for three years educating police, district attorneys, community groups, students, businessmen, teachers, government officials in nine area towns and cities. My Women's Studies background prepared me for that. I wrote articles and appeared locally and nationally in the media—providing a feminist voice to the rape controversy. Again, Women's Studies prepared me for that.

"UMass had a few staff and professors—specifically Arlene Avakian and Mary Ruth Warner—with a strong antiracist voice and position. I continue to take that into my work. I enrolled in a master's program in counseling women. I continued in a doctoral program—focusing on feminist psychology, the psychology of women and lesbians, as well as cross-

cultural counseling. These continue to be important foci today. My dissertation was on 'The Psychological and Developmental Process of Maintaining a Positive Lesbian Identity.'

"I haven't been closeted as a feminist or a lesbian for many years. Women's Studies helped me find my way during some important and formative years. It's an important strand that continues through me today. I am appreciative for what I have learned, for my teachers and mentors, both in the academy and out. I am appreciative of my colleagues. And I am appreciative of the next generation of Women's Studies students—both in the academy, in neighborhood study groups and salons, in the workplaces, kitchens, meeting places, picket lines, bank lines, bread lines, and homes.

"Majoring in Women's Studies has had a very positive effect on me both personally and professionally. Regarding the personal, I graduated 10 years ago and I have several close friends and mentors from the program. Women's Studies helped me learn *how* to think, how to think critically, how to understand this society, with its misplaced values and oppressive rules and practices. I learned about social analysis and critique, and about activism. I learned about the strength of women and the intelligence of women. I learned about personal empowerment. I learned that I did not stand alone. In a sense, Women's Studies provided a key to open a door, releasing me from the oppressiveness of white male academia, where women were essentially invisible, where strong women were truly invisible along with lesbians and people of color. Women's Studies helped me learn that I had a history—as a woman, a lesbian, an activist. It showed me that I could be strong in who I was in the present. And it taught me that I had a future. That was important—especially in an academic system that denied and repressed the accomplishments of women. It's also especially important today in a current academic and governmental atmosphere that denies and represses women's strengths, accomplishments, and freedoms along with those of people of color and others."

Postscript: Elizabeth became a staff psychologist at Bridgewater State College in Massachusetts in 1993.

Cynthia J. Thomsen—Social Psychology Professor
Pitzer College—1983

Cynthia was born December 22, 1960, and grew up in Eugene, Oregon. "My parents were divorced when I was in my early teens, and I subsequently lived with my mother. Both parents were very supportive of my aspirations and abilities—they encouraged me to do whatever I wanted to do." Her mother was employed outside the home "since I was 6 months

old," and her father was, too, "other than three years in law school when I was 9 to 11."

Prior to enrolling at Pitzer, Cynthia had "short stints" at the University of Oregon, DeAnza College, and Occidental College. After receiving her B.A. degree, with a second major in psychology, she spent a year working on research and as a teaching assistant at Pitzer. She then spent five years in graduate school, earning her Ph.D. from the University of Minnesota in June 1991. She is in her third year as an assistant professor of social psychology at Tufts University in Boston. Cynthia is engaged to be married; she lives in Somerville, Massachusetts. "As an untenured faculty person, I spend almost all of my time working. This includes teaching and administration, but also a lot of time spent one-on-one with both undergrads and graduate students who are my advisees or who work with me on research. I do no volunteer work, although I frequently think about it, feel guilty, and wish I did. I hope someday to be less exclusively focused on work—and to have more time to devote to people (friends and family) and to political activism and causes."

Cynthia chose Women's Studies because, "Quite simply, the classes were by far the most exciting of any classes I took in college; I saw things a new way, my eyes were opened to new things, and I was turned on by this new perspective. So there was no pragmatic plan behind my decision to major—it was a decision made purely on the basis of loving the topic. It also fit well with my interest in psychology, so I guess I saw it as complementary to my other major. For pragmatic reasons, I wouldn't have majored *only* in Women's Studies."

Professionally, Women's Studies "has exposed me to new ideas, new perspectives, new ways of looking at the world. As a result, I think it has enhanced both my research and my teaching. If I had not majored, I'm sure that the courses I teach would be 'narrower' than they are—instead, I bring quite a bit of research/theory related to gender roles and attitudes into my courses, and try to raise students' awareness by highlighting cultural biases that favor men and exclude women. My research, much of which examines the antecedents and consequences of stereotyping and prejudice, has also benefited from my Women's Studies background. I don't explicitly do research on women's issues, but I keep a feminist perspective in mind when designing and interpreting research."

Personally, Cynthia said, "Being a Women's Studies major really transformed my world view. Although I had considered myself a feminist before becoming a major, I consolidated a lot of new opinions based on readings and discussions in my Women's Studies courses. There is no question that my background left a lasting mark on me—I question a lot of cultural

assumptions that go unnoticed by people without this background. I am stronger in my convictions, prouder of my gender and what they have contributed, and more devoted to the cause of achieving true equality for women."

"Claire" — Librarian
Kansas State University — 1984

Claire was born May 18, 1962, the youngest of four girls. She grew up in the small town of Wakeeney, Kansas, where both her parents were employed in a self-owned business. After graduation, Claire worked for three months as a secretary and then for one and a half years as an academic adviser. She was unemployed for six months and worked as a home-health-care director for six months before enrolling in graduate school at Emporia State University in 1987. She earned a master of library science degree in 1988 and since then has worked full time as a librarian.

Claire is married and lives in Norman, Oklahoma. She considers herself a feminist because "I believe that espousing feminist principles in my life is a means of securing equal rights and treatment for women and others." How did she come to major in Women's Studies? "I had been raised by and with strong women, and espoused feminist principles long before I began calling myself a feminist. When I went to college, I was amazed to see that I could get a secondary major in something that was of such interest to me. The major gave me the opportunity to acquire an academic grounding in a subject which heretofore was based solely upon emotion for me."

She said she is "always asked about my degree at interviews, but the major really was not of any great impact until I got my degree in library science. It has been a selling point in libraries because many are trying to collect in a variety of areas to support Women's Studies course offerings. A subject expertise in this area helps make me an attractive candidate. Also, librarianship has traditionally been a female career, and a majority of librarians are still female (a majority of administrators are male, of course). So women in this profession are keenly aware of and interested in feminist issues. Thus my degree has benefited me in my professional relationships.

"Personally, it has heightened my awareness. I continue to espouse feminism, but on a ground-level basis I do not try to change the world. I try to make where I work and live a better place for both women and men. I do not jump on my husband every time he makes an unenlightened remark. I, too, make unenlightened remarks about a wide variety of topics. I try to give leniency in the education process, and in return I expect the same for myself."

Postscript: Claire is pursuing a second master's degree—in public administration.

Kimberly H. Brookes—Archivist
Oberlin College—1985

Kimberly was born May 20, 1963, and grew up in Lincoln, Nebraska, in a "nuclear family—biological mother, father, and two younger sisters." She described her parents as feminists and considers herself a feminist: "Despite my problems with the fact that there are many feminisms—so how does one define oneself as a feminist? . . . I believe women are capable of anything—good or bad—as are men." After graduating, with a second major in history, Kimberly was in charge of the reserve library section at Harvard's Graduate School of Education Library for about nine months. For the next six months, she was a research assistant, a typist, and did odd jobs. She coordinated Oberlin's student-volunteer program for two years before beginning graduate school at the University of Massachusetts at Amherst. In May 1990, she earned an M.A. degree in history and a certificate in public history. During graduate school, she was a teaching assistant and worked "very part time" processing manuscript collections at the Schlesinger Library at Radcliffe College. She then spent a year as a part-time assistant archivist at the University of Massachusetts at Boston and part time at Schlesinger. Currently she works part time at Brown University's John Hay Library, where she is in charge of processing material about women, and at Pembroke College; she also continues part time at Schlesinger. Kimberly is in a "committed" relationship; she lives in Malden, Massachusetts.

She majored in Women's Studies "because I found out that all of the courses I wanted to take could be turned into a second major. Had I realized this before my junior year, it would have been my first major. I was excited about learning about women and the treatment of women, particularly in philosophy and history. I loved feminist theory. 'Gender as a social construct' helped me make sense of my own life and of society's misguided ways. Learning new ways to critique society, learning about all kinds of feminisms, learning about the problems faced and solidarities enjoyed by all kinds of women of color—I was swept up by it. And, having eclectic academic tastes, I liked being rewarded for interdisciplinary study!

"Professionally, my major has done nothing but help me. In graduate school it was a tremendous advantage. My study of feminist theory made the concept of historiography much easier than for some of my colleagues. One of my concentrations in graduate school was women's history (the others being political history and archives)—I was already familiar with

many of the works we read—the second reading is always easier. Because what I like to do as an archivist is to work on the papers of women, women's organizations, or radical political organizations, my major is an important piece of my credentials. Undergraduate and graduate study in the field means it is easier for me to identify important people and trends in the collections upon which I work. I have to write extensive histories and biographies—my major made me comfortable with doing basic research and writing. The fact that I majored in Women's Studies emphasizes my early and ongoing commitment to women's history. It also signifies that I participated in the results of an academic political movement—to get Women's Studies recognized as a major (I think mine was one of the first classes to have regular Women's Studies requirements rather than being solely an individual major, although it still was, technically, an individual major).

"In addition, my undergraduate work was filled with readings by Women's Studies pioneers and very much influenced by the newness, defensiveness, and contrariness of those scholars—that helps me better understand political movements, and the progression of movements from outside to partially inside the mainstream. Mine was a political major, not just an academic one. This also, to those in the know, helps me gain respect among those who supported Women's Studies from the beginning and who now hire people. Women's Studies' interdisciplinary nature has made it easier to be a teacher, whether leading discussions or providing reference assistance. My major was also, I suspect, quite important in my obtaining my job at Brown University.

"I haven't talked about my other jobs because they weren't 'professions' as much as growing up and learning—which I'm still doing. But let me return to one negative point, with a golden lining. My major deepened my commitment (as did going to Oberlin) to changing the world, even if only in a small way, and to not selling out. Now I find myself in a profession that, as professions go, gets paid miserably, and I find myself unwilling to be an archivist for just any old thing—so there aren't many jobs in an already tight job market. The gold is that I'm proud of that, even if I grumble, and my major, which I loved, reinforced that.

"Some of my closest remaining friends from college were in my Women's Studies classes. After graduation, I received a lot of help about grad school from a Women's Studies prof. My major makes me proud. Strong. I revel in remembering the excitement of learning not only about sex oppression, but also about foremothers in many cultures. One prof, at the end, inspired me and gave me courage to eventually go to grad school. It gave me an early start in a field I love: women's history. I'm still proud of that final seminar paper.

"How *has* it affected me? It has made me more aware of the world

around me, of people (not just women) who are not like me. It has made me aware of the dangers of 'the other.' It has made me ponder how to act politically for some women without oppressing other women. Who are women, politically speaking? What are 'our' issues? Is there such a thing as 'a woman's' issue? These questions and the gut feeling that what we called 'p.c.' (before the media capitalized and spelled it out and made it McCarthyist) has, at its core, goodness and right in its call for respect for all people, yet one has to make decisions, hurt someone, ignore someone, risk being wrong, in order to act and to get something done.

"Women's Studies has heightened my awareness of media images and gender pressure. And strengthened my ability not to give in. Which of course is also a detriment—if I refuse to wear a dress/skirt or makeup, my upward mobility will be limited. Yet I also think it's okay to wear dresses— just make sure that's what you—not society—choose. It makes me feel guilty for not joining NOW, NARAL, etc. And it makes me angry at 'Ellie' Smeal and the 'feminist majority' for supposing they, or whoever wants a 'woman's party' (don't they remember the horrible and disgusting failings of the first one?), define 'feminism' and 'women's issues.'"

Postscript: "I'm still an archivist—now at the Schlesinger Library and at UMass–Boston. I am embarrassed by seeing all of my handwritten scrawls on that questionnaire revealed in legible type, allowing my words to take on a life of their own. I hope they travel well."

Lili Mira Feingold—Part-Time Teacher
San Diego State University—1985

Lili was born September 14, 1962. "I grew up in a middle-class, semi-traditional Jewish family in San Diego. My father worked full time in a blue-collar job while my mother worked part time as a volunteer for underprivileged children. She was once a full-time career woman, but was ready to give that up when she had her first baby at the age of 34. I remember my parents very much in love with one another. They did not fight—rather, they were always sickeningly in love! They set an excellent example."

After receiving her bachelor's degree, with a second major in modern dance, Lili "set off for a year and ten months of travel and graduate education at Hebrew University in Jerusalem. I lived on a kibbutz, where I worked for room and board. I then returned to San Diego (in 1988), where I succumbed to society's pressure and found a 'real job'—for the Boy Scouts of America!! Can you imagine? I worked as an Exploring Executive (a branch of older scouts) until I resigned. I hated the neo-facist, hypocritical, misogynistic, racist, anti-Semitic, and overall hideous world of the Boy Scouts. I was expected to wear old-maid suits, suntan-colored nylons, and

my hair in a bun! I was at odds with the CEOs for months. I will never
again work in corporate America. It was a living hell being restricted and
constricted in a conservative working environment."

Lili, who is single, lives in La Mesa, California. For the last three years,
she has worked as a part-time teacher in a private Jewish academy.
"Though I love teaching, I feel that a career move is imminent. I am now
taking care of my handicapped mother part time, as my father suddenly
passed away in November 1991. I sew, help out at home, prepare lessons,
coordinate a TAGAR-BETAR (Zionist activist movement) chapter, teach, try
to exercise, redecorate the home, read, volunteer for a variety of groups,
and educate others about Israel (school talks, info tables, open houses,
etc.). I may be working part time, but I am always busy doing something
productive. I have to be doing something!"

Lili said she "originally took an Intro to Women's Studies course be-
cause it was open to 'crashers'—our university was very overcrowded, but
there was room in Women's Studies classes. I crashed the course, and it just
so happened that during the year (1981) the Moral Majority had students
infiltrating 'devious,' 'subversive' courses with the sheer intent to disrupt
them. There was a male born-again Christian who took the course in order
to intimidate the part-time instructor. She wasn't in a professional position
to tell him to go to hell, so I did! His inflexible and obnoxious born-again
rhetoric convinced me that I had to take action. After a particularly un-
pleasant incident in class regarding abortion rights, I was so angered and
inspired by his intolerance that I changed my major that day! I spent the
next four years dedicated to promoting women's rights on and off campus.
I still have that brain-washed Moral Majority drone to thank for my dedica-
tion to the women's movement! I don't think that was what Jerry Falwell
envisioned when he set out to disrupt the 'liberal college agenda'!!

"My major has affected me professionally because it has empowered
me to look my employer in the eye and just dare him or her to hire me. I
feel I was taught the skills necessary to be a self-sufficient woman in any
situation. The major opened my mind to different ideas, perceptions, au-
thors, perspectives, and greater heights. Because I feel like I have been let in
on a special secret, i.e., Women's Studies, I feel I have an edge. The curricu-
lum at my university was very difficult, therefore I feel comfortable with
research, journals, books, and academia in general. I feel that my 'training'
has enabled me to face challenges head-on. I remember the intimidating
and awe-inspiring teachers in my department; they became role models.
Oftentimes I will think of those influential instructors and use their example
for how to behave in certain situations. I was fortunate in that I became
good friends with many of my instructors; their personal and professional
examples have greatly affected me.

"I do not feel the degree has hindered me in any way. Perhaps I will be

overlooked by a conservative employer looking for a standard business student. On the other hand, I feel certain that the iconoclastic, intelligent employer looking for a memorable employee may be curious as to what I am all about. I feel this uniqueness has enhanced my career aspirations. When I have sought employment, the employer has always known that I was not a basic student looking for a job with IBM! Perhaps there are skeptics, but in the long run it really pays to have an open mind, and an educated one at that. Forget those sociology courses—I am so thankful I chose the field for both personal and professional reasons. What would I do without Women's Studies?"

Lili said she was "very glad" to be asked about the major's effects on her personally. "When I arrived in Israel, I was alone, without the language and without family or friends. My gutsy Women's Studies attitude helped me deal with many challenging situations. Once I had learned the language, I was able to live there independently and enjoy the culture. I was intrigued learning about the vast differences women experience in the Middle East. The Women's Studies world taught me one very important lesson: I mustn't accept the norm, rather I should question authority. I took this ideology with me to Israel and learned that the left-wing world, of which I was such a part, was just as full of bigots and closed-minded individuals as the opposition. This was a very bitter pill for me to swallow because I was a true 'liberal.' I ended up questioning the entire 'liberal' movement after my long experience in Israel. I returned to the States for a brief period, then quickly returned to Israel. I volunteered for the Israeli army for one year, where I served on an army base (tanks). I feel this experience was made possible because I had been in Women's Studies. I feel I was given the 'ultra-bitch' confidence necessary to survive on an almost all-male base in the middle of the desert. When times got tough, I would refer to Susan Brownmiller and suddenly feel like I could get through it!!

"This brings me back to my disillusionment: I feel that I must use the questioning skills I learned in Women's Studies and apply them to life in the bigger picture. What do I mean by that? I have had a very hard time seeing the same blindness and bigotry we supposedly abhor in others, in the women's movement. I feel that feminists are now quick to jump on any liberal cause and blindly support it. I have experienced so much negative feedback because of my dedication to Israel that I feel the movement of today has sent me running. I cannot relate to the new feminist that typifies the 'politically correct' woman of the 1990s. I have experienced blatant anti-Semitism lately in the women's movement, and I feel that I have been torn by a movement I once loved. Of course I am still a feminist, but I cannot buy all that is said, considering the plethora of erroneous information about Israel that is circulated by the Left. I think that my experiences in the Israeli army, as well as being a pro-Israeli activist, have taught

me that one must question all movements and not accept everything as 'real.'

"In a college setting I felt more comfortable with radical thoughts—it was all so simple. Now that I have spent almost five years in Israel, I am deeply saddened to see that my once-coveted women's movement embraces thoughts and ideas about Israel and Judaism that are an anathema to me. I feel that I have been squeezed out of my *own* movement by an uninformed Left that is painfully ignorant about the realities in the Middle East. My experiences as a feminist have taught me, based on personal blood, sweat, and tears, that we are guilty of our own prejudices. Ironically, the same liberalness I once embraced came back to haunt me in the form of anti-Semitism! I feel I have found a healthy balance between both worlds (Zionism and feminism) by backing off on the radicalism of the women's movement and using the *basic values* I was taught as a feminist to guide me through a Jewish lifestyle. My big lesson—all movements are led by humans who may possess the same biases they claim to deplore; in my case, I found out through my dedication to Israel."

Postscript: Her mother died in July 1992, and Lili has moved to Los Angeles to work as assistant to the consul for press and information at the Israeli Consulate. "I love my work and the field of foreign relations! I've found my niche!!"

Tara Tull—Coordinator of Women's Services
University of Colorado—1985

Tara was born March 29, 1961. She grew up in Columbus, Ohio, in a "nuclear family—two parents (they are now divorced—phew!), three kids (I'm the baby)." Her mother was the administrator of a day-care center; her father was a college professor. After graduation, Tara was a janitor and worked in a bakery until 1987, when she started graduate school at Mankato State University in Minnesota. She earned her M.S. degree in Women's Studies in 1990. She then was night manager at a shelter for homeless families and office manager at a shelter for teenagers. She is currently coordinator of women's services at Metropolitan State College of Denver's (MSCD) Institute for Women's Studies and Services—"similar to a women's resource center, offering advising, information/referral, support groups, workshops, and conferences." Tara lives in Denver.

She took her first Women's Studies class when she was 18. "I went in to the class with no clue as to what it would be about and ended up loving it! I had originally planned to major in environmental conservation, but did not enjoy that program as much as Women's Studies. It was exciting and rigorous. I had always had a vague political consciousness. Feminism clarified and articulated that consciousness."

Professionally: "(1) My degree got me my current position! The reason I was interviewed and hired was that I had a strong knowledge of Women's Studies. Since the coordinator works closely with Women's Studies faculty and students, it would be difficult for a person with little or no knowledge of Women's Studies/feminism to be effective in the position. My experience in political organizing and human services (which came out of my involvement in Women's Studies) gave me the necessary skills to do my job, but Women's Studies gave me the knowledge and analytical abilities that are critical for the position. (2) Other jobs came from the connections I had made through Women's Studies (friends and faculty) and the fact that there was often a feminist with hiring authority. Women's Studies is always a plus with agencies and organizations with a strong feminist presence. (3) Women's Studies has enhanced my self-esteem, critical/analytical skills, and political savvy — all necessary in order to be hired and then to do a good job in a position. (4) The only negative aspect is that Women's Studies majors know too much. Professional decisions then become ethical and moral decisions. Compromise has to be constantly renegotiated on a personal level. Therefore, a feminist consciousness rules out or makes difficult participation in unethical work situations — in other words, the majority of available jobs! Feminists can and do participate in those jobs, but it creates a constant ethical dilemma. A feminist consciousness does not make life easy!"

Tara said that personally, "Feminism is the lens through which I view and understand the world. It affects all aspects of my life and helps me to make sense out of it all. The people I have met, friends I have made, and experiences I have had through Women's Studies are invaluable. I wouldn't trade any of it for a traditional lifestyle. The choices I have made about how I live my life have all been affected. I have chosen to put my emotional energy into friendships in a rather nontraditional way. I believe we need to redefine 'family,' and in order to do that I take risks and make choices that do not conform to accepted ways of being. I think my self-esteem/self-awareness/self-worth has been strongly supported/elevated by feminism. My role models' love, support, and laughter have encouraged my personal growth and my political effectiveness."

Postscript: Tara continues to coordinate Women's Services at MSCD. In 1993, she attended the Summer Institute for Women in Higher Education Administration sponsored by Bryn Mawr College and HERS, Mid-America.

"Cara" — Graduate Student
Mount Holyoke College — 1985

Cara was born in 1962 and grew up in metropolitan New York, the youngest of four children (two brothers, one sister). She attended Parsons School

of Design/New School for Social Research from 1979 to 1981. She enrolled at Mount Holyoke in 1983, and after graduating (with a minor in French) studied in Paris for a year. She has been at the University of Wisconsin–Madison since 1987; she earned her M.A. degree in 1988 and currently is writing the dissertation for her Ph.D.

Cara's career path has not been "traditional," as she explained: "I am genuinely surprised that the only question about employment is for 'since you graduated from college.' The implication is that Women's Studies majors all fit into a nice neat upper-class pattern of living with their parents until they were 18, at which point they went off to have four years of college education somehow given to them, after which, B.A. in hand, they had their first initiation to the job market. I can almost imagine a 'typical' college sophomore going home for Christmas and being asked by dad, who is paying for her education, what she's going to major in and how she expects to get a job with her degree. Almost, but not quite.

"Well, I didn't do that. And most of my friends at Mount Holyoke didn't do that either. Most of us had to work to pay for our educations. And some of us majored or minored in Women's Studies precisely because of those experiences. Some of us had been working as wives and mothers long before we became college students.

"In my own case, I didn't get a job because I went to college; I went to college because of my job. I worked for a university — in a national research facility. I had worked there since I was 16 and had been self-supporting since that date. All of my skills were acquired on the job. I became a computer programmer/marine technician. That was easier to do then than it would be now, but even then, without a college education or even a high school diploma, I can tell you it was not easy. Out of a staff of 600, there was only one other female programmer. Her husband, whose qualifications were identical to hers, was the system manager. Female graduate students, and especially female scientists, were few. Female secretaries were many. When I was offered a promotion, without any raise, to full-time marine technician, that would have made me the first female marine technician that any of us knew of at any comparable research institution.

"People who have never done that kind of work always think that the hardest part is being a woman, sometimes the only woman, on the ship. It's not. The hardest part is the men who sit in the offices back in the lab and make decisions that affect you. One month before I was scheduled to leave for the ship in my new job classification, a new employee was brought in who, I was told, would replace me in the lab while I was away. He had a college degree, zero working experience, and had never been on anything bigger than a sailboat. His starting salary was 50% higher than mine. I was told to train him for marine operations. When I confronted the head of the

department, he admitted in so many words that this new person had been hired at the last minute for 'my' new job just because he was male.

"I loved being a marine technician, loved the job so much I wanted to scream in frustration. There was sexual harassment. There were inequities in the pay scale. There was unpaid overtime, all-nighters in the lab. There were the men they tried to hire to replace me, who somehow never worked out. Then there was my boss' refusal to sign one little piece of paper, and too much was suddenly too much. The university had just voted to admit women to undergraduate courses. As a member of staff, my benefits package entitled me to free courses. My boss refused to sign the form on the grounds that it would take too much of my time and energy away from work. I told him that I had applied for a job with a different department, had applied for admission to several colleges, and that I would take any of those or a better offer from him, whichever came first.

"Mount Holyoke came first. As far as I was concerned, I knew a degree would get me an automatic raise, no matter where it was from or what field it was in. And I was sure that my job would be waiting for me. My father, pleased that I had been accepted, offered to contribute. All of my savings went into it. The dean and my professors allowed me to take leaves of absence for short-term contracts at sea. One of those contracts produced my ideal job offer — as full-time marine computer tech on state-of-the-art equipment at two and a half times my previous pay. But to accept that would have meant leaving school indefinitely, and especially leaving my degree program in Women's Studies, which by then had become a goal in itself.

"Before, during, and after being a student, I worked nights in the radio room of a cab company, wore flesh-tone stockings and high heels as a receptionist in a dentist's office, typed other students' term papers, knocked on doors canvassing for an environmental organization, served drinks in a bar, worked as a freelance artist, and served as a merchant marine. To go to graduate school, I deferred on admission and went back out to sea to pay for it. Once in graduate school, things got easier. I worked as a reader, as a project assistant, and then as a lecturer. Then I got a grant and was able for the first time to devote myself full time to my studies. Two more grants — a Fulbright and an alumnae fellowship from Mount Holyoke — sent me abroad to do my dissertation research. Now it's back to school and a job as a research assistant while I finish up and enter the academic job market."

Cara said there is no simple answer to why she majored in Women's Studies. "I was coming from a very male-centered, male-dominated profession; that's part of it. Part of me was sick of all that, and I really had the attitude that my college education was 'my time,' to do with it whatever I wanted. Another factor was my transfer credits. Perhaps the most impor-

tant reason was the content and design of the program at Mount Holyoke. I felt it permitted me the greatest variety, the most breadth in choosing my courses. It gave me what I saw as the most dynamic and exciting faculty. Also, having been involved in a couple of women's centers in New York City, and being at a women's college, I wanted to take full advantage of that, learn more about it, do more of it, do it more intensely."

Professionally, Cara said, "perhaps the single most important thing Women's Studies has given me is a combination of perspective and analytical skills, which I believe would be equally valuable in any profession. It has taught me that there is always more than one way to look at any situation or problem, and that there is usually not just one right answer. It has taught me to always question assumptions, particularly my own; that to do research, the researcher must always query his- or herself, before, during, and after. That every person has different experiences and a unique way of looking at these experiences, that these exist for a reason, that these are all valid, and that these must be respected. It has enabled me to bring a unique perspective and background to my field, one which I hope will allow me to make a significant contribution.

"It gave me motivation to go on to grad school and the credentials to be admitted to the best program for me. Within that program, it gave me the skills necessary to pursue my research far more effectively than I would have been able to otherwise. This includes knowing how to find and interpret the kinds of sources that might otherwise go overlooked. As a result, I believe, the faculty of my department have given me much greater latitude to pursue my interests than would otherwise have been the case. In an academic environment, where the incorporation of Women's Studies even in European history is a hotly contested issue, I was given a job to design and teach a new course in 'Comparative World Women's History.' Why? Because I had a degree in Women's Studies. I was also allowed to teach that course as if it were a Women's Studies course, for the same reason."

Women's Studies also has given Cara "a much broader and more centered, balanced perspective. It has taught me to approach people as people, no matter who they are. It has made me a more capable person. And given me confidence in my ability. It has given me a better sense of who I am, what makes me a unique individual, what makes me a part of several shared group identities and what sets me apart, and what makes me a part of the human race. It has given me a better understanding of the role of choice in life, and with it an increased sense of having some control over the choices I make in my own life. But the most important thing was that it allowed me to bring all the different, separate parts of myself together into one coherent and integrated whole."

Diane Maluso — Graduate Student in Social Psychology
University of Rhode Island — 1986

Diane was born January 22, 1955, and grew up in Summit, New Jersey, along with two younger brothers. "My parents were lower-middle-class, Italian-American, first-generation citizens. My father was a mechanic, my mother was a secretary." After graduating from high school, Diane enrolled at Beth Israel School of Nursing and took liberal arts courses at Hunter College. She received her R.N. diploma in 1976, then held nursing jobs in hospitals and summer camps until 1979. She tended bar in a women's bar for a year, and from 1980 to 1983 was a counselor in a resident camp for adjudicated youth. She did restaurant work for a year before enrolling at the University of Rhode Island in 1984. While an undergraduate, she also worked as a night nurse in a nursing home. She earned her M.A. degree in social psychology from the University of Rhode Island in 1989 and is a Ph.D. candidate in social psychology. A lesbian, Diane and her partner of nine years are the parents of an 8-month-old daughter (her partner is the biological parent through artificial insemination).

Diane said majoring in Women's Studies "has affected virtually every aspect of my professional life. I have been fortunate enough to have a member of our Women's Studies faculty as my major professor. My graduate work has been primarily in the area of gender and has evolved directly from undergraduate coursework in Women's Studies. I have taken courses on gender and feminism in graduate school because of positive experiences with such courses as an undergraduate and because of positive relationships with the faculty involved with such courses.

"As a major, I learned feminist theory, which I have applied to every learning situation since. Feminist ideology has provided a framework for course content, for research, and for practice. For instance, an open-topic paper in cognitive psychology became a critique of contemporary work regarding 'sex differences' in mathematical and verbal abilities. My master's thesis was a study of sexist discrimination, and I am currently co-authoring a chapter on the social learning of gender. When teaching psychology, I make sure to use examples involving women and other underrepresented groups, and make special efforts to encourage advanced students who are women. Whenever appropriate, I debunk misogynist theories in classes. I have been fortunate to teach two Women's Studies courses: 'Gender, Race, and Social Class' and 'Alternative Lifestyles for Women.' The experience of developing and teaching these seminars has helped me come to love teaching and to feel very encouraged about my career choice. It is richly rewarding to pass on feminist ideology to a class of students. As a teacher, I have a

chance to give something back to the field that has given me so much, and I welcome the opportunity. Quite simply, Women's Studies has been central to my professional development and will continue to be so for the foreseeable future."

Personally, Diane said, "Having majored in Women's Studies has given me dignity. I learned about sexism, about the differences between misogynist myths and theories and the realities of women's lives. Consequently, I do not have to deny the reality of my experiences: I choose to live, not blissfully unaware of subjugation of women in our society, but fully aware of the patriarchy. I take feminist actions knowing I am not alone, knowing why I make my choices. Knowing that I am being honest with myself. Having majored in Women's Studies has provided me with insights into the behaviors of others. I interpret the actions of friends, family, and colleagues through a feminist lens, and so have become often more understanding, occasionally less tolerant, and usually more confident in social interactions. Having majored in Women's Studies has resulted in wonderful friendships. I have two dear friends from college who were also majors. Our friendships were cemented in classes and in the long, searching conversations following those classes. These days we are widely separated geographically but stay close and see each other whenever we can. I count them among the people I love best. Having majored in Women's Studies has shaped a core part of myself. Learning feminist theory and the realities of women's lives has given words to the feelings of outrage, concern, and the love of women I brought with me to the college experience. Because of Women's Studies I no longer feel disenfranchised."

Postscript: Diane received her Ph.D. degree in May 1992. She spent the 1992–1993 academic year teaching in the Department of Psychology and Education at Mount Holyoke College and now is an assistant professor of psychology and Women's Studies at the University of Hawaii at Manoa.

Debra Nickerson—Middle-School Teacher
University of Rhode Island—1986

Debra was born July 30, 1960, and grew up in the small town of Narragansett, Rhode Island. After high school, she attended Johnson State College in Vermont in 1978–1979, then the University of Alaska at Anchorage for a year. She enrolled at the University of Rhode Island (URI) in 1984. "I returned to complete my college degree after several years away from school. I had, in the interim, lived in Alaska (working as executive director of Greenpeace's Alaska office) and been a partner in a small construction company which specialized in passive solar design."

Debra completed a master's degree in secondary education from West-

ern Washington University (WWU) and began teaching "at a small alternative high school program in Yelm, Washington—a very small, rural, blue-collar, working-class town. I taught all grades and a variety of courses during the two years I was there. This year I made a transition to Yelm's middle school, where I am teaching American history and language arts." Debra lives in Olympia, Washington, with her husband. She volunteers for two organizations: FIST (Feminist In Self-Defense Training) and Safeplace— "a rape relief, shelter service, and victims' advocacy agency in Olympia."

Debra said she has "always been 'women-centered'—feeling a powerful connection to those of my own gender. In high school I was volunteering at a crisis intervention center, learning a lot about the oppression of women in America and globally. When I returned to finish my degree at URI, I knew beforehand that one of my majors would be Women's Studies. I was looking at a college education as much more than 'career preparation'; indeed, I was returning to school to challenge myself academically, ideologically, and experientially. I was desiring to learn and grow. I had no idea of what particular career I wanted to enter; it was not important to me at that point. I had become interested in Women's Studies when I took 'Women in American History' with Kate Dunnigan, when I was randomly taking courses. I learned that I did not really know much about 'my' history. I desperately wanted to learn more about my sisters' lives and their/our struggle against the constraints of the given culture.

"Finding myself in an abusive marital situation while living in Alaska pushed me over the edge. I was driven by the desire to discover and understand more about family power dynamics, male–female relations, and abuse/control issues in general. I had entered a world where a man's insecurity manifested itself in manipulation and control. Not having come from such a family background, I was completely caught off guard and confused about the behavior. Knowing that I was brought up not to be treated in such a way, I left the marriage to return to myself and to school."

About her major's effects on her professionally, Debra explained: "I returned to college after several years of working. Some of my positions would be considered 'nontraditional,' but in all of them I discovered institutionalized sexism and many double standards. Because of this, my mind was set on majoring in Women's Studies when I returned to school. My second major was sociology. Between these two fields, I became adept at really 'seeing' discriminatory practices in our culture's institutions. My need for effecting positive changes in our social system was acute. I had to become a change agent in some way. Having always toyed with the idea of teaching, I decided upon getting my teaching credentials after I finished my bachelor's degree.

"I left Rhode Island shortly after graduation. I had missed the moun-

tains and their majesty. 'Getting through' the teacher education program at WWU was a feat of tolerance of white patriarchal ideas of education. The faculty was dominated by white males who had taught school for a few years during the 1960s (it was 1989) and whose idea of discipline rested upon their being large people with loud voices and the fact they were male. Little did they understand the issues small female teachers-to-be were inquiring about. Females within our program were patronized consistently by several of the male faculty.

"Other students and I were thorns in their sides, as we refused to sit idly and accept condescending comments flung our way. Sexism and other discriminatory practices on the part of teachers and administrators in the public school system were only given token consideration in the program's curriculum. I kept thinking, 'How are we going to make significant changes in the way we treat the sexes in our schools if the isms are not addressed in teacher-preparation programs?' Indeed, as I got to know many of my fellow students, I knew the myths and stereotypes surrounding young women would be perpetuated for years to come. Sadly enough, the traditional views of women's inferior social position held by many men and women are passed on in classrooms around our nation. No wonder there has never been significant reform in our public educational system.

"Now I find myself teaching in a middle school just outside the capital of Washington state. Again, I feel I am a lone voice pointing out the discrepancies in our system. Some teachers are very enlightened, but for the most part female students are not encouraged to move beyond the status quo. I overhear teachers' comments about how math and science are 'just more difficult for the girls.' I see sexual harassment of girls being tolerated by the administration. I hear rape victims (students) being scrutinized for their past behavior or what they usually wear. Some male teachers comment frequently on a girl's appearance, indicating she should have no problems getting a job later as she is 'so pretty.' As a general trend, the more attractive the girl is, the more personalized attention she will receive by several members of the staff.

"Not that this attention directed at her encourages her in her academic studies. Much of it manifests itself in flattering, flirtatious comments making the child feel as though her looks are all she has. I know this because my students talk to me and I hear their confusion in trying to understand their role and place in this world. Double standards abound at our school; mixed messages are given and received several times a day. The highest academic grades are consistently earned by females at our middle school, yet they are not the ones to be given the extra push to pursue their academic studies. In the town I teach in, teen motherhood ranks quite high. Higher education is not valued, especially for females.

"Because of who I am, all that I learned in my Women's Studies pro-

gram, and all that I've seen in this institution that I once idealized, I have begun work on my own agenda. I've brought my outside activities into school by offering self-defense classes through the physical education [PE] department. They were completely supportive and got funds to provide a substitute for me two days last year. I introduced all seven classes of girls in PE to the basics of defending themselves. All three grades in our school received the classes. During the two days many girls disclosed their own stories of sexual assault. Rape is, as all the latest literature states, very common, even among girls 12 years old. There is nothing so gut-wrenching as a sixth-grader asking the question, 'But what if it's your dad?' in response to being taught how to strike bodily targets such as the knees, throat, or groin. This year the PE teachers are writing a minigrant proposal to allow me three days of working with our female students.

"In my U.S. history classes I tie together current issues and historical ones. I utilize readings, documents, and books I used in some of my Women's Studies courses. For example, right now we are studying the westward movement: Lewis and Clark's journey, Sacagawea, pioneer lives, etc. In our reading about Sacagawea's life we learn that she had no choice in whom she would marry. This brought outrage from some of my female students; we went on to examine such practices in other cultures and other times. Shockingly, they realized that many women do not have full control over their futures in many cultures. Contemporary cases in our own society of threats by husbands to wives if they attempt to leave or report abuse were discussed in depth. Myths surrounding the pioneer man as the partner who did all the heavy work during the move to and settling in the West were shattered once diaries, letters, and other reading by and about women were brought forth. Modern textbooks still do not adequately address the reality of our history. I supply much of the material I use in class.

"If not for my Women's Studies classes, I, too, would be ignorant of much of my own history. In fact, this year I changed the curriculum completely and am teaching through numerous novels, the majority of which have female protagonists. When learning is an emotional experience (as in getting caught up in a novel), it is retained in the mind for a great length of time, thus the rationale behind my method of teaching. In this way I can also insure that all 'voices' from our country's past are heard and carefully listened to. Tokenism is not for me. My students will leave my classes with a better understanding of how issues of power and domination have been inbred in our society since its beginnings. I hope they will use this knowledge and understanding to alter the future course of our country. It is my aim that my students will not condone our gender-based culture and its pillars of patriarchy but work to create a society based upon equity and individual achievements."

Women's Studies also has affected Debra personally: "Prior to return-

ing to college and finishing my degree, all my relationships with men involved some great compromise on my part. I was never a complete pushover, but I was a 'nice girl' and therefore found myself often used or taken advantage of in a romantic relationship. I had bought into the societal convention that women were not supposed to have equal status in relationships with men. I have always been an independent person, not needing a man for a greater sense of self or financial stability. But even with my solid inner core of strength, I often found myself tangled up with men who were insecure and manifested it through manipulation, emotional abuse, verbal, and eventually physical abuse. It was only because of my upbringing that I was able to leave the final, most abusive relationship. I knew I didn't have to live that way.

"Through Women's Studies, I gained great insight into all the issues of power, control, and domination in heterosexual marriages. Statistics told me the chances of our having had a successful marriage were slight. My partner had less education than I, came from a family background 180-degrees different than mine, and valued things I didn't—and vice versa. I learned all about the dynamics of power in our society and its effect upon male–female relationships. Most important, I learned about myself and the potential I had to create positive changes in the society in which I lived. The standards I had set for myself became set in concrete as a result of my coursework. No more would I bend my principles to try to salvage a relationship where I was not an equal partner to begin with. No more excuses would I make for the possessive or jealous behavior of my partner. Indeed, it was not important for me to even be involved with a man unless it was going to be an equally fulfilling partnership. Now, a few years later, I am committed to a marriage wherein the foundation is equality and mutual respect. I believe relationships like ours are rare; all tasks are shared equally, there are honest and open communication channels, and we are able to truly devote ourselves to our individual pursuits without compromising our commitment to each other."

Postscript: "My teaching partner and I were selected to be the northwest representatives on a national team that will write curriculum on watershed education through a National Science Foundation grant."

Stacy Wynne Dorian—Law Librarian
Colgate University—1987

Stacy was born June 25, 1965, and grew up in the north Bronx section of New York City, the youngest of three girls in "an extremely dysfunctional family where little or no affection was shown." Her father was an interior decorator; her mother was a junior high school teacher. After graduation,

Stacy enrolled in graduate school at the University of Texas at Austin, from which she earned a master of library and information science degree in 1988. She moved to Boulder, Colorado, where she "obtained a job through the old boys network (use it when you can!) at the University of Colorado. I am employed as an instructor, have faculty rank and status, and work as a librarian at the law school. I frequently teach classes and lecture on legal research."

Stacy lives in Boulder. "I spend 40 hours a week imprisoned at my job. I have never been satisfied with my position because it is not intrinsically satisfying for me and I want my job to be fulfilling. I originally and would still like to be a Women's Studies librarian, but the opportunities are few and far between. I have been an advocate for law librarians engaging in pro bono work and have been working on a project with the Legal Center Serving Persons with Disabilities in Colorado."

Stacy described Women's Studies courses as "by far the most relevant I enrolled in while in college. When I took my first course, it was so empowering that I immediately realized the importance of exploring women's history and culture as well as politics. Psychology became a drag, something I had to suffer through and in which I chose to take the minimal amount of classes. I took as many Women's Studies classes as I could. As a major, I was learning about life—my life and the lives of the people I cared most about."

On a professional level, Stacy said, "I refuse to allow any form of oppressive behavior in the workplace. I challenge policies, jokes, comments that I find to be racist, sexist, ageist, ableist, or homophobic. I also do my best to try to educate fellow workers—providing them with information on how to interact with a physically challenged individual or handouts from a workshop on racism, etc. I also have become known as a specialist in women and law, domestic relations, and sexual-orientation law. Faculty and students have all come to me for my insight and to utilize my extensive personal collection of resources. In addition, I frequently lecture on women and law to undergraduate Women's Studies classes, and I spend a good deal of time working one-on-one with students working on papers dealing with feminist/women's issues.

"I attempt to gear any writing or publishing that I do toward women's issues, since nothing else can grab my attention in the same way. I actually enjoy my job when I can work on women's issues. I helped organize International Women's Week my first year here. In addition, every year I set up a Women and Law display to coincide with Women's History Month and International Women's Day. Recently, I shared my knowledge with the new academic community by offering a 'Legal/Legislative Update on Women's Issues' at a local women's-space coffee house—it was a smashing success

and they want me to come back periodically with updates. I also have chosen to align myself with the radicals or troublemakers (as we are seen by the American Association of Law Libraries) in my profession. I was part of pro-choice actions at an annual conference and I was elected co-chair of the Standing Committee on Lesbian and Gay Issues.

"I believe I made a very wise choice to be a Women's Studies major, since the experience was transformational and something that has shaped who I am and how I choose to experience life. I've learned to critically examine the world around me for the hidden agenda impacted by patriarchy. I've learned how to 'dismantle the master's house' as much as I can in my own life. I have chosen to be a woman-identified lesbian, and as such I put my time and energy into women and women's concerns. I was actively involved in the Women's Encampment for a Future of Peace and Justice in Seneca Falls, New York, and I have made a conscious choice to limit my political involvement and civil disobedience to women-only actions. I don't believe it is my responsibility to educate men about their sexism, and after working in mixed groups I decided it was too draining and distracting. In a similar sense, it is my responsibility to learn about and address racism and how I can desocialize what was imprinted within me at an early age.

"I think Women's Studies is essential to young women in the university setting. Actually, it would be a benefit to any and all women since it creates self-esteem and validates our lives and experiences. Women's Studies makes women visible, and in a world where we've been kept in the closet and out of power it is crucial that we gain a sense of our past, an understanding of our present, and a vision of our future." Stacy concluded that "majoring in Women's Studies was the saving grace of my college career. I was enthusiastic and loved my courses. I wound up despising my psychology major and look back on it as a waste of time. My Women's Studies major has been an integral part of my life. It spoke to where I was coming from and where I needed to go. It gave me a voice and provided me with role models of strong, intellectual women whom I could admire. It was a place where my experience was validated and where the learning took place around the clock. I lived, ate, breathed Women's Studies—from the classroom, to the Women's Resource Center late-night discussions, to my role as co-ordinator of the Women's Coalition, my work/study position as Women's Studies research assistant, to my personal life as a lesbian-feminist."

Shizuko Suenaga—Graduate Student in Sociology
University of Massachusetts at Boston—1987

Shizuko, a Japanese citizen, was born January 2, 1958. She grew up in rural Japan "in an extended family: parents, grandparents, one sister. My

parents were probably atypical for Japanese parents because they always told me to get a career. They wanted me to be a teacher, a job in which women receive an equal pay as men." Shizuko earned a bachelor's degree in 1981 from Saga University. Between 1984 and 1988, she earned bachelor's and master's degrees in Women's Studies from the University of Massachusetts at Boston. She currently is studying for a Ph.D. in sociology at Boston College.

Shizuko was an elementary school teacher in Japan for two years prior to coming to Boston, where she has worked part time as a waitress and as a teacher of Japanese. "I'm teaching Japanese at two high schools every day (one period a day at each school). Also, I teach at the Japan Society two classes in one evening. (I give one private lesson a week, too.) So I spend quite a lot of time preparing and correcting assignments. As a grad student, I've been working on my thesis—about the so-called Japanese 'war brides.' The last few months, I've been interviewing Japanese women, usually two per week. So I've been busy juggling the two roles: teacher (worker) and student. I wish I didn't have to work; I could spend all the time finishing up my thesis."

How did Shizuko come to Women's Studies? "When I was in Japan, I read a book that described how sex roles were created in the school system. The book made me think about many things that I had never noticed. I was convinced that there must have been issues I needed to learn as a woman. Also, around that time, I read several articles on Women's Studies in America in the paper. When I started taking Women's Studies courses, I had no intention of integrating the knowledge I was receiving with my career. I was just 'studying' and enjoying the new aspects of the world and human association. But the more I studied, the more I was impressed by the new way of looking at the society. I came to feel a sort of responsibility to let many other women share what I'd learned. So I decided to move on to a Ph.D. program in order for me to teach Women's Studies in the context of sociology in Japan."

Judith A. Bryant—Teacher/Writer/Artist
University of California at Santa Cruz—1988

Judy was born November 4, 1941. An indigenous Californian, she grew up in the "then small town" of San Jose, California, in a family she described as "violent, distant, narrow-minded, silent." Her father was employed outside the home, as was her mother "sometimes." In 1969, Judy attended Palo Alto Vocational Tech, where she was trained as a technical artist/draftsperson. She earned an associate's degree in 1973. Twelve years later, she enrolled at the University of California at Santa Cruz. After earning her

undergraduate degree, with a "thematic focus" on native California history and a minor in sociology, Judy earned an M.A. degree from the College of the Holy Names. She is a part-time Women's Studies instructor, a part-time English tutor, and a self-employed writer and artist.

As a child, Judy's role models were her mother and grandmother; now they are "my Women's Studies teachers and mentors." She considers herself a feminist "because I have come to believe that feminism is the only lifestyle or ideology which offers the possibility of life to all beings." Judy is the mother of a 25-year-old daughter ("she's wonderful") and lives in Pacific Grove, California. "I spend an hour a day in sitting meditation. I live alone, by choice; therefore I am free to take care of household obligations on a flexible timetable. 'Job' is not a word I use anymore. The work that I do now is transformational both for myself and those I teach. 'Job' is a lifeless, nondescript word in this context. I do not see much of my family of origin. My women friends and students are the most significant members/beings in my life. I love tea, gourmet coffee, cats, and finally feeling good about myself. I stay in school, read continuously, and walk a lot. Twice a year I go to the woods in northern California to be alone and to spend time with the Indian women who live there."

Judy said that rather than choosing her major, "I have a deep feeling that Women's Studies chose me. I did not actively seek it and in fact wanted nothing to do with it. I went back to school at age 42 seeking an education without knowing at that time what that meant. A woman came into my life and for six months encouraged me to try 'one, just one' Women's Studies course. Finally, just to 'shut her up' I said yes. That was the beginning of a radical transformation in my life. I am deeply grateful to this woman."

Judy said Women's Studies "has radically changed the way I think about work, about myself, my relationships, life. The change is so deep and so profound it is difficult to draw lines between the professional and the personal. This does not mean there are no boundaries. On the contrary, boundaries are clearer now. It does mean that feminism has taught me the interdependence of all beings, and so there is always a flux, a fluid movement between the worlds I move in. My education has been the gift of my life. Without it I would not be here. Suicide would have been an easy choice had I continued to believe that many of the awful circumstances that have colored my life were my fault.

"When I walked into Women's Studies in 1985, mine was a broken soul. I was taken under the wings of strong women whose primary concern became the unraveling of a belief system that was literally killing me. No matter how much I resisted, these wonderful women kept moving my thinking, not in a linear manner but in a spiral-like space that little by little made the picture clear. With them I raged, I grieved, I laughed, and I grew. I

made the perilous crossing and today remain vigilant, aware always of the forces that would readily recolonize my mind. How do I stay vigilant, aware? I give the gift back: I teach, I write, I listen.

"Recently I celebrated my fiftieth birthday. It was a birthday I never expected to reach. Age was a villain in my life. I watched my great-grandmother, my grandmother, my mother defeated by a system of beliefs deliberately encoded into the very structure of their body cells. When cancer took my mother's life 10 years ago the experience was so awful I made a commitment to change things. I had no idea how, only that the alternative was utterly frightening. Do I worry, get frustrated, angry? Sometimes. Meditation helps. But I trust myself now, so I can create my own work and dream my own dreams."

Patricia M. McGarry — Women's Studies Administrator
University of Massachusetts at Amherst — 1988

Patricia was born January 3, 1964, and grew up in rural Sherman, Connecticut. She was one of seven children in an Irish-Catholic family she described as "stereotypically dysfunctional." Her mother worked outside the home part time and her father "always held two jobs." Patricia studied at Wheelock College from 1982 to 1984, when she transferred to the University of Massachusetts. In March 1988, she went to work as a staff assistant in the admissions office at the Kennedy School of Government at Harvard University. When she left in August 1990, she was assistant director of one of the school's summer programs. "Three days after I left Harvard, I started at Emory University in Atlanta as a program development specialist in the Institute for Women's Studies." Patricia is engaged to be married and lives in Atlanta.

She majored in Women's Studies "because I discovered that studying with women, about women, the history of women was the most important thing that ever happened to me. I went to a women's college for two years and 'discovered' feminism. Wheelock is a teaching college, but a professor there, Marcia Folsom, introduced me to women's literature. Her passion for studying women's lives became my passion. I left Wheelock because I wanted to broaden my education in Women's Studies.

"I have worked only in academia since I graduated from college. At Harvard I cannot say if Women's Studies had a direct influence on my work. Many of the graduate students at the Kennedy School asked me what Women's Studies was, but by then I was quite used to the question. I did get involved with a number of different women's groups at Harvard with students, staff, and faculty. But professionally, I do not know if that made a difference. I do know that I was offered my current job because of my

administrative experience and because I was a Women's Studies major. I cannot think of too many administrative jobs in programs throughout the country where you don't need a Ph.D. But because I understand and believe in Women's Studies as an academic discipline, it helps me in my work with undergraduate and graduate students. It helps me to explain to parents and graduate students what the program is all about.

"Many people close to me have had a hard time understanding why I was a major. It seems to have almost 'frightened' people because they did not understand what it was. This is especially true for my family. I think my parents are still looking for where they 'went wrong,' since the rest of my family is fairly conservative in their beliefs and politics. Because Women's Studies has made me a feminist, this has made me a threat to what my parents believe in, especially my father. It goes against his entire upbringing. Yet in so many ways, Women's Studies has made me a stronger person. It has made me believe in myself more and has helped me to pursue my convictions."

If she had it to do over, Patricia would major again, "but I'd do it differently. I was extremely disappointed in my work at UMass. Because I did not feel accepted into the women's community, I did not accept the community. I could not understand how women who wanted the same basic things could disagree so often. I could not understand how faculty and students who didn't find me 'radical' enough could make me leave Women's Studies as a major. I eventually graduated in Women's Studies, but much of it was a painful experience. If I had to do it all over again, I would stand up more for my own beliefs."

Postscript: "Sadly enough, I am not working in Women's Studies anymore. I moved back to Massachusetts and am seeking new opportunities in academia. I am looking to combine my interests in education, Women's Studies, and politics. If I could offer new advice to students—present and past—I would say, 'Mentors are a vital part of any student's experience, and that is especially true for those in Women's Studies. Choose your mentors wisely and take the time to get to know them.'"

"Vivienne Finley"—Graduate Student in Politics
Mount Holyoke College—1988

Vivienne was born in 1966. She grew up in small-town Massachusetts "with a sister, three years younger, and two parents until 1979. When my parents divorced, I lived with my sister and mother. My father visited with us sporadically." Vivienne attended a girls' boarding school for twelfth grade "and I have not lived at home since." After graduating from Mount Holyoke, with a second major in politics, she worked for a year at a private

girls' school in Massachusetts. "After being laid off, I waited tables for a year in Northampton. In 1990 I moved to Washington, D.C., and after a brief internship was employed full time." She recently moved to Denver, where she is studying for a master's degree in politics and working as a teaching assistant. Vivienne is in a "long-term committed relationship (five-plus years)" with a woman.

She majored in Women's Studies because "it was the single most interesting field I encountered in college and spanned all the disciplines. I could take any class on campus and use the skills developed in Women's Studies to analyze and critique topics in an entirely new way. In psychology, you could question Freud's methods; in science, you could debate an 'objective and impartial' law. I found it far more stimulating and relevant to my life than most traditional majors."

Because of her major, Vivienne said, "I take risks. I question everyone and everything. I don't respect titles as much as I respect an individual. I treat everyone as I would like to be treated and I avoid 'pulling rank' when I'm in a position of authority. I am far more radical than I may look on paper. What I believe in my heart—much of which I fleshed out in my Women's Studies courses—is what drives me to move on, and I hope to find a job that pays me what I deserve without compromising my beliefs. This is not an easy task. I also have developed organization, fund-raising, and management skills that I want to eventually use to further my beliefs."

On a personal level, "Women's Studies has challenged me to continue to search for my niche—to do exactly what I want to do. I look back on my undergraduate education, where over half my classes were Women's Studies, and I loved every minute of it. I love learning, I love knowing women's history, I love reading the authors, and I still have all the books. It was like being on the same playground with 50 kids and 5 of us got to play on a much better swing set. We saw the world in a whole new light."

Postscript: "Since coming to Colorado, I have been coordinating the Women's Studies program—almost nonexistent, without staff or much of a budget, and with just a handful of courses. Our school is located on a city campus shared with other schools; there is a total population of 38,000 students. The majority of students are paying their own way through school, with a large nontraditional population and a very accessible campus for people with disabilities. And it is a commuter campus. It is a difficult place for people to consider Women's Studies rather than a 'useful' major, since they must provide every cent they spend on classes. We do not have a great many students in the program, although many take the classes.

"I began hosting a series of Women's Studies events, creating a news bulletin for faculty and staff, putting out a call for membership to all women on campus, and trying to meet as many people as possible. What I

am realizing is how far we need to go to truly establish the kind of program I would find acceptable. There is a great deal of complacency at area schools. There are no 'calls to arms' over important feminist/women's issues, there is no active organizing—but there is an urgent need to get together and push for more cohesion, bigger programs, and more consciousness raising for traditional-age students, especially women—and to do it now.

"My point to all this 'reporting from the front line' is to emphasize that having Women's Studies on the books is not enough. We really need to keep developing the programs across the board. As a Women's Studies graduate, I feel very committed to making this program better and to organizing with other programs nationwide."

Susan Brookman—Social Work and Women's Studies Professor Metropolitan State College of Denver—1989

Susan was born May 14, 1938, the younger of two daughters. Because her father was a career Air Force officer, she grew up "all over"; her mother was a full-time homemaker. Susan dropped out of the University of Colorado in 1957 after a year. She enrolled at Metropolitan State College of Denver (MSCD) in 1986. Following graduation, she enrolled at New Mexico Highlands University (NMH), where she earned a master of social work degree in 1991. "Until I moved to New Mexico I worked in an attorney's office. During breaks and vacations, I worked in retail sales in Santa Fe. Following graduation from NMH, I began teaching in the Social Work Department at MSCD and Women's Studies at Front Range Community College in Broomfield, Colorado." Susan has been living with a male partner for 11 years; she is the mother of three adult daughters and an adult son. She lives in Denver, where "my week is centered around my teaching duties. I need to spend at least four hours in preparation for each class (I'm a new teacher). This comes before anything else. I want to bring the best information in the most interesting way to my students. I'm crazy about them."

Of her own student days, Susan said: "I was fortunate in that the first class I took as a returning student to MSCD was 'Introduction to Women's Studies' taught by Jodi Wetzel. We worked our butts off. It was more than challenging. I loved what that class opened up for me and I discovered that if I could get an A from Dr. Wetzel I could get an A in any other class at the college. It was one of the few college classes I took that made absolute sense, and I knew I had found (at last) my academic place. Remember, I was 48 when I returned to school. From the first day in Women's Studies, I was hooked. I believed that I was the most fortunate person in the world to be able to learn about women and to be in the company of these marvelous women at college.

"I am told that I was hired at MSCD with a master's degree because my major gave me the advantage over other applicants to teach the course (required) 'Women's Issues in Social Work.' There is a recognition that it requires study in the discipline to be able to teach it. And really, if one has not taken advantage of the opportunity to take these courses, it may imply misogyny or extreme male identification on the part of the instructor/applicant that should call into question the ability she or he may have to teach about half of humanity."

"As it seems to happen with many women who take an 'Introduction to Women's Studies' class, my life changed. One of the reasons I did not complete college in the 1950s was because I was depressed (clinically) and had no self-esteem. I didn't know it at the time, however. Within a month of my being in Women's Studies, I was in therapy with a feminist psychologist, and I was on my way to understanding and working through a lifetime of abuse. My fascination with Women's Studies made it possible to do well in the class. I earned an A in that class and every other class I took in college. I graduated number one in my class of 1,200. Leading my class into graduation was one of the happiest moments of my life. I am still proud of it.

"Further, because of Women's Studies my relationship with my children has improved. My relationship with my abusive parents is resolved. *And* my relationship with my significant other is what I want it to be. I sure did learn how to ask for and get what I want in a relationship. I laugh because we now share household tasks the way working couples do. I do 75% and he does 25%. This is in a household where I am a feminist and he is a pro-feminist. Some things change more slowly than others.

"*But most of all, personally, because of Women's Studies, I have come to know and believe that it's my world, too!*"

Would Susan major again? "Oh yes. I regret I wasn't able to take all of the courses that were offered. The first day, my professor asked us why we were taking Women's Studies, and I said I was taking Women's Studies because I wanted to be a dangerous woman. I have not changed my mind."

Postscript: "I opened my psychotherapy practice in June 1993; my clients are mostly women. I'm applying feminist theory and brief, strategic-therapy techniques in helping my clients learn problem solving in their lives."

Megan S. Mitchell—Graduate Student
University of Richmond—1989

Megan was born November 14, 1967, and grew up in suburban Pittsburgh. "My parents were divorced when I was an infant. My mother and I lived with my maternal grandmother until I was 11. My mother and I lived alone together until I was 18. I never met my father." After receiving her B.A.

degree, with a second major in English, Megan went to work as a reference assistant at Boatwright Memorial Library at the University of Richmond (UR). In September 1990, she started graduate school at Rutgers University and began working as a part-time student assistant in the serials department of the library. She added another part-time job—information assistant in the reference department—in January 1991. She received her master of library service degree in 1991 and is continuing with graduate studies. Megan is "single; not dating." She lives in Somerset, New Jersey.

Like our other UR graduates, she learned of Women's Studies through her participation in the Women Involved in Living and Learning (WILL) program. "After the introductory course, taught by a feminist psychologist (an adjunct professor), I never considered *not* majoring in Women's Studies. Nearly everything this teacher said applied to me or to someone I knew. She named things for me, made me feel connected in ways I never had before. Majoring was something I had to do for myself."

Professionally, "Women's Studies provided me with wonderful role models—both in history and on campus. My courses made me aware of women whose efforts created the opportunities available today. My professors encouraged me to set high goals, taught me valuable skills, offered practical advice and moral support. Women's Studies improved my self-confidence by reinforcing my belief in myself and teaching me how (and in some instances when) to assert myself. It gave me an idea of what I could expect when interviewing and in the workplace; it made me more sensitive to subtle forms of discrimination. I learned how important it is to be sensitive to office politics and to understand how power shapes relationships. Women's Studies prepared me for my professional life by teaching me about myself and about the world in which I will work.

"From the first day of class, Women's Studies named things for me, confirmed feelings that I had, made me realize that I was not alone. In a way, Women's Studies introduced me to myself. The courses, the professors, and my fellow students (male and female) changed the way I think about myself, my family, my friends, my relationships with men, and my place in the world. My courses prompted me to look at my mother with new eyes and improved our relationship by helping me see her as a woman with many roles, only one of which is 'mother.' Since my family is small, friends have always been important, but Women's Studies helped me understand just how valuable friendships among women can be. Through my courses I met women I hope to know for the rest of my life. Women's Studies made me think more critically about my relationships with men, examine likely roots of fears, expectations, and patterns. It challenged my assumptions about society, history, literature, education, religion, politics, and health care, and provided me with new perspectives on things I'd taken

for granted all my life. It increased my awareness of gender, race, and class issues—close to home and around the world.

"There have been times when my heightened sensitivity has been as much a curse as a blessing—reality can be hard to bear when I know how things 'should' be. I have been hard on myself and my friends for compromising on difficult issues, particularly in terms of our relationships with men. It was easier to be a 'radical' thinker in college than it is in daily life. I still have hope for a better world for women, but I admit that I am often cynical. The title of the textbook from my introductory course, *Women's Realities, Women's Choices*, is on target; the truth is not always palatable, but I would much rather know how things are and be able to make informed decisions."

"Augustine"—Researcher
University of Arizona—1990

Augustine was born August 18, 1918. "My parents were divorced when I was 5 years old. I was 'boarded out'—to a school and friends; lived with my mother (who was self-employed) for a number of years—in New York, California, and Israel. At 18, I was on my own—earning $10 a week— paying rent, food, and clothing, supporting myself." Augustine dropped out of high school in the eleventh grade. In 1965, she earned her general equivalency diploma and then attended community college at nights, earning her associate's degree in 1970. She entered the University of Arizona in the summer of 1987 and enrolled in home economics. "I found out there was a Women's Studies major available; I changed my major and I'm happy I did. I was 69 years old." She had worked in a factory as a bookkeeper before her marriage in 1940. "The day after I was married, my husband got me a temporary job with the state (New York). When he bought a business, I became the bookkeeper until I became pregnant. Then I became a housewife. I went back to work for him when we moved to another location. This was just adding another 'hat' to the many 'hats' I wore at the time."

Augustine considers herself a feminist: "Having been married in 1940 and divorcing my husband after 45 years of marriage, I was painfully aware of the inequities of marriage in our social system." The mother of two adult children, she lives in Tucson and audits classes at the University of Arizona. "The days pass very quickly for me. Being on campus two days a week, there is a great deal of reading to be done. Theater, movies, concerts, and lectures are also part of my 'curricula'—as well as traveling. I have made some wonderful young friends, who were originally in classes we shared. Some are working on their master's degrees and will go on for their Ph.D.'s. We share a common knowledge and enjoy getting together. Of my own

chronological-age peers—communication is on a different level and not as interesting. I am interested in being an assistant to someone doing research on older women. So far, no luck, but I explore any contact I'm given. I have not sent out resumés as I do not want to leave the state. I am hoping something will turn up.

"I never stopped to ask myself—'why' Women's Studies. I only know that when I came to the university, looked at the catalogue of courses offered, and saw 'Introduction to Women's Studies,' I told the adviser that I wanted to take it. She said, 'no,' I should take another, as the professor was only going to teach it that term. In the fall, when I saw my adviser again to set up my program, she was leafing through all the requirements (that didn't really interest me) when again I saw 'Intro to Women's Studies,' and it was at that point she said to me, 'Augie, do you know you can major in Women's Studies?' It was an exciting moment for me. Something in my psyche told me this is what I wanted. I will never have enough! Women's Studies obviously fulfilled a need to know.

"When one chooses to do something that is out of the mainstream of today's society, there are pluses and there are minuses. I find it intellectually stimulating to be on campus and to enjoy the company of the young people—most of them are a little this side of 40, or a couple of years into 40 (my children's ages). We find we have a great deal in common and share many interests. What Women's Studies has done for me has been to truly 'broaden my horizons' and make me aware of the position of women in this patriarchal society. When I get a chance, I sound off, and perhaps some of it is taken to heart. I have two granddaughters and two grandsons. Hopefully, I have shown them that you can do most anything if you are willing to try.

"Women's Studies has helped me define myself, where I've been and what I am now. I am an independent woman, beholden to no one, other than to myself. I am able, in my small way, to be there for those I love and care for. Women's Studies has made me more aware of the inequities and inequalities of women, be they Anglos, minorities, or lesbians. We have a long row to hoe before women are treated as equals at home or in the workplace. With the Supreme Court eroding some of the civil rights laws and Roe v. Wade teetering, we need to make the young women coming out of high school aware of what they face in the workplace and at home.

"I learned a long time ago that all through life, we make choices. Coming to the university and majoring in Women's Studies is one of the best and finest choices I have made in my long life."

Postscript: "I'm active in NOW. I traveled to Israel and the occupied territories with a woman-to-woman peace group organized by the Middle

East Children's Alliance. I returned to the United States far more concerned
with the situation there."

Aurora M. Sherman—Preschool Teacher
Pomona College—1990

Aurora was born June 8, 1968, and grew up in rural southern Oregon
with her parents and younger sister. "Dad very loving but uncomfortable
expressing it. Mom suffered severe clinical depression. Working class,
moved many times (seven times before I was 12)." After graduating, with a
second major in psychology, Aurora worked for four months as a recep-
tionist/mail clerk at the college. Since October 1990 she has been an assis-
tant teacher at The Learning Tree Montessori Preschool in Seattle.

"Life is so ever-changing, it's hard to decide what 'typical' is for me.
For example, my mother was diagnosed with advanced breast cancer and is
in the middle of horrific chemotherapy treatments, so much more of my
time is taken up with weekend visits, letter writing, and moral and emo-
tional support for both my parents. In addition to my demanding, often
more than full-time work, I am currently applying to graduate school. I
have spent time volunteering on a statewide abortion-rights initiative."

Aurora said majoring in Women's Studies "was a way of solidifying
my wide range of feminist interests, from history to religion to politics to
psychology, in a program that reflected those interests and gave me a solid
background in many of them. It allowed me to combine my scientific inter-
ests in psychology with my emotional and intellectual growth as a feminist.
Most of the classes I took were interesting and intellectually challenging,
but the Women's Studies classes engaged me emotionally as well. They were
the ones that I *loved*, not just enjoyed."

Aurora said "the biggest test of how Women's Studies is going to affect
me professionally is just now coming up, as I apply to graduate school and
attempt to continue in my professional development after a one-year
breather away from school. But my feeling is, if a school doesn't want me
because of my major, it's more than likely not an environment I want to be
in anyway. However, so far since graduating, my feminism and the major
have been helpful. The preschool where I teach is a progressive facility,
with a group of teachers and directors excited about nonsexist, nonviolent,
antibias curriculum. We work together to integrate environmental aware-
ness, conservation, feminism, peace work, and antibias work in the class-
room and in educating the parents.

"I also serve as the teacher liaison for the parent committee working on
ways to increase child-care funding on the state and local level. My feminist

awareness of the racial and class 'factors' in child-care funding and use is useful in guiding our work. Past projects have included programs for Women's History and Black History Months, and an exchange program with a local retirement home to develop intergenerational contact. One of my future projects will be assessing our library, using my 'feminist lens' to see where (and if) we are lacking."

Personally, "My decision to major in Women's Studies was a logical development in my increasing feminist awareness, so I tend to use feminism and Women's Studies interchangeably. I met my greatest friends and allies in Women's Studies; my two mentors are Women's Studies professors. I became a part of a feminist community at Pomona that included Women's Studies majors, but also many folks involved in other areas. I was one of two original graduates. The Women's Studies classes were the ones that affected me on a personal, intimate level, the ones I loved and remain passionate about. It also had its downside—because I was a vocal feminist, actively and publicly engaged in a wide variety of projects both within the feminist communities and the larger college environment, I was often an easy target. I received threatening phone calls (anonymous, of course), hate mail, and ridicule in the college paper. I was often seen as a spokesperson for feminist projects in which I was not at all involved, almost an attempt to reduce all feminist activity to one person. However, I don't scare easily! Through all this, my leadership abilities grew, my resolve and determination strengthened.

"It's hard to put into words exactly how Women's Studies affected me. It really entered into every aspect of my life; changing relationships, professional goals (I was first planning to be a kindergarten teacher, now I'm aiming for a Ph.D.), global awareness, music (!), added self-confidence. I would say even with the few problems, the experience was overwhelmingly positive, and since I've graduated I've become part of a *much* larger community and so feel much less a target."

Postscript: "I have nearly completed a difficult first year as a Ph.D. student in developmental psychology at the University of Michigan. I am planning research in social aspects of aging, especially age and gender interactions with friendship. My mother's battle with breast cancer has taken an ominous turn, but I am pleased to be back in school in such a well-known and rigorous program."

Susan Zeller—Graduate Student in Counseling Psychology
Barnard College—1990

Susan was born September 2, 1968. She grew up in Silver Spring, Maryland, outside of Washington, D.C. She has a sister two years younger than

she "plus we always had a relative or friend living with us." Both her parents worked outside the home; her mother was executive director of a nonprofit organization affiliated with Georgetown University. Susan studied at Hebrew University from January to June 1986, and in September enrolled at Barnard. During her junior year, she spent three months at the University of Edinburgh, Scotland. After graduation, Susan was employed for a year as a social worker for the Jewish Association for Services for the Aged and as a research assistant for a graduate student in social psychology. Since June 1991 she has been a full-time graduate student in counseling psychology at the University of Minnesota (UM), where she is a research assistant for the Minnesota Twin Study and a teaching assistant for "Psychology of Women."

Susan "started college planning to major in economics with the intention of going into business. I had some second thoughts my first year because I took some great political science classes. In line with my economics major, I took a class called 'Sex, Discrimination, and the Division of Labor.' This course changed my life. I did not want to go to Barnard because I didn't see the point of a women's college in a world I thought was now free of sexism. I thought the sexism battle was won in the 1960s and I was ready to move on. The 'Sex Discrimination' course showed me that I was quite wrong. Clearly, though, I had to be ready to see this.

"I think a year at Barnard in an environment of all women facilitated my ability to see a truer experience of women, my own experience included. I also met some women who proudly called themselves feminists during this time; some were Women's Studies majors. Inspired in 'Sex Discrimination,' I took 'Women and Men: Power, Poetry, and Politics.' This is the introductory Women's Studies course. The reading was extensive, but I ate up every last word on every last page. The course met once a week as a lecture and once a week as a discussion section. Jane Bennett, the teaching assistant who facilitated my discussion section, was dynamite. She asked the questions that made me think all week. And she expressed her confidence in me, thus making me feel really strong.

"Although these two courses were instrumental in my decision, the other major factor in my decision was a feeling of community. By the middle of second semester sophomore year, I had met a bunch of women I really liked. They all encouraged me to study Women's Studies. I had already filled out a major-declaration card saying that I was going to be a political science major when I started thinking about changing my mind. I talked to one of the inspiring women I had met and she took me to talk to Leslie Calman, her adviser and acting chair of the department. We talked for a while and then I finally said, 'But will I ever get a job if I major in Women's Studies?' And Leslie told me that employers *would* wonder about

my major. But she suggested that it could lead to an opportunity to have an interesting discussion during a job interview. Most important, though, I felt like people were excited for me to be a major. Nobody batted an eyelash when I decided to be a political science major; I was just another major. But in Women's Studies, I was part of the community. Once I realized that what I was enjoying the most in college was my Women's Studies life, the decision to major was easy. The hardest part came after I made the decision, though, because then I had to face doing something that wasn't too popular in the mainstream."

Susan explained that professionally "my major is part of me. I see Women's Studies and feminism as an articulation of all that I know to be true. Therefore, I cannot talk about it as a thing separate from me, an isolated force which works on my life. Given that preface, though, I can say that my activities since graduation have been women-focused. When I graduated I got a job as a social worker for a community-based agency serving the elderly in Brooklyn. Given aging demographics in the country, I worked mostly with older women. My tasks ranged from case management to counseling. But, mostly, I saw the year as a chance to learn about the lives of the women I came into contact with. In a sense, I saw my experiences as a continuation of my work in Women's Studies. I was and still am particularly interested in the way our society discards older women. And I am continually inspired at older women's resistance.

"One of the attractions of UM is its advanced degree in feminist theory. The Center for Advanced Feminist Studies offers a minor in connection with any other degree-granting program. Given the misogyny of traditional psychology and the ways in which traditional research methods erase the richness of women's experience, I cannot imagine working toward an advanced degree without the support of a feminist community. Academically, Women's Studies provides a grounding for me to turn to for a more positive perspective of women. It is validation that women resist. Often I turn to feminist writings to help me articulate ideas that I have been working on but which I have not been able to bring together.

"My professional goal is to work with women in a feminist therapy model. I anticipate that my degree and professional track will also lead to advocacy and policy work. A feminist psychology understands women's experience in the context of social forces. In order to better the life of one woman or the lives of all women, individual psychotherapy will never be enough. And, in fact, to work professionally purely as an individual therapist is only perpetuating women's oppression. Finally, my own program in Women's Studies provided me with role models (faculty) for how to live my life, professional and otherwise, with integrity."

In response to our question about the personal effects of her major, Susan replied: "The full answer to this question would be a complete auto-

biography. Women's Studies showed me feminism and feminist theory. I understand these things to be the articulation of what I already know to be true. I feel comfortable with the questions and framework it provides. My life follows its framework because it is true to me. This, in contrast to me thinking that feminism is right on and so I follow it. Feminism is not a doctrine I bought into. Women's Studies does not affect my life. Rather, I live Women's Studies."

Postscript: "During the 1992–1993 academic year, I worked as the editorial assistant for *Signs: Journal of Women in Culture and Society,* which provided me an invaluable view of academic feminist scholarship. My relationship to Women's Studies has changed as a result of that work and my coursework in advanced feminist studies. However, I have not found graduate school to be the academic, personal, or professional experience I expected or wanted. I have decided to leave my program with an M.A. in psychology and a minor in feminist studies. After I complete my degree, I expect to pursue work as a therapist."

Deborah A. Cohler—High School Teacher
Wesleyan University—1991

Deborah was born March 30, 1969, and grew up in Berkeley and San Francisco. "My parents divorced when I was 12. Until high school, I lived with my mother and older brother. In high school, I lived half of each week with mom and half with my father, stepmother, and two stepsiblings." Her mother is a travel agent; her father is a lawyer. Deborah enrolled at Wesleyan, in Middletown, Connecticut, in 1987. The summer following her graduation, she worked at her father's law firm. Since September 1991, she has worked at Drew College Preparatory School teaching algebra, computers, and theater, and coordinating student life. "I hope to teach English or a Women's Studies elective next year." A lesbian, Deborah is "involved with a girlfriend"; she lives in San Francisco.

Deborah "was in the first class of Wesleyan students who could major in Women's Studies. I had been taking classes within the English major, which cross-listed with Women's Studies, and my academic adviser was on the Women's Studies steering committee. My interest was in gendered analyses of literature and I wanted to major in Women's Studies. Politically and intellectually, it seemed to be the right place for me. As well, English is an extremely large major at Wesleyan; it is easy to feel lost or insignificant as an English major. The small size and individual focus in Women's Studies appealed to me. I also wanted to be in the senior seminar. So a lot of different factors brought me to Women's Studies."

Deborah said her major "affects my teaching daily. Though I am not teaching Women's Studies at the moment, the way I learned to think and

view dynamics between individuals helps me in all respects. In the class-
room, I assign feminist pieces to my word-processing students. I also point
out gender biases in the algebra textbook which my school uses. I try to
encourage my female students to feel confident using computers and doing
math. I change word problems so that women and men are not slotted
into stereotypical gender and sex roles. For example, I saw a problem in
the teacher's manual that began, 'Betty and Sue are writing invitations to
Sarah's wedding.' The problem I assigned my students began, 'Manuel and
Akeisha are writing letters to their senator.' My Women's Studies courses
taught me to see race, gender, class, and sexuality as interconnected issues.
The critical skills I acquired affect how I conduct my class.

"Outside the classroom, my major informs my input in faculty meet-
ings, my interactions with my colleagues, and the committees I sit on.
Currently, I am part of committees to formulate a sexual harassment policy,
to institute advising groups, and to review our ninth-grade curriculum.
When I feel that girls are being overlooked or when a tone upsets me, I
speak up. The major trained me to see individual issues in social context. I
think my comments and contributions are less 'antagonistic' than they
might have been had I not been a major. For example, rather than attacking
an idea as 'sexist,' I can suggest alternative structures or talk about cultural
forces and how we as educators can shape or react to existing conditions. I
am also viewed as a resource on the faculty when students are racist or
sexist. I cannot emphasize enough how much Women's Studies shapes my
professional choices."

Deborah finds it difficult "to pinpoint how the major has affected me
personally. It contributed to my development as a feminist, as an intellec-
tual, as an activist. The interdisciplinary, multicultural (I hate that word
now!) emphasis trained me to be aware of myself as a gendered and racial
subject, as part of a political system which privileges my whiteness but not
my gender or sexual orientation. The major gives me a context for my
reactions to the events and people that surround me. It fuels my continuing
interest and commitment to political and cultural events. It gives me a way
to react to the morning newspaper and to people with whom I interact. To
be more specific is a daunting task because I feel that so much of who I am
comes from and through my experiences as a Women's Studies major."

Postscript: Deborah left her job at Drew to pursue a Ph.D. degree in
English.

Betty Eppler Gooch — Graduate Student in Counseling and Guidance
University of Arizona — 1991

Betty was born June 13, 1947, and grew up in the small town of Miami,
Arizona. "My parents were 42 and 44 when I was born. I had two nephews

(sons of older brothers) when I was born. One nephew lived with us until age 5; I was closer to him than to my sister, who was six years older than I. My family was and is totally 'blue-collar.' They expected me to marry and be a homemaker; they discouraged college." Her father was a copper miner; her mother was never employed outside the home. Betty has been married for 26 years and is the mother of two adult daughters. Her husband was in the U.S. Air Force, "so I worked wherever we were stationed. I was employed with civil service for 10 years. Before that I worked as a sales clerk occasionally, but mostly I was a homemaker." Betty enrolled at the University of Arizona full time in August 1989; she previously had spent varying amounts of time at the University of Maryland, Bellevue (Nebraska) College, Metro Tech in Omaha, Nebraska, Rose State College in Oklahoma, and Pima Community College in Tucson. Betty lives in Tucson and began work on a master's degree at the University of Arizona in fall 1991.

"All the while we were moving around, I was interested in women's issues. I was aware there were Women's Studies programs, but never found one offered where we lived. When we 'retired' in Tucson, I was pleased to see that the University of Arizona offered the major. The program offered all the classes I was interested in—I wanted to learn more theory and more cross-cultural women's issues. With my husband out of the military (a job which paid our bills but exacted a *heavy* toll), I felt it was *my* time to pursue *my* interests—women's issues."

Asked how Women's Studies has affected her professionally, Betty noted that "this really doesn't apply to me since I went right into grad school after graduation and have not really worked yet. I expect to specialize in counseling women, so my major will play an important role once I become a professional.

"For some reason, I always felt that women's lives were more interesting than men's. Women's Studies confirmed that for me. I am in a period of my life when I have *no* interest in what old, white men think, say, write, sing, etc. There are so many books, essays, plays, songs, etc., by and about women that I've become aware of, I just want to make up for lost time and embrace them all.

"I am so thrilled that my husband is away from the military. He now works in a 'normal' job—store manager—and our lives have expanded because of the great women I met through Women's Studies. When we attend a lecture or concert and see these women (and their partners), there is always much hugging and laughter. I feel much closer to these people than most of my family. My daughters (one married with stepson and one single) are here in Tucson and add a lot of joy to my life. I feel they look at me differently now—I'm more assured and interesting and full of knowledge about women's strengths.

"In my graduate program, not everyone is feminist, so I am the resident defender of women. I can't help but take on that role. In the past, I didn't have enough courage to challenge sexism at work or in my personal life. I'll never be like that again. I know now that there are plenty of like-minded individuals out there and have been for centuries. I've met a lot of lesbian friends and rejoice in being included often in their community activities and support. All in all, I feel part of a *community* of women—they will be there for me in the coming years. I just hope some of this will rub off on other women when I become a counselor and can make a difference in other women's lives. We are so great! I want everyone to realize it."

Postscript: Betty received her M.A. degree in May 1993 and is employed at Tucson Shalom House, a shelter for homeless women and children. "I use my Women's Studies background daily in working with clients—especially in group counseling. My Women's Studies friends remain a big part of my life; we meet regularly to socialize, exchange books, attend plays, and just generally enjoy one another. One of my next goals is to become more active in the local community support group for Women's Studies; that's one way I can help the next generation of scholars."

"Martha"—Academic Administrative Assistant
University of California at Santa Barbara—1991

Martha was born May 27, 1958. She grew up in suburban St. Paul, Minnesota, in a family she described as "abusive, oppressive, alcoholic, and misogynist!" Her father was a factory worker and cab driver; her mother was a factory worker. Martha earned a general equivalency diploma in 1976 and first enrolled in college in 1985. She attended Santa Monica (California) College for a year, then Santa Barbara (California) City College for a year. She enrolled at the University of California at Santa Barbara (UCSB) in 1988 and double-majored in sociology. Since graduating, she has worked part time as an office assistant and as a bartender and waitress. She currently is a full-time administrative assistant at a California academic institution. "I am a single parent [of a 6-year-old son], so much of my time not working is spent caring for and being with my child. I am continuing my feminist studies in a 'self-directed' program, which means that I am doing some reading that I didn't have time for during school. I miss school because social and political activities were so accessible, and there was *time* for them." At UCSB, Martha was co-founder of a nontraditional student organization and served a year as an undergraduate representative to the Women's Studies Advisory Committee.

"I had dropped out of high school and returned to college finding everything fun, manageable, and challenging. Yet I didn't really find a focus

until I took my first Women's Studies class. Then, everything that I had studied up until then came into a new light — Greek philosophy suddenly became comprehensible under feminist analysis, and many of the experiences and thoughts that I'd had were suddenly being recognized, discussed, and even researched. Women's Studies felt like 'home'; it is a way of viewing the world that is closer to my experience than is offered in other disciplines. When I first went back to school, it was with the intention of pursuing a profession that would have fit perfectly with my gender-role socialization. I stayed with this intention up until my senior year. Now I have decided to pursue a graduate degree in either sociology or in an interdisciplinary program with the intention of teaching Women's Studies."

Personally, Martha said, "I've become more aware of myself in the world, and of my sexual, racial, class, and gender identity. I've discovered a sense of belonging and importance in the sense of feeling as though my experiences actually *mean* something in a sociohistorical context. I parent differently and relate in a much more effective manner to the men and women in my life. I feel enriched by the astounding role models that have surrounded me and given me a positive role model that I feel proud to emulate."

Postscript: "I am in my second year of a Ph.D. program. As a head of household, I am unable to survive on sporadic teaching assistantships, so I have kept my full-time job. The struggle to continue my education *and* stay financially afloat has led me to reevaluate my goals. I have left behind the idea of full-time teaching and am working toward a future in educational administration, an area where increased consciousness about race, class, and gender is sorely needed."

6

LAW AND GOVERNMENT

In 1970–1971, in the infancy of Women's Studies, 7.1% of law degrees awarded were conferred on women (U.S. Department of Labor, 1975, p. 208). By 1988–1989, that percentage had grown to 40.8% (Ries & Stone, 1992, p. 289). As our final group of profiles demonstrates, Women's Studies graduates who have been a part of this wave found their undergraduate major to be excellent preparation for law school and law practice. As Eve Belfance observed:

> Women's Studies teaches you to deconstruct every idea, every premise, every belief. This constant questioning and disciplined analysis has served me as an attorney because it is necessary for me to engage in rigorous analysis in order to do the work I do. I learned critical analytical skills and developed an ability to distill my thoughts into ideas, then express those ideas in a coherent fashion either orally or in writing. Those tools have proved invaluable to me professionally.

Certainly those tools also prepared well the graduates whose career paths include law enforcement and governmental leadership.

Annie Thorkelson — Freelance Legal Worker
University of Massachusetts — 1977

Annie was born December 14, 1955. She and her three older brothers grew up in Storrs, Connecticut, in an "intact academic left-wing family. My parents are old radicals and very supportive of me." Her mother was "not usually" employed outside the home; her father taught at the University of Connecticut. Annie noted that she graduated with a B.D.I.C., "officially a bachelor's degree in 'individual concentration.' UMass didn't yet offer a B.A. in Women's Studies; 1977 was only the second year in which a student was allowed officially to major in Women's Studies. I graduated summa cum laude, and it was one of my proudest moments." She went "immedi-

ately" to Antioch School of Law and earned her J.D. degree in 1980. That was "followed by two years at D.C. Legal Aid Society (family law litigation); editor at Legal Services Corp.; move to California—coordinator for the 15th National Conference on Women and the Law; one year criminal defense; another year of editing; about five years of civil litigation (family law, civil rights, general practice)."

Annie, who lives in San Francisco, noted: "I change my life often. In the past two years, I've traveled through Europe, the Caribbean, and the Mideast, and left a downtown well-paid associate position for freelance work. I taught legal writing to law students. I am active in the abortion rights movement. I spend a lot of time with children and read a great deal. I have recently begun a new relationship with a woman who lives in D.C. I volunteer at The Women's Foundation, a small philanthropic feminist foundation."

She majored "because Women's Studies spoke to my heart. Essentially, it provided me with a philosophical framework for how I perceive the world and for development of my values. Being a strong feminist gives me strength but also makes me very intolerant of the value system women must contend with in a professional world. I find it hard to be polite with my colleagues in the legal profession who are not, shall we say, politically sensitive. Indeed, I came to the point where I could no longer tolerate the game with equanimity, so I quit my job. I am now working pretty exclusively with other progressive women, and I'm much happier." Annie said that although Women's Studies "also shut some doors, they were not doors I was much interested in going through in the first place." As for the major's effects on her personally, Annie said: "I could write tomes. My feminism is my strength and my foundation. I came out as a lesbian at 16, before I had a political consciousness. Feminism and Women's Studies spoke directly to me and gave me community and self-respect. I am still a committed activist feminist, and I always will be."

Postscript: "I am still working as an attorney. I describe myself as freelance mostly because I change jobs frequently as a survival mechanism in this difficult profession. I am currently a research attorney with a firm in Oakland, California, that specializes in asbestos litigation and other products-liability cases (such as silicone-implant and electro-magnetic-field litigation). At least I'm on the right side of the issues here, and the best part of being a lawyer for me is the research and writing."

Eve V. Belfance—Lawyer
Yale University—1984

Eve was born January 23, 1962, and grew up in Akron, Ohio. "Until I was 13, my parents were married. We lived together with my maternal grand-

mother." Both her parents were employed outside the home. After her parents divorced, Eve lived with her mother, sister, and brother. Following her graduation from Yale, she worked in an art galley in Athens, Greece, and then was involved in hotel management in New York City and California. She enrolled at Case Western Reserve School of Law in 1987 and received her J.D. degree in 1990. She worked summers as a legal intern and was employed at a large firm in Cleveland before joining her mother in practice. Eve lives in Akron, Ohio. "At this point the focus of my life is my profession. I have not been in practice long, and as such spend the majority of my time learning to practice."

Why did Eve major in Women's Studies? "I was searching for answers. Yale in itself is the hallmark of male tradition and male history. Despite the fact that women composed much of the campus, I somehow never felt 'right' there; I felt out of place in the environment. By my junior year, I deduced that the discomfort I was feeling was due in part to the fact that I was attempting to assimilate myself to an environment which was based upon a completely male ethic and tradition. It was in that same year that Yale allowed women to major in Women's Studies. I decided to explore the discipline for personal reasons. I felt a need to understand why I always had this feeling of not quite belonging, not quite relating to what was around me.

"In an immediate professional sense, Women's Studies does not directly impact me. I am not an academician and have not continued my interests in the discipline at a professional level, although one day I may choose to do so. But my major has had an impact on me professionally because the discipline itself taught me to examine every premise with a critical eye."

Personally, "you *never* see the world the same again. I think Women's Studies had a tremendous impact on my personal development. By that, I mean exploring and discovering my essence as a woman and as a human being. I believe that women feel a general malaise socially and in their professional milieu. I believe that malaise is due to the fact that social and professional strictures have been structured in a manner which coincides with what makes men comfortable. Men have found these strictures to suit their nature, and women are continually attempting to adopt to strictures which don't comport with their basic nature. I think Women's Studies has given me the ability to tease out these subtle yet powerful societal influences. I can confidently build a world and a work environment which suits my 'femaleness' instead of trying to 'fit' into a male-established environment. I don't think I would have been able to put my finger on and name the problems I see women having or have felt myself without the aid of Women's Studies.

"In many respects Women's Studies has set me 'on the edge' of American society. I don't feel as if I belong to or identify with most women or

men. I feel as if my ideas and my consciousness are atypical of my peers. I guess in many respects Women's Studies taught me to be very critical of the society in which I live. I have questioned every aspect of that society via an array of disciplines—history, sociology, anthropology, psychology, literature. When you examine each of those critically and discover that your life has been influenced by men, that the ideas and perspectives you've been given from day one are those of men, that what is 'normal' is what is male-defined, it's as if a huge light bulb goes off in your mind. You can never think the same and you must begin to ask yourself, What is the female perspective? What is the woman's voice—*where* is the woman's voice? Women's Studies put me on the road of constant self-evaluation and inquiry, which continues to this day."

Eve said her major "was a great example of what a liberal arts education is supposed to be about—I was exposed to a tremendous variety of ideas and disciplines through my studies. I think the function of the liberal arts education is to enable the student to explore and delve into as many areas of thought and ideas as possible. I did that and something more—I explored all traditional disciplines from a completely untraditional perspective, something which has only enhanced my ability to be a critical thinker."

Denitta Dawn Ward—Lawyer
University of Kansas—1985

Denitta Ward (née Ascue) was born April 29, 1963. She was raised in rural Gardner, Kansas, "in a two-parent household where both parents worked full time (although my mother did not begin working until I entered first grade)." She has one sister, who is 16 months older than she. At the University of Kansas, Denitta also majored in political science. After graduation, she worked for one year as a legal secretary and then entered Georgetown University Law Center in Washington, D.C. She worked for the Justice Department and Senator Nancy Kassebaum, and during her last year of law school was a research assistant for then-Professor Eleanor Holmes Norton. Denitta earned her J.D. degree (magna cum laude) and received a federal clerkship. Since her clerkship, she has been employed by a law firm. Denitta, who is married, lives in Arlington, Virginia. "My work consumes most of my time—I work 9 A.M. until 9 P.M. (or later). Unfortunately, this is not a Monday–Friday job—and I find my weekends are often taken up with work. When I take vacation time, my husband and I travel; we have visited Vietnam, Thailand, Belize, and Guatemala. It seems that long stretches of leisure time are what I am working for."

How did she come to her major? "I met a wonderful professor [Karlyn Kohrs Campbell]—she was intellectually alive—challenging, thinking, and

demanding. She was also director of Women's Studies and was one of the reasons I pursued my major. I also very much enjoyed the classes, the books, the other students—I made some lifelong friends in those courses—and the ideas of liberation, equality, and oppression that could be discussed openly. After a year and a half of political science courses—which were taught by men and (I felt) were about men—I knew something was missing. There was a fundamental absence in the coursework of political science—and that was the failure to address women, their relationship to the wider world of politics. My political science courses did, generally, address race and class issues, but gender was rarely mentioned, let alone integrated into the curriculum."

Denitta said her major "has been a mixed blessing for me profession-ally. While in law school, one is expected to interview for summer jobs with private firms after the first year—and I found that some of the interviewers were taken aback by Women's Studies on my resumé. More than one inter-view was spent defending it. While I suppose that displayed my oral advo-cacy skills, it did not make for a very comfortable job interview. After a few weeks I made a choice which I know in retrospect was not wise. I took my major off my resumé and, yes, felt like I had sold out. I did get a very 'good' summer job with a top law firm, but after that summer I had to face the job market once again, and I realized that I did not want to work anyplace that would look upon a Women's Studies major as a threat. And, yes, I do feel that some places considered it to be a threat, a problem. I found a great job in a great firm whose partners and fellow associates are not threatened by equality, maternity leave, paternity leave, children in the office, and who welcome discussions of gender, race, and class. It is, I believe, a unique law firm—not rigidly hierarchical and very committed to democratic values."

On a personal level, Denitta said she believes "my years of studying writings by and about women have made me more difficult to live with—I do not accept stereotypes (gender or otherwise), and therefore answers to social, economic, and political questions do not come easy. I'm more ver-bally combative than I once was—possibly exacerbated by my legal train-ing. On a more practical level, I went through a period of almost stridency. I did not want to be called 'Miss' and resented it, even when it was said by an 80-year-old man. I felt burdened whenever I had to cook dinner and do the dishes; I felt angry when a door was held open for me by a male. Those feelings were short-lived and, as I continued my studies and growth, I became more reasonable and learned to distinguish between the gentle-manly acts of a geriatric and the chauvinistic acts of a college boy. But there was a time when all of my gender 'antennae' were out and most everyone appeared to be an oppressor. I have come to see that there is more gray in the world—no longer is it all black and white—and that the important thing

is to have a choice over things—whether it means childbirth or taking a man's name at marriage. It is important to have the choice, give it thought, and make a decision independently."

Postscript: "My long work hours have paid off. We won an eight-week civil jury trial—a case I had been working on for years! My work and home life are now in better balance, and I've started to reflect on ways to maintain this balance. Look me up in 10 years and we'll see if it worked."

Madeleine E. Henley—Town Manager
University of Rhode Island—1987

Madeleine was born August 28, 1957, the 10th of 14 children in a Roman Catholic family. She grew up in the small town of South Kingstown, Rhode Island. Her father was employed outside the home and her mother was "occasionally, but mostly as the children became school-aged." In the six months between receiving her University of Rhode Island diploma (with a second major in economics) and beginning graduate school at Syracuse University, Madeleine worked as an office temp. She was a teaching assistant at Syracuse and graduated with a master's degree in public administration in 1988. Since then she has held two jobs: the first as administrative assistant to the Board of Selectmen in Antrim, New Hampshire, and her current job as town manager in Bethel, Maine.

Madeleine and her husband live in West Bethel, Maine. "On average, I devote 45 to 55 hours to work. This typically includes normal (8 A.M.– 5 P.M.) office hours and a couple of evening meetings. Those nights I am home are mainly spent catching up with my husband, David. He and I are truly homebodies. After attending the introductory meeting of the local Domestic Violence Program, I signed on to help. My irregular work hours prohibit most routine commitments, but the coordinator and I negotiated that for odd jobs and emergencies I can always be called."

Madeleine said she "honestly doesn't know why I majored in Women's Studies, except that the introductory course seemed an interesting way to fulfill a social studies requirement. And after that I was hooked." Professionally, "I do not believe I would have chosen this career had I not been a major. The combination of knowledge of injustice and awareness of power, both of which I learned through the program, established a pretty clear path for me. I determined to change the world, and had only to decide which part and how much of it I thought I could tackle. Some may think working at the local level to be settling for small potatoes. Rather, I chose the position which allows me to connect with citizens at their most comfortable level on interaction with governance.

"I cannot relay specific aspects of my career that were or are affected

by this major. The thing is, Women's Studies changed, in a very profound way, my image of myself and my life. Thus, everything I do, all my choices, are based on the broader view of life I hold due to Women's Studies. Again, it's not necessarily the knowledge gained in the classes, but the perspective brought by the discussions and arguments in the classes that have had a lasting effect."

Personally, Madeleine said, "two major areas of my life were and are affected. My co-majors (all two of them) and I formed a bond which I am positive will last our entire lives, and my sorry self-esteem was healed. The former needs no discussion; the latter was summed up above."

Lynne A. Patton—Congressional Fellow
Wichita State University—1989

Lynne was born July 31, 1946, and grew up in Wichita, Kansas. "My mother and father divorced when I was 3, and from then until I married at 18, mother worked. She remarried when I was 7, divorced when I was 11; married when I was 15 and divorced within six months." A nontraditional student who started college at age 39, Lynne is working toward her second Wichita State University (WSU) degree—an M.A. in liberal sciences: Women's Studies, sociology, counseling, and history. During the 1991–1992 school year, she was one of a handful of women selected for the Women's Research and Education Institute's Congressional Fellowships on Women and Public Policy.

At home in Wichita, Lynne is a member of the WSU Friends of Women's Studies and has helped plan the Women's Writing Series, Women's History Month activities, and fund-raising for scholarships. In 1989–1990, she was student representative to the Women's Studies Executive Committee. As a member of the Friends of Sedgwick County Commission on the Status of Women, she helped organize its second annual Working Women's Conference. In January 1991, Lynne attended the U.S. Commission on Interstate Child Support Enforcement public hearings in Los Angeles and presented testimony about conditions in Kansas since the Family Support Act of 1988. For two years, she was president of CHEK (Creating Hope for Every Kid), a nonprofit organization that she organized in September 1988 to aid families with child-support enforcement. Lynne is the mother of four children aged 17 to 26. In an essay for her fellowship application, she wrote, "I consider the most urgent and important areas of legislation and political action for women to be those which lead directly to the economic status of women."

Lynne said her mentor, Dorothy Walters, one-time director of Women's Studies at WSU, "instilled in me an interest in the image of women in literature. However, my actual decision to major was based on the knowl-

edge that to retain a Women's Studies Department, we had to have majors." Lynne said Women's Studies "was a major factor in my receiving my fellowship. Professionally, the degree and the fellowship will open doors for me that would never have been opened. For now, I will be concentrating on getting my master's, possibly transferring to a Washington, D.C., university if I can find one that will accept my credit hours."

Personally, her major "has helped me see myself as an important part of affecting change in this country for all women. It has empowered me and led to a more active lifestyle in public. I never (before I started taking Women's Studies courses) felt that I had the right, or enough, knowledge to speak out about issues that concern me. Now I know that it is my responsibility."

As Lynne wrote in her fellowship essay: "I am from a generation where it was considered important for a woman to obtain an education, but only so that she could raise more intelligent children who would have a better chance of success in a world that was rapidly changing. Emphasis was placed on marriage to a 'good man who would take care of his wife.' Two marriages, two divorces and four children later, I found myself undereducated, unemployable, and on welfare. The emphasis in my life suddenly centered on survival in a system that seemed to undervalue me and was intent, not on helping me become employable and self-sufficient, but on keeping me at home to raise my children. I was informed that I would never get off welfare and that my children would also grow up to be welfare parents. I don't know where it came from, maybe frustration and/or anger, but I found the strength to challenge the system." Lynne said she did not "think that I would ever have been able to participate or do the things I have if I had not started taking Women's Studies classes. Yes, I would major in Women's Studies again. This major has opened the world for me. It has helped me discover who I am, and it has made me aware that I have social responsibilities, as well as my family responsibilities, and that I can help shape the future."

Postscript: Lynne received her master's degree in May 1993. Governor Joan Finney appointed her Institutional Conservation Program manager for the Kansas Corporation Commission, and she administers a $7 million grant program that funds energy conservation measures for schools and hospitals statewide.

Darl Chryst—In Transition
University of Utah—1989

Darl was born July 25, 1958. She grew up in Utah, in a "big Mormon family (seven children) in which there was a lot of fun, but my parents

fought severely and continuously. They should have separated years ago. If socioeconomically classified, we would probably have been considered lower-middle class." Her mother was employed outside the home (as was her father), "but only grudgingly." Darl attended public schools but said they "were in an exceedingly Mormon community so they may as well have been 'religious.'" Darl earned a cosmetology degree and attended Brigham Young University for about two semesters in the late 1970s. "Numerous odd jobs (waitressing, sales, etc.) supplemented a 12-year modeling and acting career." In 1990, Darl was featured in *inView* (Keller & Warner-Berley, 1990), where she explained: "I think my modeling grew out of the desire to feel attractive, which all people have regardless of gender. I don't think you have to deny physical beauty to be a feminist" (p. 5). She added that there were conflicts between her feminism and her career, and said that during this period she urged other models to speak up and urged photographers to try less sexist set-ups.

She enrolled in the University of Utah in 1985, when she was 27, and earned a French minor along with her Women's Studies degree. She also studied at Hunter College in New York City during this time. Darl told *inView* that a three-month senior-year stint helping battered women file legal complaints made her aware of the legal system's sexism and insensitivity. After graduating from the University of Utah, she attended Fordham Law School for a year, eventually receiving her J.D. degree from Whittier Law School in 1992. Darl took the California bar exam that July and "now will look for work, but I don't yet consider myself unemployed." She said she will pursue a singing career and look for legal employment.

"I have *always* been a feminist, and at the time I went to college, feminism was the only subject I felt passionate about. Therefore, Women's Studies was a natural choice." She said she does not "think Women's Studies has necessarily affected me professionally. I think, rather, I picked this major and made subsequent professional decisions because of my personal connections. In the positions for which I have applied (ACLU, domestic-violence projects) the major has usually been a positive resumé addition and I am questioned about it. However, I will have to see what will happen when I seek legal opportunities. I don't foresee any difficulty (unless, perhaps, I apply for some types of religious, GOP jobs). I think if someone hires me it is because of who I am, which necessarily includes my feminist bent. Therefore, the major is just part and parcel of my whole package. I don't think Women's Studies necessarily prepares one for anything in particular, but then, does any undergraduate degree, except perhaps engineering? It has just made me a better-educated person. I have friends, however, who had limited or nonexistent feminist convictions, and I have witnessed dra-

matic changes in them once they became involved in Women's Studies. They, in fact, changed career choices as a result."

Personally, Darl said, "I thoroughly enjoyed the women I met through Women's Studies. But because I'm certain I was born a feminist, Women's Studies didn't really affect me profoundly. I made the right choice because I can't imagine enjoying any other major as much. Because of its diverseness, the course that affected me most was the 'Women's Political Theory' seminar at Hunter. Up until this time, my major courses were fairly homogeneous and white bread (i.e., Caucasian). This course, although it had only two men, was well represented by people of different colors, religions, socioeconomic backgrounds, and sexual orientations. Everyone was also *very* outspoken.

"From this experience I learned how it felt to be blamed for all societal ills and oppression simply because I am white, heterosexual, and appear to be of a privileged socioeconomic class (in reality, I grew up poor and we relied on welfare briefly during a couple of difficult bouts when I was a child). This experience benefited my marriage, because I understood firsthand how my husband feels when I blame him just because he is male, even though he sincerely tries to make the world a better place for all. I realized that I had to move from a position as a victim to one of power. Although I still feel and know the political dynamics and societal structure need to be altered, and I blame oppressive individuals for their misguided beliefs, I am much more sensitive to how I go about making changes. Needless to say, this one course gave me precious insight that I would not have gotten from any other course.

"One final observation: Having experienced the Los Angeles riots (1992) up close and personal, I am finding that I am becoming less tolerant of whiners, including women. If people want change they should stop bitching while they sit on their asses and expect the oppressor to change. But *violence* is never the way to effect change. It only embitters those upon whom you inflict it and puts you in the position of 'bully.' I always admired (and continue to do so) the feminist movement for being nonviolent. By being pacifists the change might not come as quickly, but it will be more permanent because you have altered, not just the actions, but the beliefs and attitudes of society. I feel the need to say these things because my feminist beliefs are continually evolving, and this is the mindset I have right now. Besides, it might give some insight into what happens to Women's Studies majors as they go through life. Check back in seven years; I might have yet a different view."

Postscript: Darl passed the bar exam and has been admitted to the California bar.

Marianne R. Merritt — Law Student
State University of New York at Albany — 1990

Marianne was born May 15, 1968, and grew up in New York City. "My family contains individuals who are all extremely independent. My mom has been working since I have been in third grade, so I have always had a good deal of independence and autonomy." After earning her B.A. degree, Marianne enrolled at the American University Law School in Washington, D.C. "I intend to become a civil rights attorney, and since last summer [1991] I have been working for a law firm doing voting-rights work. I love it a great deal, and find it extremely fulfilling work. There aren't a lot of civil rights positions available, so I am a little anxious about my employment opportunities after I graduate."

She explained that "upon leaving high school, I knew I was interested in pursuing whatever classes had a political tone. Women's Studies was a natural for me, for I have been a feminist for as long as I can remember. I declared my major my frosh year and never regretted my decision. Potentially, Women's Studies opened many doors for me. I was able to teach an undergraduate class, 'Introduction to Feminism,' for two years (sophomore and junior). That was an incredible experience — being responsible (along with a women's collective) for choosing texts, developing a syllabus, facilitating classes, grading papers. In addition, I interned with our university's affirmative action office, which I continue to put on my resumé. I became a Senior Sexual Harassment Adviser, which is something I get asked to talk about frequently in interviews.

"I was politically active both on and off campus. There are a lot of doors that open for you as a major, for feminist communities tend to be supportive of other women's endeavors. But again, a great deal of responsibility lies with each individual — if a woman wants to work her butt off in an internship, or makes efforts to get involved on the campus or outside the women's community, then undoubtedly the connections will pay off in one way or another. I also minored in political science, so I balanced my Women's Studies work with political theory, judicial, and Leftist Studies. I did an independent study with a political science professor in which I read a series of affirmative action and abortion cases. Those are, of course, feminist topics, and when combined with casework the independent study was a very positive experience. But I did it on my own initiative — every woman must pursue what she really wants to do. The opportunities are usually out there.

"Women's Studies generally forces a woman to confront very personal — and frequently painful — topics. I developed an honest assessment of my strengths and weaknesses, which took a lot of work. I was lucky and

had a close circle of supportive friends. This enabled us to relate on the most personal levels from the same feminist perspective. I value that a great deal when looking back because I haven't connected with that same kind of feminist network at law school."

Lauren Eskenazi—Law Student
University of California at Berkeley—1991

Lauren was born December 18, 1967, and grew up in Los Angeles. "Both parents worked, and when my brother and I were younger we had live-in help." She attended private, nonsectarian schools. After graduating from Berkeley, where she minored in philosophy, Lauren "had three jobs. First one, I did clerical work. I quit after a month because I didn't like the people I worked for—felt they treated me as if I had no brain (economy was so bad I couldn't get more challenging work). Then I got a higher-paying job ($10 an hour) in a law firm—also clerical, but people were nicer. Neither job provided health insurance. Next, I was offered a job at a nonprofit. This was great!! I worked as a community health educator at L. A. Free Clinic. Health insurance. Salary $24,000 a year." She now is a first-year student at the University of Southern California Law Center and expects to receive her J.D. degree in 1995.

Lauren explained why she majored and some of the effects: "I took a few Women's Studies classes and became passionate about this subject. (1) The reading material articulated vague feelings I had about myself and society—I felt very empowered. (2) Enjoyed the academic challenge. Evaluating status-quo assumptions that I and others take for granted. Also, logical inconsistency with arguments traditionally made to keep disenfranchised groups from gaining power. (3) At Berkeley, most classes are huge and impersonal. Women's Studies classes are usually small, intimate classes that require and depend on student participation. This gave me a chance to *know* professors and be privy to 'cutting-edge' issues emerging in this area of study. (4) Provided a great support system and community! Allows you to take your beliefs seriously.

"For me, it is hard to separate personal from professional. My professional goals directly reflect my affiliation and love for women's issues, which were nurtured and expanded through my major. Now I am in my first year in law school and I see multiple opportunities to build a career around feminist ideology. At the moment, I am most interested in legal interpretation of a woman's pregnant body. I am concerned about laws that restrict, prohibit, and punish pregnant women in order to protect the fetus. My concern for abortion rights has subsided a bit since Clinton's presidential victory. However, abortion rights are obviously not enough. Child-care

and pregnancy-leave policies that allow women access to economic stability and independence are also very important. Feminism extends beyond issues concerning maternity and paternity rights, and women's control over their own bodies. But at this moment I'm most interested in these. I would like to litigate cases that address these issues or perhaps join lobby groups to change laws. After my torts class, I have considered going into medical malpractice and specializing in women's health issues.

"In terms of successfully gaining employment, my major has not hampered me. However, I am very self-conscious about it on my resumé and often wonder what an employer interviewing thinks. Sometimes, I must admit, I will overemphasize my philosophy minor to downplay Women's Studies. Other times, I attribute my Women's Studies degree to qualities I think the employer is looking for. For example, Women's Studies really taught me to be confident and assertive. Made me much more independent, etc. For the most part, I think of it as a gift that I keep inside at all times. I don't feel the need to explain my views to everyone who feels uncomfortable when I tell them what I studied as an undergraduate, but I know for me it affects all of my decisions and interactions. And this is enough for me."

Heather R. Moss — Law Student
University of California at Irvine — 1991

Heather was born October 9, 1969, the oldest of four children. She grew up in suburban Los Angeles. "Parents married happily. I have one brother (8 years younger) and twin sisters (14 years younger)." Heather, who minored in history, attends Western State University School of Law; she also works as a law clerk. Her young-adult fiction book, *Kimfessions*, was published in April 1993 by Aegina Press. "Eighty percent of my time is spent studying, commuting to school, going to class, doing research. The other 20% goes to my family, significant other, household obligations, and working three days a week. I occasionally socialize and often write political protest letters for women's rights, animal rights, etc."

In college, Heather was "very curious about gender issues and disturbed by our world's lack of awareness and sensitivity on gender issues. Each day appears to bring a more hostile and negative climate to feminism. Few people, I believe, truly understand what 'feminism' means. Women who could rally together to change patriarchy would rather 'buy' into it. This bothers me a great deal and is the primary reason I chose my major. I hope to use my knowledge to help heighten awareness and, if nothing else, minimize the feelings that make me marginalized in this society.

"My awareness makes me a lot less tolerant when I confront gender/sexual/religious/racial issues in my professional life. As a law student, I have had professors who ignored gender issues altogether and used the

pronoun 'he' except in hypothetical examples involving housewives, secretaries, etc. Then the pronoun 'she' was used. My major has also taught me to be cautious in how I choose to deal with issues, and I have learned the ramifications of being outright with my feelings. Not that I always agree with this approach; it does have certain advantages because in being tactful, the people on the other side tend to listen more and perhaps will begin to understand our plight. I can't accept people's backward views, but finding the proper forum in which to air my views is sometimes difficult."

Personally, Heather said, Women's Studies "has helped me understand many feelings I grew up with. I have been a feminist all along, though my parents aren't. They have been very accepting of my beliefs and want me to be happy. Their rationalization is that times are different and they realize that many of my points are very practical in application. My major gave me the desire to *educate* and not sit still and be passively consumed by patriarchy.

"The faculty and students in UC–Irvine's program are a wonderful and caring group of people. The knowledge I acquired through my wide variety of classes showed me diversity and taught me about issues that aren't discussed in most college classes. In some ways, my major helped me dispel myths about women that we all grew up hearing (the public/private dichotomy and nature vs. nurture argument). I feel that I am a better, more well-rounded, and educated person because of Women's Studies."

Postscript: Heather, who expected to receive her J.D. degree in June 1994, is engaged to be married, "and I will be retaining my name. My fiancé and I are on equal footing, and I look forward to a marital partnership filled with love, honor, and equality. I look forward to helping make a change in our legal system. A 'rethinking' of equality can only occur in an environment that weaves creativity, determination, and transformation into a world not governed by 'protective' policies that serve to hinder the interests of humankind. I am writing a children's book to encourage a 'progressive' focus on future generations."

Anne M. Package—Law Enforcement Employee
University of Pennsylvania—1991

Anne was born March 11, 1969, and grew up in Washington, Pennsylvania, which she described as "small-town America." She lived "with my married birth parents until I was 14. Then my mom, brother, and I moved in with her boyfriend and his four children. At 17 I moved in with my grandparents. At 18, my mother, brother, and I moved in together." Her father worked outside the home; her mother did not "until after the divorce." After graduating, Anne worked as a resident adviser at the University of Pennsylvania while she looked for full-time employment. In July

1991, she "returned home and kept up the search. In the meantime, I worked as a shoe-store clerk, at Sbarro Pizza, and at Kmart. Finally, the Department of Labor offered me a position in Manhattan. I took it."

Anne took her first Women's Studies course during her sophomore year. "It was titled 'Women and the Law,' taught by a visiting professor who is a practicing attorney. It was an extraordinary experience. There was a real bond between all the students, and the professor spoke my language. At the same time, I encountered my first feminist role model (an employer) and read my first feminist book—*Outrageous Acts and Everyday Rebellions*. There was no question at the end of that semester. Feminism had become a fundamental part of me—it had to be the driving force in my life. There was nothing that interested me as much, and no course of study that seemed so real, so imperative—a life-and-death matter.

"The effect of my major on my career plans and achievements has been mixed. Women's Studies has given me a feeling of community, as if there will always be a feminist network into which I may always step when and if I choose to do work in this area. However, I have not yet sought employment in feminist activism, so I have yet to test that theory. Theory is all I have about the real impact of my major on my job search. I was categorically rejected in all requests for interviews from businesses and law firms in the Pittsburgh and Philadelphia areas. It is possible I deserved those over 50 rejections; however, with a degree from Penn, magna cum laude, I would expect at least some interviews. I am also suspicious because almost all my rejection letters mention my qualifications in a way that makes me think that they believed Women's Studies was a trouble-making major with a lack of real education. Of course, this is only conjecture—the recession also caused many of my friends to have trouble with their job searches.

"On the other hand, my employer at the Department of Labor was impressed with Women's Studies. Although I expected a government employee to be a conservative high-sell, he explained that his wife is an outspoken feminist and his daughters are budding feminists-to-be. He said it was his belief that my job, which is investigative, could be done with special insight by a woman. Although this comment was in itself somewhat sexist, at least in this job my degree did not appear to be a liability, but an asset. Currently, I am applying to law schools. I am confident about claiming and explaining my Women's Studies experience on the applications. In fact, I believe that my feminism will be attractive to admissions committees—not only because feminist legal theory is on the cutting edge of jurisprudence, but because it is an area in which I have shown demonstrable commitment, ability, and passion. I believe that being an outspoken feminist allows me to live a life of integrity, morals, and ideals that will appeal to employers throughout my professional career."

Personally, "Women's Studies, or perhaps feminism, has affected me

so profoundly I am unsure I can express the result in words. To do so, I'll avoid discussing the details of my larger experience with feminism and concentrate solely on the major. Women's Studies classes were the best I had at Penn—by far. There existed an understanding of what it meant to be a woman (most of my courses had no men; at most, one or two) that made me realize the extent to which that experience is not accounted for in mainstream disciplines. For example, a 'Psychology of Women' class spent the entire period discussing the subconscious, omnipresent fear of rape in our lives. Everything was different in Women's Studies courses, from the structure of the class to the teaching style to the understanding of what could be included in 'required reading.'

"The department was very aware of and part of the campus feminist movement and its issues, as evidenced e.g., by Peggy Sanday's book *Fraternity Gang Rape* and by Women's Studies professors announcing feminist events and speaking at rallies. This interaction between theory and practice, faculty and student, made me feel much more integrated, more whole. My thesis allowed me to explore an area of great import to me personally—women's spirituality. Religion is very important to me, and I was curious about Wicca, goddess worship, and feminist critiques of Judeo-Christian religion. Happily, I learned a great deal in preparing my thesis, and feminism now informs my spirituality as well.

"Perhaps the most important part of Women's Studies was my colleagues. Professors and the chair of the department were extremely supportive and *human*. Some of the ordeals friends in the sciences underwent because of their sex made me shudder; my experience couldn't have been more comfortable and yet challenging. I studied from and with outstanding women from diverse backgrounds; together, we all explored our world, our womanhood, and our humanity.

"Majoring hasn't always been the easiest undertaking—it can make one doubt one's own practicality, 'sense of reality,' or educational achievements. But if I had to go through school again, I would absolutely choose Women's Studies. Possibly I would choose to double-major, but it is the only department I could even conceive of being deeply involved in. It was a niche for me, a deeply personal and comfortable arena of study. The students and faculty were the brightest, most committed, and most admirable people I met at Penn. No contest."

Lola A. Smith—Law Student
Metropolitan State College of Denver—1991

Lola was born April 28, 1959, and grew up in Denver. "I lived with my mother and father, five brothers, and two sisters. We were very poor, as my father was an unskilled laborer and there were so many of us. We never

went hungry, though." Her mother also worked outside the home "at times she worked as a waitress, cook, secretarial, clerical." Lola earned her real estate license in 1986. In October 1987, she earned a word-processing certificate, and in January 1988 she enrolled at the Metropolitan State College of Denver. After earning her degree she spent the summer with her three children, then entered Southwestern University School of Law in "a part-time program that is designed for people with child-care responsibilities." She expects to receive her J.D. in May 1995. Divorced for five years, Lola has two sons (aged 12 and 10) and an 8-year-old daughter; they live in Glendale, California.

"Right now I have to just live one day at a time. Between financial aid and AFDC [Aid to Families with Dependent Children], I try to make ends meet without worrying too much if I can do it. I try to live my life as a model for my children. I want them to have a whole life with a range of perspectives, not simply the sex-role stereotypes they see in books, on TV, in school, and in society as a whole. I want my kids to learn that people are people, whether male or female, black or white, Korean or Chinese, Armenian or Iranian, etc., and all deserve respect. I want them to integrate nurturing, empathetic, assertive, self-assuring, altruistic, independent behaviors and characteristics into their lives. An open heart, an open mind, and good communication skills are essential. To have a fulfilling life but not at the expense and oppression of others."

Lola explained that she "had changed my major twice already before I even discovered Women's Studies classes. I did not come into college knowing that I would major. As a matter of fact, I had never even heard of it before I came to college. However, once I started taking classes, I found I just could not get enough. I found an identity, a history, a movement, and as I thought, an academic anomaly. Finally, I was being challenged to critically analyze the information I was learning — not just accepting as fact. Enough absorption and regurgitation. I was being able to learn and apply what I learned to real life.

"My own personal life experiences had a lot to do with my decision to major. An abusive husband led me to seek therapy, where I discovered long-hidden-away deep dark secrets. Incest and attempted suicide were part of my life I had blocked out from my memory. Throughout therapy I was able to find myself and face these memories. Discovery of Women's Studies helped me find out who that self is and why. I soon realized that what I had thought of as a unique set of life experiences were fairly common in women's lives. Finding out that I was not the only person in the world with this kind of background was very empowering for me. It helped me to see that I was not crazy. A lot of women lose their identity within marriage, even where there is no abuse. I found that an identity is crucial to being able to live any kind of fulfilling life.

"When deciding upon Women's Studies, I asked myself, 'What can one person do?' If I think I can change the world, I am having delusions of grandeur because realistically I know that it cannot be done. But, maybe I *can* change my own little corner of the world. My major was titled 'Writing and Research in Women's Studies.' My ultimate goal was to be able to do research on issues pertaining to women and children with the results being publishable. To be able to educate others on issues important to all women, as well as to me, and in the process doing something I enjoy and feel strongly about, would be how I could go about changing my little corner of the world.

"Since it is now November 1991 and I just graduated in May, I can't say that my major has affected me professionally much at all. Although I believe that if I had majored in anything else I would not even have thought about going into law school. My participation in Women's Studies classes, two internships through Women's Studies—one with the Senate Democratic Office at the state capitol and one with NOW—and working part time at the Institute for Women's Studies and Services as a work-study student all helped me to come to the decision of going to law school.

"Knowing that things don't change easily and seeing that the most effective way to bring about change is from within 'the system,' I finally decided that the best way for me to be able to change my little corner of the world would be with a juris doctorate degree from an accredited law school. My intent, when applying, was that the legal education was what was important. To be able to do the kind of research I wanted to do, I figured that legal research would be the way to go. I really don't know where I will be when I graduate. Coming to the end of the first semester of my first year, I am thinking more about actually practicing law itself. Prosecution seems to be an especially magnetic urge for me."

Personally, "my major has given me a whole different perspective on the way I look at the world and everyone and everything in it. I no longer take things for granted, or on their face value. I no longer believe everything I hear or read. I question everything and everyone. I find myself looking differently at my family—the one I grew up in, I mean. I just sit back and observe them and listen to them. I realize that some of them are not aware, and when I try to educate them they won't listen. They have *a priori* ideas and are not open to any others.

"My mother is different, though. I have a much better relationship with her as a result of Women's Studies. I never really knew that she was a feminist before. I think it's because she's one of these people who say, 'I'm not a feminist, but. . . . ' In a way, she's kind of a hypocrite. I mean, she knows what's wrong with her marriage and that the only way to fix it is to leave my father, but she never will. I find it hard to sympathize or even to empathize with her when she complains about it. But then, I guess I'm not

being very open to her. I can understand, sort of, because I stayed married for so long myself. She says he doesn't abuse her, he just drags her down. She has a college degree and he's never finished high school. Now that we are all grown and have children of our own, and the two of them are retired, she finds they have nothing in common. They sit around the house and stare at each other or watch a lot of TV, but they have nothing to talk about. I think it's rather sad that she's so afraid to be alone. She wants them to die together because she doesn't know what she will do without him.

"I have carried on quite a bit about my mother, but I believe that it does say something about how my major has affected me personally. I don't know if I would be reacting at all to my mother's situation if not for Women's Studies. I look at things differently. How we, as women, have been socialized to believe that we need a man in our lives in order for them to be fulfilling is illustrated very well by my mother's situation. Also illustrated is society's image of women as they age. She is feeling very much a throw-away; she says she's too old to do anything worthwhile (she's 62). I tell her she's not, but I'm fighting a lot of years of socialization and conditioning.

"I find a similar type of fight against society while trying to raise my children. Teaching boys that it's okay to cry when your feelings get hurt, or to talk about anger rather than acting it out, that a song about 'shake that body for me' has nothing to do with cosmetics, or that drinking beer does not make you a macho lady-killer, is really very difficult when almost everything and everyone they come into contact with thinks differently. Trying to teach my daughter that she should be proud that she is female is difficult when she sees professional baseball, basketball, hockey, and football players making millions of dollars a year, when she sees that dad is the boss in all of her friends' families, when she knows that dads make more money than moms even if the moms work, when she sees women on TV being exploited and oppressed and abused, when she sees no boys playing with dolls or kitchen toys and no girls playing with all the 'neat' toys on TV, when even the books she reads have only the boys enjoying exciting adventures. And so, even though it is more difficult, it has made me more determined to change my little corner of the world."

Lola said she "can't even imagine majoring in anything else. The classes in Women's Studies were so much more interesting, exciting, and pertinent to my life. Not only the classes, but also the feeling of belonging to the sisterhood of women, gave me empowerment. Being a part of Women's Studies heightened my sense of self-esteem and also my pride in being a woman. Rather than feeling like one more piece of paper being rolled through a department just because it's what I majored in, I felt that Wom-

en's Studies was really glad it had me as a major. I felt honored to be majoring. It wasn't easy. I worked harder in these classes than in any of my others. But it was well worth it."

Postscript: "The most important thing is that my parents are now divorced . . . and my mother is trying to rebuild a life without a partner after being married for 47 years. Also, I didn't agree with law school. There *are* feminist attorneys out there in the world; I know there are. However, *I* was not able to reconcile *myself* with the thought processes required to do well in law school. But I do not regret the time I spent there. From the perspective of what I wanted from the legal education, I came away with quite a bit. I now work for a statewide organization working toward the elimination of domestic violence. The ultimate goal I wrote about originally is still what I am working toward. The work we do at the coalition is so important to so many women and children, as well as to so many men. Before leaving my husband for good, I had stayed in four shelters, and I do not know what I would have done if they had not been there. I could have died; many women have. That is how important this work is."

Kay Paden—Law Student
University of California at Berkeley—1992

Kay was born May 1, 1952. She grew up in Kentucky with her mother, father, and sister (five years older). "My father was a coal miner. We lived in the eastern, central, and western parts of the state. For three years (when I was age 10 to 13) my father worked in the mines (Harlan County) while my mother and I lived with my maternal grandparents in Lexington." Her mother also worked outside the home. Kay attended junior college for a year (1980–1981), then continued her formal education at California community and junior colleges in 1988–1989. She transferred to Berkeley in 1990 and graduated at age 40. She is a first-year law student at Golden Gate University (GGU) School of Law and expects to receive her J.D. degree in 1995.

Kay, who plans to specialize in women's issues law and feminist jurisprudence, said, "Women's Studies gave me a historical, present, and future perspective of where women have been, are today, and hope to be in the future. The major provided me with a strong foundation for initiating change in a male-dominated profession that has historically oppressed women. It certainly gave me a grasp on why the law is gender-biased. I could not possibly hope to change a system if I do not first know and understand how the system was created and how legal reasoning is used to maintain the status quo. Women's Studies gave me this understanding and the confidence to pursue my professional objectives."

Kay said that because she is in law school, "I will have to discuss the major's effects from a 'professional student' perspective versus a career perspective. First of all, I continue to be amazed how few women *care* about women's issues and concerns. There is a complacency among women students and professional women that is beyond my comprehension. Women seem (at times) to be excited that I am a warrior who wants to fight for women's rights. But in the next breath they say, 'God, you're putting all that time and money into school and you're going to work for nothing because you *think* we don't have enough rights.'

"Where do these women live—in Herland? The younger ones either don't know or care about the battles that have been fought so they can even go to law school or have viable careers. They see an opportunity, but they don't see a glass ceiling that will prevent them from achieving managing or senior partnerships. It's as if getting there is enough. I'll worry about tomorrow when tomorrow gets here. On the other hand, I hear too many professional women say they have never experienced discrimination—personally or professionally. Again, do they know discrimination when they experience it or see it, or are they living in a perpetual state of denial?

"In most of the law schools in this country, students are taught by middle-aged to aged white men. We are fortunate at GGU to have several women faculty. But the students don't compute the significance of having a woman's perspective. I have noticed that women professors earn less respect from students than do male professors. I can also assure you that this is no reflection on the women faculty. It is a student attitude—male and female. Perhaps my major helps me appreciate these women's accomplishments more. Perhaps my major helps me appreciate law school more because I see law as a vehicle for change and not just a money and status machine. I am not discouraged by what I see and hear these days, but I am concerned that complacency can and will undermine the hard work and dedication of millions of women who have gone before me. I only hope that I will plant a seed of change in law that some other 'warrior' will nurture and help grow."

Personally, Kay said, "my major has helped me see women and men differently. I have learned to appreciate the battles that have been fought for the past 300-plus years. My respect and admiration for women advocates and 'rebels' have motivated me and given me a goal to strive for. I have learned to evaluate the present based on my knowledge of the past. This major has made me even *more* proud to be a woman—if that is possible.

"I have been living a lesbian lifestyle since 1975. Because my life partner is a professional Realtor doing business in an extremely homophobic community, we are forced to remain closeted in that area. But my major has helped me understand the professional battles my lover faces whether

she comes out or not. Women's Studies has strengthened our relationship because I can share my knowledge with her and she, in turn, can begin to help other women understand their own professional trials and tribulations in a male-broker-dominated field. The downside is her enthusiasm at times creates animosity with men and women in her office. The men feel threatened—the women feel fear. But she feels stronger because she has a better understanding of her environment, and I feel stronger because I know I was a part of her growth. Individual strength has ultimately led to relationship strength. I don't mean to leave the impression that our relationship was made or survives because I majored in Women's Studies. But the major has centered our relationship. It has made both of us stronger and enhanced our pride of being who and what we are. How many economics majors can say that?"

Kay "most definitely" would major again. "Other than law school, Women's Studies at Berkeley was the most fascinating and challenging thing I had ever done. After spending many years in accounting management and as an entrepreneur, I had experienced many professional challenges. But the Women's Studies Department at Berkeley had a very high standard of intellectual stimulation and expectation. We had to be better because we were a department on the fringes. I benefited from this program beyond explanation. It was a hell of a ride, but I wouldn't have missed it for the world."

7

ADVICE FROM THE EXPERIENCED

Thank you from the bottom of my heart. If it is difficult to be a Women's Studies student, it is doubly so to be a faculty member or chair. But don't give up, and please don't think you must emulate the "old boys" for respectability's sake. Continue to be innovative, challenging, supportive, and inspirational. You mean so much to us.
— Anne M. Package

Women's Studies faculty and administrators should find it reassuring that our 89 graduates speak so highly about their major. Potential majors, parents, and others also should be reassured by this, as well as by the wealth of advice the graduates offered. Their responses to two questions— "What advice would you give to students contemplating a major in Women's Studies?" and "What advice would you give to faculty and administrators involved with Women's Studies?"—contained more than encouragement and advice, however. Their responses provided further insight into the nature of Women's Studies as an academic discipline and bolstered graduates' statements about the professional and personal impacts of the major.

SPEAKING TO MAJORS AND OTHER STUDENTS

Several graduates advised that choosing Women's Studies means choosing to undertake an important personal journey. "If you are ready to determine who you are and what you think, if you are ready to defend those thoughts and feelings, then you are ready for and will flourish with the experience of Women's Studies," Betsy Dollar said. She added:

> It is not an easy program and it will require a commitment. I don't know of any other educational program that puts its students through

182

as much emotion—generally negative emotions like anger escalating to rage and sometimes ending in depression. This is not a program for the weak-spirited. The payoff is that you are personally prepared to face the "working" world when you are finished.

Lili Feingold also referred to the emotional journey:

This field is a challenging one, not to be entered into lightly because the courses are difficult and distressing. I found myself angry, saddened, incensed, excited, horrified, and elated. I had my head turned inside out and back again. I recommend it for people who wish to better themselves personally and academically. But be careful, it is a bumpy and challenging journey! One journey I am glad I took! Bruises and all!

Ellen Divers advised that the major is not necessarily a career move:

It's a personal journey, so be open to examining your own life, your family. Be open to change. You will not see the world in the same way after this major; indeed, it may affect your relationships in both positive and negative ways! If you have any interest at all in making the world a better place, this is a great way to start. An important bonus is that you will always have a bond with the friends you make in this program.

And Lauren Eskenazi said:

If you find the subject interesting, then study it. Don't worry about how your parents or potential employers, etc., will react. Do it because it speaks to *you*. You will benefit so much from it because you will be nurturing inner power in yourself, and this will be invaluable. . . . What you need to learn is to think, to be critical, to write, and you *definitely* will learn these skills.

Dawn Paul suggested:

If you are in school to prepare for a very narrowly defined job, you are aiming at a rapidly moving target. Instead, prepare yourself to be a competent and successful person—one who can think, express herself/himself, confidently take on a project, make decisions—that is the person who will be able to enter the work world and succeed even as things change. Women's Studies will help you to become that person.

But perhaps you still are not quite sure if the Women's Studies journey is one you want to make. Perhaps you remain a curious skeptic. A number of graduates offered this advice, which applies to any major: Explore it. "Try a few courses and see what you think," Diane Maluso said simply. As you take classes, Larisa Semenuk advised, "notice the differences—try to pin down what they are—see if you feel comfortable in those classes. Do you feel they're teaching something important? If you like them, do not hesitate to be a pioneer. Don't devalue it just because it's called 'Women's Studies'—that's what we're trying to change." Once you have taken a few classes, "if the major is not for you, you will know it," Lola Smith observed.

Although as an older student Sandi Gray-Terry did not have "the complication" of parental anxiety, she urged potential majors to "attend gatherings of prospective majors—ask questions of students and faculty . . . find out where Women's Studies graduates went." Gray-Terry herself

> wanted to be a competitive candidate for graduate school, and I was a little nervous that Women's Studies would not be viewed as valid or scholarly (particularly in the South); so at the end of my sophomore year, I "pre-interviewed" at two graduate schools of my choice (one in the South) and asked *directly*: How would you view a Women's Studies major? For my field [social work], I was told that the broader base I had in liberal arts, the more they would *want* me, and Women's Studies would be viewed quite favorably. I recommend this tactic for anyone who may have concerns.

If you already are close to making—or have made—the decision to major in Women's Studies, our graduates would exhort you to "just do it" or "go for it." Most would add a qualifier, such as Leona Roach's admonition to, "Do it for yourself, your sister, your mother, your daughter. Do it for the rest of your life. Don't ask me why; the experience is different for each woman." Or Susan Brookman's declaration: "It will change your life and you will change the world." Or Betty Gooch's observation that "we certainly need all the knowledgeable women (especially young ones) we can get. We know *enough* about men. Learning about women is like unearthing hidden treasures."

Our graduates also had plenty of general and specific advice. As you read it, remember, in the words of "Sara," that "you get out of the major what you put in." Also keep in mind that each graduate is drawing on her experiences in one particular program. That does not mean every student in that program would agree, or that other programs might not be different. You might not share a graduate's concern. Programs and the people running them change, and an observation even just a year old might no longer

be appropriate. On the other hand, the graduates' comments can help you know what questions to ask. They suggest how Women's Studies is different from other majors. And, even more important, practically everyone conveys the positive message: "No matter what you do professionally or personally, the major is an invaluable education" ("Kate's" words).

One characteristic that helps make the major invaluable is its interdisciplinary nature, and several graduates urged majors to take advantage of that. As Yoon Park said, "The interdisciplinary nature of Women's Studies provides lots of room to learn/experience important issues from a variety of angles (e.g., history, literature, human biology). I found my courses very enlightening, enriching, challenging, and worthwhile." Heather Moss noted, "You will learn not just about 'women,' but about how institutions seek to ignore/erase gender, class, race, religion, sexual orientation in social/political/historical/economic discussions." And Victoria Pillard observed, "Women's Studies can be extremely flexible and can enhance training in any area—women in business, women in arts, women in medicine, women in history, etc. It is a great home base and on the cutting edge of education and diversity."

Because Women's Studies is inter- or even transdiciplinary, many students choose it as a second major or choose to have another major. One-quarter of our graduates advised students to double-major or to plan on earning an advanced degree. In explaining why, many suggested that the other major may make you more employable. Kaaren Boothroyd would insist on a double major. "While the major on its own might be the most valuable part of your education, the reality is that it won't hold up during a job interview, with few exceptions. Moreover, Women's Studies is a fantastic complement to almost any discipline, for both women and men." Heidi Boenke observed: "Women's Studies is great, but supplement it with some practical skills—management? teaching? counseling? What *do* you want to do after college? Women's Studies is *how* to do it, not *what* to do." And Susan Hillsman said:

> I'd definitely not make it my *only* major, unless I were certain I would have a career dealing with women's issues. I don't mean that a Women's Studies major wouldn't be "enough"; it would. It's just that having it as the only major on your resumé may not help you get the job you want. Besides, if you can possibly double major, why not? Why not get as much as you can for that college tuition?

The graduates were being realistic, even as they were encouraging. That is nowhere more evident than in the following compendium of their advice. Read it carefully; the wisdom of our first generation of majors is wide-ranging.

• *Sarah Luthens:* Go for it . . . if you have a passion for feminism/ social justice. Push yourself, your classmates, teachers, and the Women's Studies staff to think and feel deeply about what you will be learning. Apply your lessons into college or community activism as you're going through the program. Also, take ethnic studies and labor studies classes to help round out your social justice curriculum. Be determined to endure the frustrations and occasional despair of learning how far we have to go in transforming the oppressions of this world. Wrestle with these emotions in the process of being inspired to work for positive change.

• *Keiko Koizumi:* College is a block of time set aside so one can find out about oneself, so one doesn't wake up at the age of 50 realizing that her true self has been stifled. Presently, the common perception of a college education is career training, but in reality career training takes place in the workplace. One has to take care of oneself first. Then, one can accomplish *anything.* So do what you enjoy. Now is the time. Give yourself time to grow—in Women's Studies or any other program.

• *Valata Fletcher:* Go into the study with an open mind, but don't be afraid to challenge any works or lectures. Use your mind on new ideas; the exchange of ideas is the best learning experience in Women's Studies. Majors are making history—women's history—and changing the educational system. Eventually society will change for the better.

• *Deborah McGarvey:* Be prepared to think critically, to do a lot of writing and reading. Expect to have your thoughts and feelings change and your outlook on the world to be totally different. You may feel the need to find other friends who are also thinking critically and questioning society both in school and out. At times you may feel overwhelmed and want to escape from the knowledge you are gaining while at the same time you may feel frustrated with people who are not going through the same educational experience you are going through.

• *Denitta Ward:* I would encourage any woman considering the major to do it, with gusto. Read the works of Adrienne Rich, the speeches of the Grimke sisters, the words of Elizabeth Cady Stanton, and the insights of Eleanor Holmes Norton. Do not just accept the writings but consider them, criticize them, integrate the ideas—into your own life, where appropriate. The great thing about Women's Studies classes is that they are not passive-learning classes. They challenge you to think and respond from personal, emotional, and intellectual levels. Importantly, a Women's Studies major does not end with a degree, but can continue to be a part of you for all your days.

• *Jill Tregor:* (1) Don't become part of a herd—even a Women's Studies herd. If you disagree—say so! (2) Discipline is still important. If you're not being challenged enough—take classes outside the major. I don't think

my Women's Studies professors were critical enough of my writing and research skills, but it's possible to get these things elsewhere. (3) Don't become a major if what you are looking for is an "easy" way to get a degree. (4) Don't forget to take lots of different types of classes (no matter what the academic requirements). Get experience in many disciplines. Don't only take classes with professors you "agree" with politically.

- *Terri Bartolero:* We major in Women's Studies because we find the material exciting and challenging, but we need more majors to impact society. We need to infiltrate the system in order to change it. I worry that most Women's Studies students will remain in academia. Unfortunately, here we only educate our own. We need to go beyond the university walls and spread our knowledge throughout our educational system, government, the business world, advertising, journalism. We need to educate people, make them acknowledge their own sexism and racism, and challenge their beliefs!

- *Elizabeth Bennett:* Remember to look beyond white middle-class feminism. There's so much to be learned from our diversity. If your program doesn't offer this, create it.

- *Diane Kraynak:* Just make sure you know where you stand on your issues because you'll always be forced to defend your position. Pick your arguments carefully and be ready to chip away at all of those preconceived notions of feminism.

- *"Susan Anthony":* Don't think about what your friends and family or your boyfriend may say about your choice of major. Do it for yourself—give *yourself* the rare chance to get a woman's education, to find the woman's point of view, and to find your own voice to speak out and express yourself. After all, no one should have to dance backwards all her life!

- *Katharine Rossi:* Sometimes the things you learn are not always easy to digest and accept. That is okay because hopefully your anger will motivate you to change things. I would also advise you to take an active role in the learning process. Discuss with faculty how you feel about a class or the material read and if you think changes can be made. This is part of feminist process and it should be exercised within the patriarchal university system.

- *Lannette Washington:* Take well-rounded classes. I would recommend business, advanced math, economics because there is a lot of money to be made in investment banking and other business-related jobs. Women's Studies does not have to mean that you have to have a woman-related job.

- *Debra Nickerson:* Use your major as a window from which you examine and thoroughly analyze all you see. It will enable you to uncover the secrets of patriarchy and all its negative messages to women. Critical examination of all facets of any issue is almost a given for Women's Studies majors; be critical, be thorough, be unaccepting of the status quo and be

proud of yourself, for you as a Women's Studies graduate will help make the world a better place.

SPEAKING TO FACULTY AND ADMINISTRATORS

Our graduates speak highly of their degrees, admiringly of their teachers, and respectfully of the rigor of their classes. It may be that graduates who might have been disappointed by Women's Studies were not recommended as participants or chose not to participate. But our experience is that Women's Studies students *are* overwhelmingly positive and enthusiastic about their major. Indeed, a common theme is how it transformed their lives and gave meaning to their learning. Not surprisingly then, the advice graduates offered to faculty and administrators often was enclosed within statements of gratitude and encouragement. Heather Moss went so far as to offer a global "thank you to each and every person who helped make Women's Studies a major in various schools."

"Kate" urged administrators, "Establish the program as a priority major and stop debating the question of its validity. Tap Women's Studies alumni for sources of funding in a woman-focused way (i.e., don't follow the regular alumni association model)." And "To faculty: Keep up the good work. The caring and commitment that you give your students is appreciated." Lynn Patton offered this: "To administrators: This is not a 'fluff' degree. The courses are among the toughest, most demanding, and most enlightening that I can think of. To faculty: Please keep teaching these courses. They finally put women into history, a place where we've been forgotten for too long, and are showing our young women the role models that they have needed for so long."

Janet Fender told faculty and administrators that "your role is potentially the most important in a female student's life—all schools should be required to have Women's Studies." She also suggested that even younger women should be involved: "Women's Studies classes should begin in the seventh grade at least." Betsy Dollar agreed:

Please keep trying to reach more and more women at a younger age. More and more is being expected of teenagers with less and less support—not to mention the myths that go with a more conservative sociopolitical environment. The teenage women I know are not getting a clear picture of where women are, where we have been, and where we may or may not be going. This is not just your responsibility—it is every woman's responsibility.

Along with such pleas came a wealth of advice, from the very general to the very specific. Although we asked graduates to direct their comments to faculty and administrators, other readers can learn much about the discipline by studying what graduates said. As with responses to other questions, these reflect each individual's experiences with one program. But if you think about the responses as parts of a puzzle, when you are finished reading them you should have a clearer picture of what distinguishes Women's Studies. To provide a framework for that picture, we have categorized the responses. But as you soon will see, graduates' answers often did not have such a narrow focus.

Don't Get Discouraged

• *Madeleine Henley:* I have never understood why anyone would want to teach. Women's Studies must be especially exhausting because of the students' emotional response to the curriculum. For the same reason, it is more important that faculty avoid burnout. This doesn't mean faculty can't share the frustrations and energy-sappers they experience. A great deal of trust can be realized by frank discussion between teacher and student about the challenges posed by being associated with a Women's Studies program.

• *Constance Tanczo:* (1) Don't be afraid of strong women. (2) Take advantage of the interdisciplinary strengths of Women's Studies. (3) Don't make the intro course deadly weak or deadly exhibitionist. Better yet, skip the intro course and make the capstone course the compulsory integrator. (4) Balance scholarship with experiment and hands-on opportunity/application in the curriculum. (5) Don't be afraid of or cater to frightened women and threatened men.

Remember That Students Are Students

• *Nancy Arnold:* Remember that the students are people who have lives beyond the Women's Studies program. Because it is such a personalized/individualized course of study, students may need more help in finding their way through it. Be patient with this process even though you've followed similar processes 2,000 times. Continue your own academic development while remembering that students can't possibly be where you are after years of involvement. On the other hand, they know more than we sometimes think because it comes out of their own experience. And they carry with them all the hurts the culture has inflicted on them. They may remind us too much of ourselves. We can't take that out on them.

- *Kaaren Boothroyd:* Try to offer a balanced curriculum; the opportunities are great for polarization and extreme elements being held up as a representative of the whole. Don't hide your passion for the issues, but be careful not to alienate those younger students who, still struggling with their own identities, might be scared off by a strident call.
- *Patricia McGarry:* Be open to your students. Don't let your politics get in the way of working with them. So often I have felt ostracized from faculty who didn't take me seriously as a student, who didn't respect my politics. It took me a very long time to find a faculty member I could work with, and when the student–faculty relationship finally happened it was wonderful. It's vital for Women's Studies students to have mentors.

Involve Students

- *Megan Mitchell:* Present material in such a way that raises intellectual and personal issues. Assure that the courses are challenging academically, but make time for discussion. Have students write about material so they can apply it to their own experiences. Whenever possible, share something of yourself with students. Knowing that a respected faculty member has struggled with difficult issues can help undergraduates handle their own dilemmas.
- *Alisa Clemmons:* Allow students to be involved in the creation and/or development of the department. Students and faculty should work together to effectively gain status in the university. Students should be aware of what changes are being discussed for the department, what courses are being considered to add or cut, who is being considered for teaching positions, etc.
- *"Augustine":* Closer ties to the students, and if possible, a networking system for the students, so they can meet, ask questions, get to know each other, advise, and make suggestions.
- *"Cara":* Don't do it to death. Every student in that class should be his/her own primary text. The classroom should be a safe, live environment where each student is encouraged to discover his/her self. In the process, they discover each other and their written texts. Learning has to be interactional, it has to be about the process of learning itself. Written materials are only one of the many different kinds of materials that can be used to facilitate and stimulate that process. A professor of Women's Studies is not there to impart knowledge. Neither is a text there to impart knowledge. The professor's role should be that of a guide, challenging students to formulate their own questions, to seek their own answers, to recognize what they have in common, and to respect their differences.

Be Rigorous

• *Dawn Paul:* Keep turning out well-rounded critical thinkers because we need them. And keep the program intellectually rigorous. Provide students with plenty of exposure to the program by offering 100-level intro courses—it is subject matter that will knock their socks off the way college is supposed to.

• *Lola Smith:* Encourage students to challenge themselves. The challenge of Women's Studies, I found, was one of the most important aspects. I learned more and was able to retain and utilize the materials. I learned more in my Women's Studies classes than in any other area because I was challenged so much more.

• *Leona Roach:* Support cross-registration—get the math and science and music people to audit the department to raise the awareness among others about the field and its intellectual rigors. Do not relent—keep the program alive.

• *Denitta Ward:* Be demanding, be critical, and play devil's advocate. One of the best Women's Studies courses I took had a raving chauvinist in the class. Tempers would flare, ideas would be hashed out, and people would leave the class exhilarated from the battles. If the chauvinist is not in your class, then that view must be created (and critiqued). However, demand reasoned, careful thinking about the issues raised and never let a student get away with a simple emotional response to a hard question.

Curriculum Diversity Is a Must

• *Jill Tregor:* Make sure that the material considers race, sex, class, and sexual orientation. Make sure that students' own racism is challenged. Provide opportunities for dealing with internalized oppression as well.

• *Roxie Beyle:* Don't get too focused on things that don't have to do with real life, i.e., 'deconstruction.' Also, I am concerned that Women's Studies has become an elitist movement. How many women of color do you have in your program? This is a question I put forth when I was at school and a reason I was unhappy with the U of Utah program in general.

• *Kay Paden:* Stay objective. There are two sides to every story—make sure both the male/female sides are discussed. Berkeley had the best when I was there: Ellen Lewin, Kathy Jones, Evelyn Nakano Glenn, and Barbara Christian. One weakness, however, from some professors: fear of teaching diversity—the African-American, Latin, Asian-American, and lesbian elements of the historical and contemporary women's movements.

• *Lindsay Rahmun:* Keep the focus on grassroots movements and "un-

glamorous" women. Don't fall for lionizing only rich and successful women. Too many women equate success with money. I say success is a just world with dignity for all.

• *"Sara":* I would stress the need to include Jewish women in Women's Studies. Racism is discussed all the time, but anti-Semitism is completely ignored. It is an important issue. Also, religious women need to be recognized. Organized religion is not "inherently sexist" or patriarchal.

• *"Molly B.":* Please develop a progressive curriculum which takes the student through the history of women in the world or, as a microcosm, through that of North America. Base it upon a developmental/historical approach, outlining the status of women in the world and what we have done to change it, shape it, and otherwise affect the world at large. Also, intergenerational classes or visiting a community of old women will give young students a memorable experience and perspective from the other end of the life cycle. Sadly, the "bad news" courses are necessary to instill the anger needed to understand the position of women under an oppressive culture. However, I cannot stress enough the need to balance the bad news with strategies for change and *good* news. Otherwise the students become despondent, pessimistic, and depressed. Invite women who are doing good things, and the students will see that change is possible and then have ideas for their own future careers.

• *Susan Zeller:* Women's Studies must maintain an appreciation of the complexity of women and our lives. In the 1980s, feminist scholarship began to raise issues of different oppressions to the forefront. I challenge Women's Studies to maintain its integrity toward developing a theory which understands the range of oppression people face and which draws on the strengths of women's diversity. And I challenge myself to maintain that same integrity in my own work.

Push for Curriculum Integration

• *Heidi Boenke:* Stop thinking in terms of a "department." We should have Women's Studies *schools* which then teach psychology, sociology, history, the arts, etc. Women's Studies is not a "subject" to major in; it is a perspective through which to study all things.

• *Stacy Dorian:* Try not to ghettoize—force the university to incorporate women's issues, literature, etc. into the core curriculum. We are not outsiders. I had to take Women's Studies courses to find my history and my sense of place in the universe. The white-male experience is not universal.

• *"Claire":* Try to integrate feminism into all classes, not just Women's Studies, but don't give up separate Women's Studies courses. We are entering tough times and we need to fight to keep our flame alive. There are

plenty who would like to see us snuffed out. Do everything in your power to see that useful and enlightening information is imparted in coursework. Do everything in your power to keep class time from degenerating into therapy sessions.

• *Sandi Gray-Terry:* All academic disciplines can benefit from the inclusion of the historical and epistemological lenses of gender, race/ethnicity, and class (et al.). When we degrade or erase other's experience, history, culture, religion, societal contribution, etc., it degrades and disempowers us all. Such exclusion speaks strongly to a deep insecurity and an incredibly immature defensiveness. It is no way to live in this complex and fascinating world. It traps us all.

• *Keiko Koizumi:* I believe there is a place for Women's Studies as a separate entity. Perhaps mainstream academics could incorporate women into their courses (history, literature, etc.) so there will no longer be a need for courses such as basic women's history or women's literature. But I believe that mainstreaming will necessitate dropping feminist analysis, which we desperately need. What we also desperately need is the feminist education model of a nonhierarchical (as practically possible), co-teaching supportive environment.

• *Ali MacDonald:* Honor the field. Do not apologize for Women's Studies. Ideally there should be no Women's Studies or Black Studies or etc., etc., but simply studies of history or literature or music. But we do not live in an ideal world, so let's not pretend we do. If not for Women's Studies I would not have read Zora Neale Hurston and my life would be severely diminished.

Link Theory and Practice

• *"Susan Anthony":* Bring every issue of the political back to the personal or vice versa. Make it real! Seize the moments when open-minded women come to you and pour on *thick* whatever will build their confidence, self-esteem, and desire to push beyond traditional norms and ways of thinking. It takes all the courage, brilliance, and imagination we have! Show an example of this kind of courageousness in order to inspire that in younger women. Also, I learned about so many women's issues, such as battery, rape, marital inequality, unequal pay, abortion, child care, etc., without learning enough of how to personally empower myself on these issues when they came home to roost.

• *Yoon Park:* Make the learning experiences real, applicable. It's always much more effective to combine theory and practice. Push for things like internships. For example, I did an independent study on family violence while simultaneously volunteering at a shelter for battered women. I ended

up working there for two years, and that experience was the single most educating experience of my college years!!

• *Bernadette Hoppe:* Maintain the radicalism of feminism within the field. It's not enough to just teach about women, we need to use radical (or at least different) methods of teaching to develop skills, confidence, and knowledge. Also, help prepare students for jobs by encouraging internships and helping them find a focus.

• *Deborah McGarvey:* At Wooster we had a practicum experience as well as a year-long independent study project, which enabled me to combine theory and practice. These two aspects of my education were two of the best parts of my Women's Studies experiences and my college experiences in general. I was able to work with my values in academic as well as practical settings, which enabled me to think and process my ideas a lot differently by putting them into practice.

Deal with Career Issues

• *Jill Tregor:* However much career counseling type stuff you are doing — do more! Make sure that your campus "career planning" office, not just the Women's Studies Department, has information about careers for majors. Additionally, make sure that the career planning office is sensitive to the needs of lesbian students. Many are afraid to use the career planning resources for fear of not being able to be out, or being unable to ask important questions. Set up an alumnae resource network — where an undergraduate can contact a graduate working in the same or similar field for information and support.

• *Deborah McGarvey:* I discovered that our career center was not real helpful to me in finding the type of jobs I was seeking. Through my time as the co-director of the Women's Resource Center on campus, I created a program in which students, faculty, and administrators met to discuss job opportunities and experiences. More discussions during senior year about life outside of college may be useful.

Odds and Ends

• *Valata Fletcher:* Women's Studies needs lots of public relations people. Many people do not know what it really teaches. Others are in fear of what it will accomplish. One of the things that was really detrimental to my learning was the professor or instructor who pushed his or her politics or religion or lifestyle onto a student. It happened also during my Women's Studies classes that many poorly written books and papers were assigned. Poor English was the very thing I *didn't* need.

• *Ellen Divers:* Be sure to discourage reverse discrimination. Ensure that all students are exposed to books about women's voices so that they learn to appreciate those qualities that are wonderful about women, instead of emulating men. Provide plenty of opportunities to meet potential role models/mentors. Avoid discrediting roles of wife and mother as compared to that of career women. Most important, really encourage the student as an individual first, and woman second.

• *Susan Hillsman:* Discuss the sexual differences between men and women, the completely different ways in which men and women think about sex, love, and intimacy. This is one of the major areas in which men and women are completely different creatures. If I had learned that, it would have been a tremendous help.

• *Kay Sodowsky:* Although your department will doubtless be small and underfunded compared to other departments, conduct department business with the utmost of professionalism. You may not have the clerical support that the psychology or math departments enjoy, but make sure that student records, honor society applications, and other important paperwork does not get neglected because of a "casual" atmosphere in the office. Students in Women's Studies deserve the same level of departmental support as those who select a more traditional major.

• *Larisa Semenuk:* Be very careful not to oppress your students by holding too close to strict academia. That is, when I wrote my senior thesis in Women's Studies, my professors forced me to revise my thesis in a way that didn't feel right to me. This seems to me to be tragic in a field where we're trying to promote empowerment, not simply how to work the (patriarchal) system.

• *Kristin Chandler:* Promote it as a field not for women only, but for all students interested in affecting change in our world.

• *Darl Chryst:* Try to get the introductory course into the required general education curriculum for every undergraduate. Everyone could stand to be challenged at least once during their lives.

• *Katharine Rossi:* Please vary your curriculum! There is so much information that can be used. There is such a wide variety of material by many different women. Do not use Alice Walker's *The Color Purple* to represent Afro-American women writers. I love the book dearly, but to have it as required reading for three classes was overkill and tokenism. I also advise faculty to take the time to consult each other on the materials being used, see if these books have been used in the past, and make your syllabus reflect the richness of women's work. I found myself no longer challenged by Women's Studies classes because I was reading the same material over and over.

• *Amey Stone:* My main frustration with the program at Yale was that

I found I was constantly taking courses with people who had never been exposed to feminism before. It would have been helpful to me if the more theoretical courses had "Introduction to Women's Studies" or some other course as a prerequisite.

• *Betty Gooch:* I know Women's Studies is usually low on the totem pole as far as funds and support, but I hope our faculty and administrators will continue to fight for us. I think these programs really change people's lives much more than typical programs because they touch us personally.

• *Philip Gütt:* I feel Women's Studies is one of the most important vehicles we have for effecting real and long-lasting change. If you are a teacher, it is important to stay open to fresh and innovative perspectives. That is how it first began and that is how it will continue to be a powerful force for positive change.

8

WHAT WE LEARNED FROM
THE FIRST GENERATION

The bottom line: The Women's Studies education I received was so important to who I am and have become that I can't imagine life without it.

—Lola A. Smith

As we were beginning to collect our data about the first generation of Women's Studies majors, Susan Faludi (1991) exhaustively chronicled the backlash against American women that has accompanied the contemporary feminist movement. Three years later, when we put the finishing touches on this book, the backlash was very much alive and well, with Women's Studies a favorite target. Karen Lehrman's (1993) scurrilous "tour" of Women's Studies, for example, prompted a barrage of letters (including one from Faludi), debates, and newspaper articles. There even was a cartoon from Nicole Hollander. In fact, *Mother Jones* (Backtalk, 1993) noted there were so many responses that it would "continue the discussion" in future issues. Lehrman's supporters were as adamant as her critics.

For some women, in the words of Felicia Kornbluh (1994, p. 9), "the backlash finally found me" after reading Lehrman. Kornbluh's essay, published in a special section in *The Women's Review of Books*, was introduced with this editorial explanation, "As the mainstream media proclaims feminism passé and sneers at the work of Women's Studies, we ask women scholars from the supposedly post-feminist generation to talk about life in academia today" (p. 2). Among others contributing to that section were Deborah Cohen (1994), whose essay, "An Intellectual Home," would fit nicely as a profile in this book. Cohen was one of ten students to become a Women's Studies major at Harvard in 1987, the first year of its program, and she observed that "Karen Lehrman's portrait of women's studies bears not even a passing resemblance to my experience" (p. 17). Undoubtedly, the graduates in our study would agree.

197

BECOMING A MAJOR

Through the profiles, you learned of graduates' journeys to and through Women's Studies. Whether the graduates were traditional-aged or older students, their introductions to the major were similar. Some mentioned specific courses or instructors instrumental in their decision to major. The class mentioned most often was the "Introduction to Women's Studies." Based on our observations over the last 15 years, although a few students may know about Women's Studies before attending college, most have no information about the major. Or, if they have heard of it, their views may be similar to those described in Chapter 2.

Until students learn about Women's Studies from books like this, or in high school courses, or from media presentations, the introductory college course will continue to be the most important source of majors. Consequently, it should be staffed by excellent teachers, and class size should be manageable (25 to 30 students at most) to facilitate discussion. Programs may also want to develop a more theoretical introductory seminar specifically for majors. When our curriculum was revised in 1993, we designed such a course, "Introduction to Feminist Theories," and kept "Introduction to Women's Studies" (accepted for general education) as an elective by our majors.

Our 89 contributors cited other courses that affected their decisions to major. They ranged from self-defense to political theory and included economics, history, law, philosophy, and literature. In most instances, "women," "feminist," or "gender" was part of the title, e.g., "Women, the Novel, and Cultural Change." The fact that many students come to Women's Studies from courses offered in traditional departments suggests that communication between a program's faculty and those who offer these courses must be maintained. Likewise, formal ties to Women's Studies for faculty whose courses are approved for majors or minors should be explored through joint appointments or other types of affiliation that give recognition, rights, and responsibilities to faculty. These arrangements strengthen programs by committing faculty and giving them a greater role in the success of the discipline. Formal recognition relieves faculty of the tug between allegiance to Women's Studies and to their home departments; they have a sanctioned place in each, and their contributions to both will be considered when tenure and promotion decisions are made.

Further, core faculty in Women's Studies benefit from having more colleagues from diverse backgrounds to share in decision making, personnel matters, advising and mentoring of students, the teaching of core courses, and advocating for the program with administrators. Women's Studies will be stronger and able to command greater resources for students, staff, and

faculty and will be better able to resist cuts when budgets are trimmed and/ or programs are eliminated.

EFFECTS OF THE MAJOR

While each Women's Studies program is different and each graduate is unique, when we analyzed graduates' responses, we identified several outcomes that majors mentioned: being empowered; developing self-confidence; learning to think critically; understanding differences; discovering the intersections among racism, homophobia, sexism, classism, ableism, anti-Semitism, and other forms of oppression; and experiencing community. These themes are similar to those identified by the researchers who assessed Women's Studies and student learning on seven campuses throughout the United States (Musil, 1992). What current majors described about their educations-in-process have been put into practice by graduates. What has been happening (and continues to happen) in Women's Studies classrooms across the nation clearly has tremendous effects beyond graduation.

Intellectually, Women's Studies gave many of our respondents a history and identity as women. Among the effects of this recognition were an affirmation of their gender, validation of their experiences, discovery of foremothers, and awareness of a world previously unknown. Learning to think critically, to question assumptions, and to not settle were also described by numerous graduates. They learned to look at the world in new ways or from a variety of perspectives, to examine every premise, to become critics of the media, to question assumptions before and during research, and to challenge the status quo. Some described the development of their communication and analytical skills, the challenge of engaging in rigorous feminist analysis, and the ability to integrate theory and practice.

The interdisciplinary perspective fostered in Women's Studies' classes produced changes that had positive effects in the graduates' professional lives. Of all the intellectual themes described, understanding differences and increased awareness of the forms of oppression were cited most often. Graduates learned to understand the connections between oppressions and about personal racism, the value of diversity, the impact of patriarchy, and the effects of injustice. These insights made them better at whatever they have done since graduation. The accusation that feminism is mainly concerned with white, middle-class women's lives is not substantiated in our study.

Some graduates commented on a major project or thesis they completed as a Women's Studies requirement. One, for example, wrote and directed a videotape; another taught a class. These intellectual endeavors

had a profound impact on them. For others, an internship course led to their professional work or to the decision to pursue an advanced degree.

What seems apparent is that as an academic discipline Women's Studies is intellectually challenging and rigorous. Although there are critics who contend otherwise, often basing their assumptions on flimsy, anecdotal evidence, our graduates—from 43 programs nationwide—demonstrate that their education has enabled them to succeed professionally. Also, the fact that the majority of our respondents have pursued or are planning to get advanced degrees hardly suggests an anti-intellectual bent among Women's Studies graduates.

On a personal level, numbers of graduates believe their major increased their self-confidence and self-esteem, as well as helping them find their voices and become more assertive, stronger, and empowered. Other effects were greater awareness, self-sufficiency, courage, pride, dignity, self-worth, and respect. Because of Women's Studies, graduates are effecting social change, taking action, feeling passionate, questioning authority, looking employers in the eye, understanding abuse done to them and recognizing they are entitled to lives free from it, acting with more assurance, having the courage to speak and write, behaving boldly, and even returning to the home because they don't need a paycheck to prove their worth.

The latest accusation against feminism and Women's Studies is that they promote the idea of women as victims. Karen Lehrman (1993) concludes, "It's for its own sake that Women's Studies should stop treating women as an ensemble of victimized identities" (p. 68). And Katie Roiphe (1993) observes: "Preoccupied with issues like date rape and sexual harassment, campus feminists produce endless images of women as victims" (p. 26). The responses of our graduates call into question such characterizations, so popular with backlash purveyors. After reading the profiles, would you conclude that majoring in Women's Studies promotes a victim identity?

For many of our graduates, their major offered a sense of community and support within their school. Colleges and universities—particularly those that are very large—can be forbidding places. While higher education often is referred to as a community of scholars, it is not uncommon today to hear students referred to as clients or customers, and the institution labeled a business (with an organizational structure that is certainly bureaucratic). Students quickly learn their ID numbers, and large classes can exacerbate a sense of anonymity. Deborah Cohen (1994, p. 16) recalls the "cavernous lecture halls and departments stewarded by exasperated graduate students" she experienced for a year at Harvard before becoming a Women's Studies major.

Our graduates repeatedly mentioned that Women's Studies classes gen-

erally were small—and graduates liked them that way. Several remarked that Women's Studies classes were the best and most rewarding classes they took. Faculty were seen as role models and mentors, and friendships were forged that have continued since graduation. Among our graduates, acceptance of others regardless of age, sexual orientation, class, race, gender, or religion seems to be a guiding principle. There is no evidence of competition or conflict among students. Time and again, graduates spoke about personal changes but never about succeeding at the expense of others.

Another important academic benefit of being a student in a small department is the opportunity to get to know the faculty. Majors got personal attention, support for their research, and intellectual challenge. Such bonds between students and faculty are important during college and after graduation, when letters of reference are needed and professional advice may be sought. Graduates repeatedly recalled being inspired by their teachers, who became their role models and mentors.

Reading the responses from our graduates, we were heartened to note that the sense of community and belonging has not been lost as the discipline has matured; it was mentioned as often by recent graduates as by "old timers." We must consider seriously, however, comments from graduates who felt left out: One did not feel accepted because she was not radical enough, another does not call herself a feminist today because she believes the word implies radical female. While such feelings were rare, Women's Studies faculty and students need to encourage dialogue and respectful listening among all. As the number of majors increases, so will the range of feminisms reflected. To maintain this vital sense of community and belonging, each person must be respected and welcomed.

This does not imply that radical voices must be silenced or that faculty and students must respond to every criticism or stereotype, thereby losing their critical edge. Neither does it mean that faculty and students should tolerate such classroom abuse and harassment described by Bedard and Hartung (1991), who conclude: "Free speech versus responsible speech is an issue that undoubtedly will be fought out in the courts during this decade. . . . This makes teaching women's studies increasingly stressful because the threat of a lawsuit is ever present and because serious classroom disruptions will occasionally occur" (p. 17). Most of the disruptions they chronicle have come from men taking courses to satisfy general education requirements. Based on our observations, these confrontations are spreading into other subject areas and are being experienced by male faculty as well as female. But as one of our graduates, Lili Feingold, pointed out, "a disruption can be an important learning experience."

From our vantage point, feminist process and consensus building are alien in higher education outside of Women's Studies. As programs grow

and strive for acceptance, those qualities that have made us unique must not be lost. The admonition of Audre Lorde (1984) reminds us that being on the margin should be a strength rather than a weakness, that survival "is learning how to stand alone, unpopular and sometimes reviled, and how to make common cause with those others identified as outside the structures in order to define and seek a world in which we can all flourish" (p. 112). As students, staff, and faculty in Women's Studies enter the second generation, great care must be taken to include all women within our circle. If the lives of the 89 graduates we studied are any indication, we *have* made progress since Lorde spoke her words in 1979. But Women's Studies must remain on the cutting edge and on the margin to avoid co-optation. Oppression, inequality, ignorance, injustice, and violence are as real today as they were when Women's Studies began. Until each person who enters this world has the opportunity to experience life unfettered by oppression, there will be a need for Women's Studies and the people who choose to major in it. Perhaps you are one of those special people.

APPENDIX

RESOURCES

If you are interested in learning more about Women's Studies, we suggest the following sources:

• If there is a college or university in your hometown, ask the admissions office if the school has a Women's Studies program. If it does, ask for the name of the director and give her or him a call. If not, check the library for *Women's Studies Quarterly* (Spring/Summer 1994) for the 1994 Women's Studies Program List (pp. 141–175).
• Check the undergraduate catalogue or bulletin of colleges and universities you are interested in attending. Contact the Women's Studies program; if you visit the campus, be sure to talk with the program director. Try to talk with students, too.
• Contact the National Women's Studies Office. Be sure to ask them if there is a regional Women's Studies association for your area. The address is NWSA, 7100 Baltimore Ave., Suite 301, College Park, MD 20740. The telephone number is (301) 403–0525.
• A 24-page booklet on Women's Studies, based on the report *Liberal Learning and the Women's Studies Major*, is available from NWSA for $3. NWSA also has published *Guide to Graduate Work in Women's Studies: 1991.*
• Read *The Courage to Question: Women's Studies and Student Learning*, published by NWSA.
• Check your library for *Engaging Feminism: Students Speak Up & Speak Out*, edited by Jean O'Barr and Mary Wyer.
• If you have access to E-mail (electronic mail via computer), there is a discussion list for Women's Studies. Subscribe by sending a message to Listserv@UMDD.Bitnet or Listserv@UMDD.UMD.EDU. The message should read: Subscribe WMST-L your name.

BIBLIOGRAPHY

Backtalk (1993, November/December). *Mother Jones*, pp. 4–12+.

Bedard, Marcia, & Hartung, Beth (1991, Spring). Blackboard jungle revisited. *Thought and Action*, pp. 7–20.

Bose, Christine E., & Priest-Jones, Janet (1980). *The relationship between Women's Studies, career development, & vocational choice*. Washington, DC: The National Institute of Education.

Bray, Rosemary (1991, November 17). Taking sides against ourselves. *New York Times Magazine*, pp. 56+.

Cohen, Deborah (1994, February). An intellectual home. *The Women's Review of Books*, pp. 16–17.

Crenshaw, Kimberlé (1992). "Whose story is it, anyway?" In Toni Morrison (Ed.), *Race-ing justice, en-gendering power* (pp. 402–440). New York: Pantheon Books.

Faludi, Susan (1991). *Backlash: The undeclared war against American women*. New York: Crown.

Friend, Tad (1994). Yes. *Esquire*, pp. 48–56.

Howe, Florence (1977, June). *Seven years later: Women's Studies programs in 1976*. Washington, DC: National Advisory Council on Women's Educational Programs.

Kamen, Paula (1991). *Feminist fatale*. New York: Donald I. Fine.

Keller, Kathryn, & Warner-Berley, Judith (1990, May/June). In praise of women. *inView*, pp. 4–6.

Kornbluh, Felicia (1994, February). After "The morning after." *The Women's Review of Books*, pp. 9–10.

Lehrman, Karen (1993, September/October). Off course. *Mother Jones*, pp. 45–51+.

Lorde, Audre (1984). "The master's tools will never dismantle the master's house." In *Sister outsider*. Trumansburg, NY: Crossing Press.

Lutz, John S. (1991, Spring). Feminism: Cornerstone of political correctness. *Campus*, p. 1.

Morrison, Toni, (Ed.) (1992). *Race-ing justice, en-gendering power*. New York: Pantheon Books.

Musil, Caryn McTighe, (Ed.) (1992). *The courage to question: Women's Studies and student learning*. Washington, DC: Association of American Colleges.

National Women's Studies Association (1992). *Preamble to the Constitution*. College Park, MD: Author.

National Women's Studies Association (1991). *Liberal learning and the Women's Studies major*. College Park, MD: Author.

National Women's Studies Association (1990). *Directory of Women's Studies programs, women's centers, and women's research centers*. College Park, MD: Author.

Observations (1990). *NWSA Journal*, 2(1), pp. 79–100.

O'Barr, Jean, & Wyer, Mary, (Eds.) (1992). *Engaging feminism: Students speak up & speak out*. Charlottesville: University Press of Virginia.

Paglia, Camille (1992). *Sex, art, and American culture*. New York: Vintage.

Reuben, Elaine, & Boehm: Strauss, Mary Jo (1980). *Women's Studies graduates*. Washington, DC: The National Institute of Education.

Ries, Paula, & Stone, Anna J., (Eds.) (1992). *The American woman 1992–93*. New York: Norton & Company.

Roiphe, Katie (1993, June 13). Date rape's other victim. *The New York Times Magazine*, pp. 26–30+.

Stimpson, Catharine R., & Cobb, Nina Kressner (1986, June). *Women's Studies in the United States*. New York: Ford Foundation.

Sommers, Christina Hoff (1992, October 5). Sister soldiers. *The New Republic*, pp. 29–33.

U.S. Department of Labor (1975). *1975 Handbook on women workers* (Bulletin 297). Washington, DC: U.S. Government Printing Office.

Westkott, Marcia, & Victoria, Gay (1991). A survey of the women's studies major. *NWSA Journal*, 3(3), pp. 430–435.

ABOUT THE AUTHORS

Barbara F. Luebke, professor of journalism and Women's Studies, has been chairwoman of the University of Rhode Island (URI) Department of Journalism since 1989. Her involvement with Women's Studies began in 1972, when, as a graduate student at the University of Oregon, she enrolled in a groundbreaking political science course, "Women in Politics." Several years later, as a faculty member at the University of Missouri, she was a member of the University Women's Studies Committee and obtained permanent-course status in the School of Journalism for "Women and the Media," which she taught. At the University of Hartford, she served for five years on the Women's Studies Steering Committee and regularly team-taught "Introduction to Women's Studies." At URI, she is an active member of the Women's Studies Advisory Committee. The primary focus of her current research and writing is images of women in the news media.

Mary Ellen Reilly, professor of sociology and Women's Studies, has been director of the Women's Studies Program at the University of Rhode Island since 1983. During that time, the program has grown from several to more than 25 majors. In addition, the director has become full time, and the program has added a half-time tenure-track faculty member, a graduate assistant, and a half-time secretary. More than 40 faculty are affiliated with the program. Courses offered in the interdisciplinary program have grown to more than 60, drawn from four colleges and 16 departments. During her tenure, Women's Studies has received a gift of a scholarship and a deferred endowment that will provide an endowed chair and a large scholarship fund for single mothers when it becomes operational. Since joining the URI faculty in 1973, Reilly has developed courses on "Sex and Gender," "Sexual Inequality," and "Women in Irish Society," and co-developed and taught "Introduction to Women's Studies," "Field Experience in Women's Studies," "Women's Studies Senior Seminar," "Women and Aging," and "Alternative Lifestyles for Women." Her research and publications in the last decade have been mainly in the areas of sexual harassment and assault, lesbian issues, and Irish society. She is co-editor, with Bernice Lott, of *Combating Sexual Harassment in Higher Education,* to be published by the National Education Association.